Caring for Photographs

Display, Storage, Restoration

This volume is one of a series devoted to the art and technology of photography. The books present pictures by outstanding photographers of today and the past, relate the history of photography and provide practical instruction in the use of equipment and materials.

LIFE LIBRARY OF PHOTOGRAPHY

Caring for Photographs
Display, Storage, Restoration
Revised Edition

BY THE EDITORS OF TIME-LIFE BOOKS

TIME-LIFE BOOKS, ALEXANDRIA, VIRGINIA

For information about any
Time-Life book, please write:
Reader Information, Time-Life Books,
541 North Fairbanks Court,
Chicago, Illinois 60611.

TIME-LIFE is a trademark of
Time Incorporated U.S.A.

Library of Congress Cataloguing in Publication Data
Main entry under title:
Caring for photographs.
 (Life library of photography)
 Bibliography: p.
 Includes index.
 1. Photographs — Conservation and restoration.
I. Time-Life Books. II. Series.
TR465.C37 1982 770'.28 82-10497
ISBN 0-8094-4420-8 (retail ed.)
ISBN 0-8094-4421-6 (lib. bdg.)
ISBN 0-8094-4422-4 (reg. bdg.)

ON THE COVER: Using a fine-tipped
sable brush and a liquid dye, a
photographer retouches a color print by
covering the damaged area with a
careful shading of tiny dots and flecks.
Like other methods of caring for
photographs, retouching requires
meticulous attention to detail.

Time-Life Books Inc.
is a wholly owned subsidiary of

TIME INCORPORATED

FOUNDER: Henry R. Luce 1898-1967

Editor-in-Chief: Henry Anatole Grunwald
President: J. Richard Munro
Chairman of the Board: Ralph P. Davidson
Executive Vice President: Clifford J. Grum
Chairman, Executive Committee: James R. Shepley
Editorial Director: Ralph Graves
Group Vice President, Books: Joan D. Manley

TIME-LIFE BOOKS INC.

EDITOR: George Constable
Executive Editor: George Daniels
Director of Design: Louis Klein
Board of Editors: Dale M. Brown, Thomas A. Lewis,
Martin Mann, Robert G. Mason, Ellen Phillips,
Gerry Schremp, Gerald Simons,
Rosalind Stubenberg, Kit van Tulleken
Director of Administration: David L. Harrison
Director of Research: Carolyn L. Sackett
Director of Photography: John Conrad Weiser

PRESIDENT: Reginald K. Brack Jr.
Executive Vice President: John Steven Maxwell
Vice Presidents: George Artandi, Stephen L. Bair,
Peter G. Barnes, Nicholas Benton, John L. Canova,
Beatrice T. Dobie, Christopher T. Linen,
James L. Mercer, Paul R. Stewart

LIFE LIBRARY OF PHOTOGRAPHY

EDITORIAL STAFF FOR
THE ORIGINAL EDITION OF
CARING FOR PHOTOGRAPHS:
EDITOR: Richard L. Williams
Designer: Arnold C. Holeywell
Chief Researcher: Nancy Shuker
Picture Editor: Adrian Condon Allen
Text Editor: Betsy Frankel
Writers: John von Hartz, Johanna Zacharias
Researchers: Sondra Albert, Helen Fennell,
Lee Hassig, Peggy Jackson, Ruth Kelton, Don Nelson,
Carolyn Stallworth, John Conrad Weiser
Art Assistant: Patricia Byrne

EDITORIAL STAFF FOR
THE REVISED EDITION OF
CARING FOR PHOTOGRAPHS:
SENIOR EDITOR: Robert G. Mason
Picture Editor: Neil Kagan
Designer: Sally Collins
Chief Researcher: Patti H. Cass
Text Editor: Roberta R. Conlan
Researchers: Rhawn Anderson, John Hankins,
Molly McGhee, Charlotte Marine, Reiko Uyeshima
Assistant Designer: Kenneth E. Hancock
Copy Coordinator: Anne T. Connell
Picture Coordinator: Eric Godwin
Editorial Assistant: Jane Cody

Special Contributors:
Walter Clark, Don Earnest, Mel Ingber, Charles Smith

EDITORIAL OPERATIONS

Design: Arnold C. Holeywell (assistant director);
Anne B. Landry (art coordinator); James J. Cox
(quality control)
Research: Jane Edwin (assistant director),
Louise D. Forstall
Copy Room: Susan Galloway Goldberg (director),
Celia Beattie
Production: Feliciano Madrid (director),
Gordon E. Buck, Peter Inchauteguiz

CORRESPONDENTS

Elisabeth Kraemer (Bonn); Margot Hapgood, Dorothy
Bacon (London); Susan Jonas, Miriam Hsia, Lucy T.
Voulgaris (New York); Maria Vincenza Aloisi,
Josephine du Brusle (Paris); Ann Natanson (Rome).

*The editors are indebted to the following individuals
of Time Inc.: Herbert Orth, Chief, Time-Life Photo
Lab, New York City; Peter Christopoulos, Deputy
Chief, Time-Life Photo Lab, New York City; Photo
Equipment Supervisor, Albert Schneider; Photo
Equipment Technician, Mike Miller; Color Lab
Supervisor, Ron Trimarchi and Black-and-White
Supervisor, Carmine Ercolano.*

All photographers have old pictures they would like to restore, new ones they want to preserve, some they hope to display and many others they must index and file away. Yet until recently, the technology to guarantee maximum life for photographic images seemed arcane, the province of a small band of laboratory specialists and museum curators. Archival processing, in fact, is the term used for the techniques that guard prints and negatives from chemical deterioration.

Today, there is widespread interest in the preservation of photographs—both as art and as historical documents. Most of the techniques of restoration, storage and display are no more difficult than common photographic procedures; nevertheless, they are special. This volume brings them together for the general photographer, showing in text pieces and easy-to-follow picture sequences how to use them. Walter Clark, former director of Applied Photographic Research at Kodak, explains why photographs are potentially so durable—and why this potential is so seldom realized. Eugene Ostroff of the Smithsonian Institution shows how to restore original quality to photographs made by processes of the past: calotypes, daguerreotypes and ambrotypes. And George A. Tice demonstrates how to preserve images with some special printing techniques, including a version of the platinum printing process. The book also shows the basic steps that are used in archival processing.

In response to the growing popularity of color photography, this revised edition includes an examination of the relative stability of the dyes used in various color materials, and the techniques for restoring color lost from faded transparencies. Also included is a discussion of a process worked out by experts such as Henry Wilhelm for preserving highly prized color pictures in cold storage.

The object of restoring and preserving photographs is to keep them available for people to see and enjoy. A special photo essay shows the classic effort to bring the enjoyment of fine photographs to the public: the famed Family of Man exhibit prepared by Edward Steichen. Such an elaborate show may never again be attempted, but the principles that made it so successful can also guide the planning of smaller exhibits; they, like the other ideas outlined here, help all photographers to make more out of their pictures.

The Editors

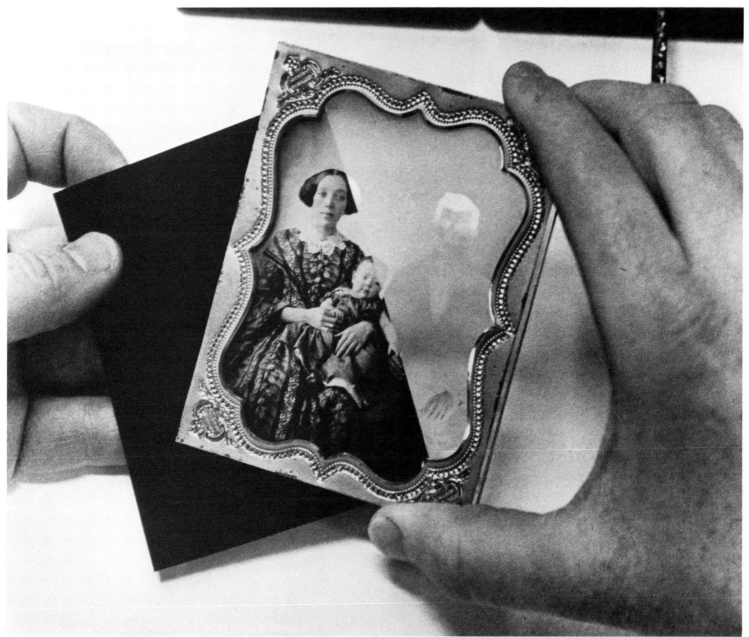

PHOTOGRAPHER UNKNOWN: *Family Portrait*, c. 1860

How "Lost" Images Are Recaptured

In 1933 an old and famous photograph came to grief. Made in 1840 by Dr. John W. Draper, chemist, scholar, as well as pioneer American photographer, it was a daguerreotype portrait of his sister, Dorothy Catherine Draper, and it had been exhibited here and in Europe as the earliest surviving daguerreotype portrait. Like many daguerreotypes it had tarnished with age, and an expert restorer had agreed to repair it. But the restoration went awry: Instead of emerging bright and clean, the Draper daguerreotype came out completely blank, its image totally destroyed. For 36 years it lay untouched. In 1969, a young curator of photography at the University of Kansas Museum of Art, James Enyeart, thought he had hit on a way to revive the image. He speculated that the ghost of such a "lost" daguerreotype might still be etched as an image in the plate's silver surface. After weighing the risks, Enyeart immersed the blank and once-again badly tarnished plate in a solution of thiourea, a tarnish-removing compound, and left it there. After several minutes the blackened silver was clean, but there was no sign of an image. Seven or eight minutes later, however, for reasons not yet fully understood, a faint image began to appear. In another five minutes Miss Draper's image could be seen.

Not all "lost" photographs are so badly damaged, although some may look worse off than they really are. An ambrotype, a kind of photograph popular in the 19th Century, is actually a glass negative that looks positive when viewed against a black background. Often an ambrotype image will seem to be vanishing when, as the example on the preceding page shows, the fault is merely a worn-out backing; a new backing easily restores the picture to its original beauty. Like the ambrotype, thousands of photographs tucked away in thousands of attics and desk drawers are simply past their prime. Either they are showing their age or they are suffering the effects of careless or uninformed handling. Some of these photographs, like the Draper daguerreotype, may be quite old. Although it is unlikely that very many examples of the earliest paper prints and negatives, called calotypes, exist outside museums, occasionally one turns up—sometimes in good condition, but often with its naturally soft image faded to an almost imperceptible yellow. Far more frequently the family collection of photographs contains daguerreotypes, which were enormously popular for mid-19th Century portraits. Even more numerous are images based on a later development, the collodion process—ambrotypes, tintypes, collodion-coated glass-plate negatives—and on a contemporary of this process, the photograph printed on albumen-coated paper. Occasionally collections of old photographs even have examples of the fleetingly used albumen-coated glass-plate negative. All can be penalized by time.

But in any average collection most of the damaged photographs probably were made in the early 20th Century by processes that are basically the same as those used today. Black-and-white prints and negatives tarnish and turn

yellow, develop brown and purple splotches, fade or bleach, suffer scratches and finger marks, grow fungus, stick together or are eaten by insects. Color films and prints are even more susceptible to change with age: They share many of the problems of black-and-white materials, but they have special problems as well. Most often, their dyes fade, destroying the color balance.

Most of these troubles are caused by improper processing, handling and storage. The photograph, made of potentially unstable materials, is very sensitive to the chemicals used to process it, and to its environment. It can be damaged by excessive heat and cold, by intense light and humidity, by pollutants in the air or in the paper, and by adhesives used in mounting and storage. Most of all it can be damaged by the complications that arise when the processing chemicals and their by-products remain in the finished negative or print. Most of these troubles can be prevented in new photographs. Processing techniques *(Chapter 2)* and methods of storage *(Chapter 3)* designed by archivists can make a black-and-white photograph almost as permanent as any other human artifact; a life span of centuries seems quite probable.

But the problem facing many people is not so much preserving new pictures as rescuing old ones from decline. The cures can be strange. In an experiment conducted for Washington's Smithsonian Institution, one of the world's great repositories of historical photographs, nuclear scientists at the Brookhaven National Laboratory on Long Island, New York, exposed a badly faded calotype to radiation in the laboratory's atomic reactor, making the almost invisible image radioactive. Then they put the "hot" picture in contact with a sheet of X-ray film. On development, the radioactivity generated a recognizable image of a breakfast table that had been virtually a blank on the original calotype.

A similar process known as autoradiography offers one of the most promising means of recovering images on the edge of extinction. In the procedure developed by the National Aeronautics and Space Administration to intensify extremely underexposed astronomy photographs, a faint negative is bathed in a solution with a radioisotope that combines with the silver in the image. When the negative is placed in contact with fresh film, the irradiated silver exposes the film. The process can produce an almost normal print from a 90 per cent underexposed negative; used on 70-year-old negatives that are badly faded, it can recover all the clarity and detail of the original images.

Atomic reactors and radioisotopes are hardly necessary in ordinary restoration. But techniques unfamiliar to most photographers may be involved. The nature of the restoration process depends largely on the image itself—on the substances that form it and hold it together and on the chemicals used to develop and fix it. Also important is the kind of material behind the image—its support. Modern photographs are standardized. The image, whether negative or positive, is composed of silver metal suspended in a gelatin emulsion. Sup-

porting this combination in a print is paper; in a negative or slide the support is usually a film of cellulose acetate or polyester synthetic plastic.

The materials in old photographs vary and it is not always easy for restorers to tell at a glance what they are dealing with. Both daguerreotypes and tin-types, for instance, have a metal backing, but they are made by very different processes; fortunately, they are easy to identify. On the other hand, other old photographs have a glass backing: collodion negatives and ambrotypes, silver-albumen negatives and silver-gelatin plates. Though the emulsions of many of these processes differ markedly, often only an expert can tell them apart. In some cases there is no emulsion at all. In many of the earliest photographs, like the calotype negatives and positives, the paper itself was impregnated with light-sensitive silver compounds; only later were they incorporated into emulsions on the surface of the glass or metal or paper backings. Albumen, made from the whites of eggs, was the first coating material, introduced in 1848. Collodion was the commonly used medium for glass-plate negatives between the early 1850s and the early 1880s, while the popular printing papers at that time were coated with silver in either albumen or collodion emulsions. After about 1880, gelatin superseded collodion as an emulsion medium for glass plates and, after 1889, for roll film. Gelatin emulsions were also used to coat many printing papers after 1880, although some photographers continued to favor albumen papers into the early years of the 20th Century.

Combinations of processing chemicals and photographic materials can result in a number of problems—some shared by many processes, some unique to one process alone. But whatever the trouble, there is one corrective measure that works for all of them: copying. Indeed, copying is frequently the only practical remedy for a deteriorated picture. For instance, the faded image of an old calotype can sometimes be restored chemically *(pages 28-35),* but the result is never foolproof. Even when the print appears to be in relatively good condition, the wetting that inevitably accompanies chemical treatment may very well cause the fragile paper fibers to tear or fall apart. Copying can also be the simplest way to rid a photograph of stains, restore a badly buckled print or remove the scratches from a negative. Ideally the copying procedure is done with a copying camera, but such specialized equipment is by no means essential. Many enlargers can be adapted to copying purposes, and accessories for use in copying are available for a number of cameras.

Copying can do more than merely provide a sturdy and accurate duplicate of an old and fragile picture, because a number of optical tricks can be used to minimize or eliminate damage. Some stains can be made invisible by copying through a color filter. If a light area in a print has a yellow blotch on it, a yellow filter on the lens of the copying camera will make the spot disappear—the copy film "sees" everything in yellow light, and the stain registers the same as

other bright areas. If the stain is a faded yellow patch within a dark area, a filter in yellow's complementary color, blue, would be required; in this case, yellow light would be blocked and the yellow stain would register dark, like the dark area of the image around it. For the more common problem of a print faded to an overall yellow, the solution is to copy through a blue or blue-green filter.

In addition to wiping out stains, another technique can be used in conjunction with copying to make scratches on a negative nearly invisible. The trick requires sandwiching the original negative between two pieces of glass thinly coated with microscope immersion oil, a liquid that is normally used to bring together lens and specimen for examination under a high-power microscope. In this case the immersion oil fills in the scratches so that they seem to match the surrounding surface.

The copying process can introduce defects of its own, however, unless proper techniques are followed. The most common problem is reflections on the surface of some old pictures — either mirror images of the copying apparatus or bright spots and streaks caused by bouncing light. Light streaks can be very troublesome when copying photographs that are buckled or scratched and dented — as tintypes frequently are. These reflections can be removed by putting polarizing screens over the light sources and using a standard polarizing filter on the lens of the copying camera; simply adjust the angles of the lights and rotate the lens filter until the reflection disappears from the image on the viewing screen. When copying extremely reflective pictures — particularly the silvery daguerreotypes — it may be necessary to mask the camera; otherwise the copy print may also contain an image of the reflected camera.

If an original negative survives, a print can often be made directly from it. When making such prints, some experts try to re-create the feel of an old photograph by using chlorobromide paper, a material that gives much warmer tones than the bromide paper most widely used for photographs today. Other archivists, especially when reprinting an old glass negative, prefer proof, or printing-out, paper, the kind used by commercial photographers for preliminary proofs. Printed-out images are created entirely by exposure to light, with no chemical development at all. Many early papers, such as albumen paper, produced images by printing out; thus the modern proof paper mimics their tonal quality more closely. Some professional reprinters, who work primarily for museums, go even further and create their own albumen or platinum-palladium papers for very authentic-looking prints, called restrikes. The works of many important 19th Century and early-20th Century photographers — Mathew Brady, William Henry Jackson and Eugène Atget, for example — have been revived and made more widely available for viewing in this way.

Instead of copying or reprinting, it may be preferable to restore the original photograph — if methods exist and if the condition of the photograph permits it.

Originals, even when less than perfect, have qualities no copy can match. Their very antiquity is appealing; the character of the image may be quite different from that produced by modern photographic materials. But restoring old photographs by chemical means always involves some risk and should be done with the greatest care. Not only may such pictures be unique and irreplaceable, but the photographers who made them did not always go by the book—even when there was one. Often there were no standard rules at all. For insurance it is always wise to make a copy of the original before attempting a restoration. If something does go wrong, there will at least be a record of the information on the picture. Care in touching and handling old photographs is even more important during restoration than it is at other times. Many are fragile from the effects of aging, and wetting them—as is usually necessary for restoration—weakens them further. Some images were fragile even when new; the daguerreotype image is so delicate that even a fingerprint may permanently mar it; these plates must always be handled by their edges.

The daguerreotype is one of the oldest photographic processes, but it has proved to be a very durable one. Removing the plate from its case and frame can be a bit tricky *(page 37)*; once this is done, however, restoration is relatively simple. The daguerreotype's main problem is tarnish. Daguerreotypes were made by fuming iodine onto a sheet of mirror-bright silver-plated copper; on contact the silver and the iodine combined to form light-sensitive silver iodide. After exposure and development of the latent image, fixer removed the undeveloped silver iodide from the plate, laying bare the nonimage portions of the metallic sheet. Like all silver, the sheet tarnishes and it is this picture-wide patina of tarnish that chemical restoration removes.

In the processes that followed the daguerreotype the problem is generally not so much tarnishing as decomposition. Most of these processes used collodion (cellulose nitrate) as the medium for their light-sensitive silver compounds. Collodion may yellow with age and become brittle. The coating may even flake off its support—whether it is the glass plate of ambrotypes or the thin metal backing of tintypes. There is no effective way to reverse the decomposition of collodion, but there are ways to slow it down. To halt blistering before flakes peel off, some restorers spray tintypes with the clear plastic fixative that artists use. Like the ambrotype, the tintype is a negative image meant to be viewed against a dark background; but in this case the emulsion is coated not on glass but directly on a thin, black-lacquered metal base. Made inexpensively to be carried around in breast pockets and purses or sent through the mail to loved ones, tintypes frequently got scratched, dirty and dented. The dirt can be removed, and the brightened picture can be copied photographically so the scratches and dents do not show *(pages 46-49)*.

For damaged photographs made with gelatin emulsions, introduced around

1880, salvage operations are essentially the same as those for the black-and-white papers and films of today. Then, as now, the gelatin emulsion was laid down in extremely thin layers. When the support material was glass or film, the light-sensitive silver-bearing emulsion was often topped with a protective layer of clear gelatin, and backed with a layer of dyed gelatin to reduce halation—internal reflections that may generate halos. Trouble comes to these gelatin-emulsion materials from chemical residues of processing, and from environmental conditions that interact with all these substances. Most difficulties stem from inadequate processing. Any unexposed and undeveloped light-sensitive silver compounds not removed by the fixing bath, and any fixer not washed away, will cause the photograph to deteriorate in time. Undeveloped light-sensitive silver compounds will gradually darken under the action of light. Fixer may react with the silver metal that makes up the image to produce yellowish-brown silver sulfide, causing the image to fade; under extremely severe conditions and over extended periods of time, the silver sulfide itself may decompose into white soluble silver sulfate, at which point the image actually begins to disappear. Other fixer residues may also decompose into silver sulfide and discolor large areas of the picture. Moisture or high humidity, high temperatures and air pollution all accelerate the unwanted sulfide formation.

Sometimes it is possible to spot trouble early. A sure sign of residual chemicals is bleaching in the light areas and along the edges of the negative or print. Oldtime photographers used to detect residual fixer by touching the photograph with the tip of the tongue: The fixer chemical tastes sweet. The taste test is not recommended; it is much wiser to confirm such suspicions with chemical tests (page 78), and often tests are essential.

After improper processing, the greatest enemies of gelatin-emulsion films and prints are improper storage and display. (For the right way to store and display photographs, see Chapters 3 and 4.) Many a print has been ruined by harmful ingredients in the envelope that was meant to protect it—by resins in the paper or sulfur in the adhesive that seals the envelope. But the most pervasive damage caused by improper storage is probably due to dirt. Many dulled images can be restored by nothing more than an application of the ordinary liquid film cleaner sold in photographic stores. Besides dulling the image, dirt may actually abrade the surface, leaving scratches in which more dirt becomes embedded. Film cleaner will lift out the dirt, but scratches require other measures. If the scratches are on the film, which is often protected by a coat of lacquer, removing the lacquer will sometimes also dispose of the scratches. Two cleaning mixtures remove the most commonly used lacquers: One is a weak solution of baking soda and lukewarm water—1 tablespoon (15 ml.) of soda to 1 pint (473 ml.) of water; the other is a combination of ammonia and denatured alcohol (page 57). When the scratches penetrate the emulsion, the

photograph will probably have to be copied and retouched. Minor retouching can be done with fine brushes and photographic dyes available at camera stores, and large, light-tone areas can be tinted with special dry dyes *(pages 58-65)*. But if the damage is extensive, the retouching will probably have to be done with an airbrush—generally a professional job.

Another agent of destruction in photograph collections is the presence of negatives made on nitrate sheet or roll film, the precursor of modern safety film. Nitrate film degenerates and in degenerating gives off gases that are likely to be extremely harmful to any other photographic materials in the vicinity. If it is kept at all, it should be stored away from other types of photographs. Nitrate film is also flammable, and in large quantities can be dangerous. It is best to copy nitrate negatives on safety film, and if the originals develop a yellow tinge or a distinct odor, they should be destroyed. An alternative to that drastic course is to use special chemicals to remove the emulsion and mount it—and the image it contains—on a new, stable film base; but the procedure requires practice and extreme care to avoid damaging the delicate emulsion. The cellulose base used on early safety film, until as late as 1930, presents a different problem: It shrinks with age, causing the emulsion to wrinkle badly. The solution again is to remove the emulsion and put it on a new base.

Other storage-related problems, difficult to prevent in certain climates, are those caused by heat, cold and humidity. Gelatin emulsions tend to become brittle and to crack in temperatures below 32° F. (0° C.). The brittleness is not permanent, however, and will disappear if the film is gradually warmed to room temperature, 68° F. (20° C.). In air with a relative humidity higher than 60 per cent, gelatin is a fertile culture medium for fungus. Cockroaches and silverfish also thrive on gelatin, and in eating it they eat the image too. When fungus has simply coated the surface of a film or print, it often can be safely wiped off with a piece of absorbent cotton moistened in film cleaner. Do not use water-based cleaner: Fungus can make gelatin water-soluble and the water may dissolve the affected gelatin. If lacquer must be taken off, do not use water-based lacquer remover.

After the fungus is removed, a coating of film lacquer, for film, and a clear plastic spray, for prints, will retard damage if the fungus grows back. If the image itself has been affected by the fungus or insects, there is no remedy but copying and retouching.

Most problems that affect black-and-white photographs become double the trouble when color photographs are involved. Fungus, for instance, not only damages the emulsion of color film but it also excretes substances that can alter the film's color. A much more serious problem is raised by the fundamental nature of a color picture. The image created by all commonly used color processes—for slides, prints and negatives—is not made up of durable silver

metal, as nearly all black-and-white images are, but of layers of dye. Unfortunately, many such dyes are relatively unstable. They fade or bleach out in the presence of light, heat and humidity — and not at the same rate. Certain dyes, for instance, cannot survive prolonged exposure to direct sunlight or the light of an illuminated display case, or a slide projector. Others fade alarmingly in heat or high humidity, even if they are kept in complete darkness.

Close attention to storage and viewing conditions can slow the deterioration of color pictures but cannot be relied upon to prevent it. To a degree, however, lost color and contrast can be reclaimed by copying the photograph using color-correcting filters to readjust the overall color balance *(pages 66-72)*. Professional restorers bring color back to particular areas in a print by a more complex procedure that involves masking parts of the image during copying.

One of the most intriguing problems in color preservation is presented by the collection of Albert Kahn, an eccentric Parisian millionaire who from 1910 to 1930 sent photographers out to document the life and customs of people all over the world. The result was some 72,000 Autochrome plates — fragile glass transparencies that carry their delicate hues on microscopic grains of potato starch. To preserve the invaluable images, curators of the collection have made accurate copies onto film, exercising rigid control of the temperature, humidity and light to which the original plates are exposed. A greater problem is posed by the roughly 20,000 plates that Kahn's globe-trotting staff had not had time to develop before the stock market crash of 1929 wiped out his fortune. With these, the curators have taken the most cautious course: They have developed a very few of the plates but will wait several years before doing the rest, to see what effect modern chemicals will have on the images.

While the prospects for rescuing a deteriorated color picture are uncertain, there is one almost foolproof method for saving the colors that exist — either to halt further loss in an old image or to preserve for the future the colors of a new image. The colors can be stored more or less permanently in the form of so-called separation negatives — black-and-white copies made by photographing the color original through three separate filters, in the three primary colors, blue, green and red. To reconstitute the color picture, the separation negatives can be used to make inexpensive prints or slides, or to produce a very high-quality color print or transparency by a process known as dye transfer. The making of color separations and dye-transfer prints is usually a job for professionals, and the cost is high. But the separations, once prepared, should last as long as any black-and-white negatives and can be used to reconstitute the original color pictures at any time. ☐

Walter Clark
Former Director of Applied Photographic Research, Kodak Research Laboratories

A Basic Procedure: Copying

More than a century has passed since two Union officers hoisted young women onto their mounts to pose for the picture shown here, and the vintage print *(right)* has faded to a sallow phantom of the original image. Deterioration like this occurs frequently on prints from that era—and on many from much later times as well—but the lost detail can nearly always be restored by copying.

With a print that has lost its highlights and deep blacks, a photographer's primary aim is to make a copy with an expanded tonal range. For a uniformly yellowed original like this example, one of the best remedies is to photograph the original using high-contrast panchromatic copy film and a blue filter. The blue filter absorbs yellow light—its complementary color—from the dark areas of the original image, decreasing exposure in those areas and darkening them in the copy print. Yellow light is also blocked from the light areas of the photograph; but all other colors of light pass through to the panchromatic film, which is sensitive to all colors of the visible spectrum. In the copy print shown on the opposite page, the blue filter has succeeded in eliminating the yellow tinge, heightening contrast and bringing out background details and facial expressions that had almost disappeared.

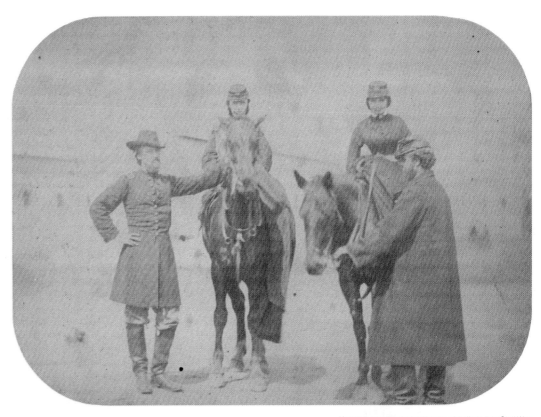

Yellowed and faded with age, details in this Civil War group portrait are barely discernible. The deterioration of the image occurred either because the print had insufficient fixing time, or because it was displayed in strong light for many years.

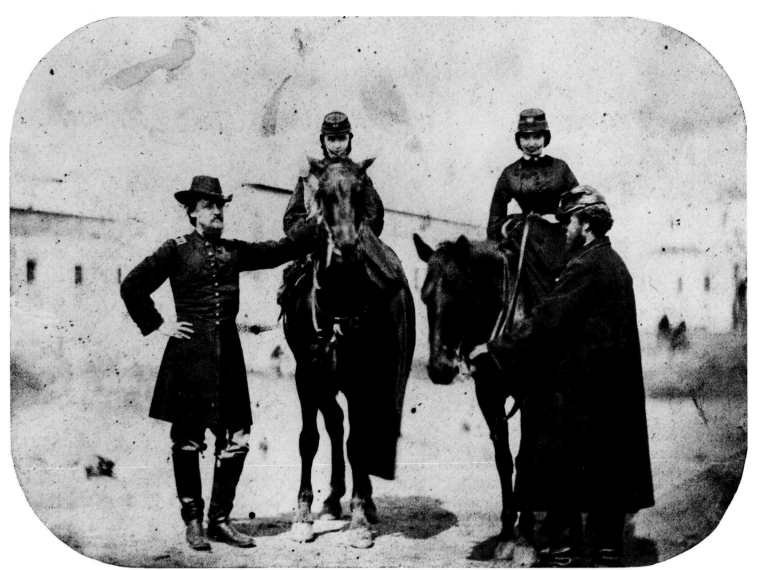

PHOTOGRAPHER UNKNOWN: *Civil War Group Portrait*, c. 1861

Photographing the faded print through a medium blue filter (left) blocked its yellows, effecting a remarkable recovery of the image. Fine-grained high-contrast copy film and an extended development time also helped. The print was then immersed in a bath of brown toner to give it the old-fashioned flavor of the original.

Filtering Out a Stain

In their rush to meet deadlines, news photographers and lab assistants will often take shortcuts in the darkroom. The wire-service picture shown at right of a heavyweight championship bout in 1953 was most likely the victim of such haste. The yellow stain seen in the middle of the picture is a telltale indication that the print was not washed long enough to remove all of the fixing solution. Over time, the residual fixer has reacted chemically with paper, emulsion and air to create a permanent discoloration. Similar blemishes can result from glue that has penetrated a print in an album or from the yellowing of transparent tape.

The method for removing such stains is simple: Using black-and-white panchromatic copy film, copy the picture through a filter that is the same color as the tainted area. A filter eliminates a stain of the same color by blocking light of its complementary color, which is what sets a stained area off from the rest of the print. In the print seen at right, a yellow filter allows yellow light to pass through to the panchromatic film. The film records both stained and unstained areas as being the same color, evening out the overall exposure and making the stain disappear—as can be seen in the copy print shown on the opposite page.

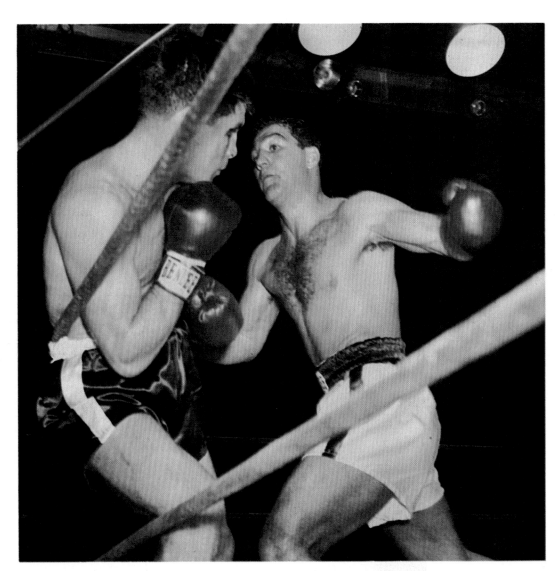

On a 1953 print showing heavyweight champion Rocky Marciano driving his opponent into the ropes, unremoved fixer taints a large portion of the image. Washing and chemically neutralizing the fixer might stop further deterioration; but now the stain can be eliminated only by making a copy of the print.

Copied through a deep yellow filter (left) on normal-contrast film, the photograph lost the yellow fixer stain that marred it. The filter used was a good bit darker in tone than the stain in order to ensure that all traces of the yellow taint would disappear.

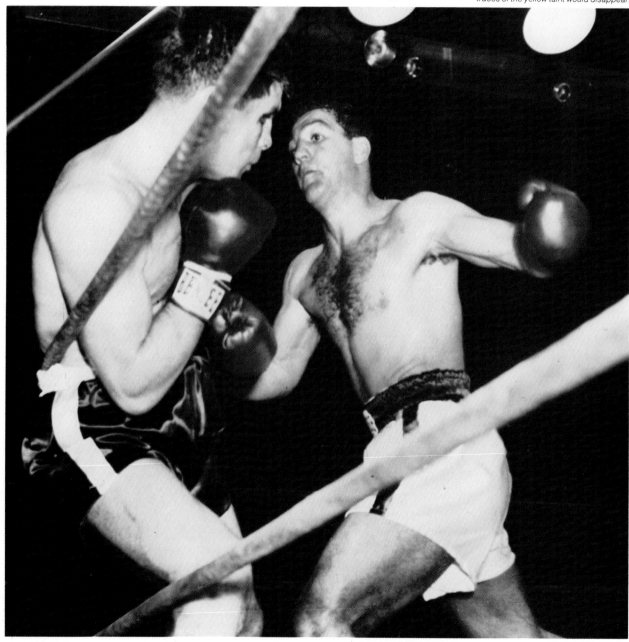

Selecting the Best Copying Film

The quality of a copy print depends on the quality of the negative from which it is made, so both the type of film used and the processing of it are of prime importance. When an original print has a good overall appearance with strong tones, the copyist will want to reproduce it as exactly as possible. The best film for this purpose is a slow, fine-grain film that will render details sharply.

When an image has faded with no discoloration, as in the example at right, a high-contrast, continuous-tone film may be used, without a filter, to darken the weak grays and blacks so they will stand out distinctly against the highlights. This effect can be heightened by subjecting the film to an extended development or by using a high-contrast developer. Both methods increase contrast by causing silver to build up in direct proportion to the amount of exposure received in a given area of the print.

High-contrast orthochromatic film may be used to copy an extremely faded image. Orthochromatic film is sensitive only to blue and green light; since it does not register the yellow reflected from such a print, the separation of light and dark tones is sharpened.

The picture at right—a shadow picture made by William Henry Fox Talbot on sensitized paper—has suffered loss of detail. The clarity of its images of botanical specimens was restored by copying the original, using high-contrast film and paper. Increasing contrast revived the fine detail of the leaves, making vanished veins reappear. There was no need to use filters as on the preceding pages, because the print was merely faded, not discolored. For another way to restore pictures made on Talbot's sensitized paper—pictures Talbot himself referred to as calotypes—see page 28.

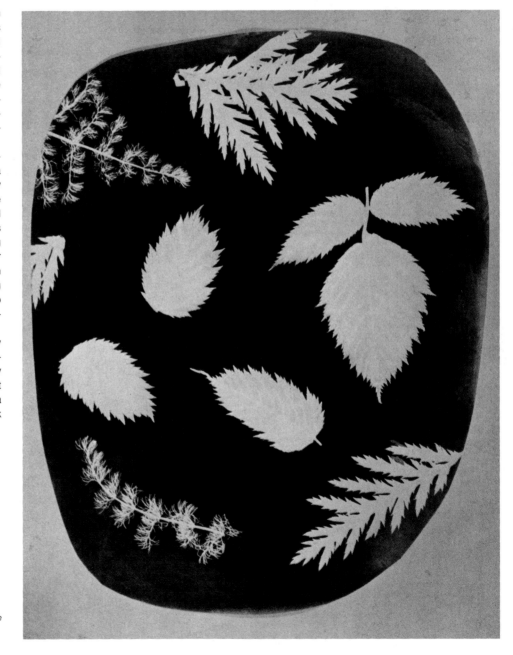

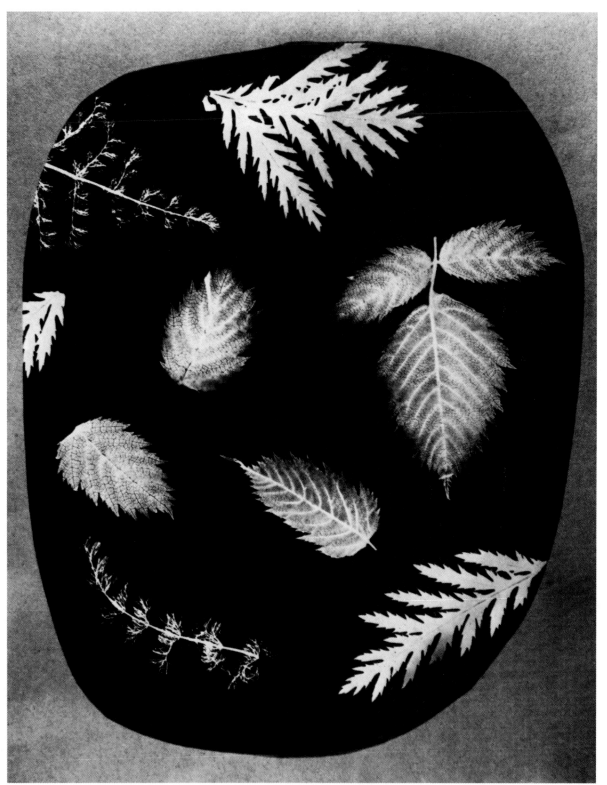

WILLIAM HENRY FOX TALBOT: *Calotype negative of leaves and grasses,* c. 1841

Lights, Camera—Copy!

Copying is most easily done with a camera that allows the original to be viewed through the lens—either a single-lens reflex or a studio-type view camera. A long-focal-length lens is best for most copying, but a macro lens or extension tubes fitted between lens and camera might be necessary for copying snap shots and other small prints. For accurate reproduction and sharp focusing over the entire surface of the original, the camera's film plane must be parallel to the print. Check the position of both with a level.

When copying black-and-white prints, use tungsten floodlights. Quartz-iodine lamps are better for color copying because they will maintain a consistent temperature. Use a reflected-light meter and an 18 per cent gray card to assure even lighting and a correct exposure setting in all corners of the original; the gray card compensates for large areas of light or dark in the original that could mislead a reflected-light meter.

In order to avoid unwanted reflections, turn off room lights, work away from windows and light-colored walls, and mask the camera with a sheet of black poster board. Placing polarizing screens in front of the floodlights and the lens will eliminate a stubborn reflection. □

Originals up to 16 x 20 inches can be copied using two floodlights and a camera mounted on a tripod. The floodlights, shielded from the lens with barn doors, should be at least 30 inches away from the subject and positioned so that their beams strike the surface of the print at a 45° angle. The beams should overlap to avoid a bright spot in the center of the original. Placing the print horizontally on a low table guards against shadows from the tripod's legs and ensures even light over the entire print.

cable release
camera
lens
filter
tripod
barn door
floodlight
45°
original print

With a larger original, the camera-to-subject distance is so great that it is easiest to copy the picture if it is mounted on the wall and the camera, on a tripod, is aimed horizontally at it. Four floodlights are needed to ensure uniform lighting of the entire print. The lights must be set at a distance twice the long dimension of the original, with their beams overlapping to prevent bright spots. Mount the print on the copy board with double-stick tape or lightly adhering artist's tape applied carefully along the edges. The print can also be put on cork board, with pushpins placed around the edges but not going through the print.

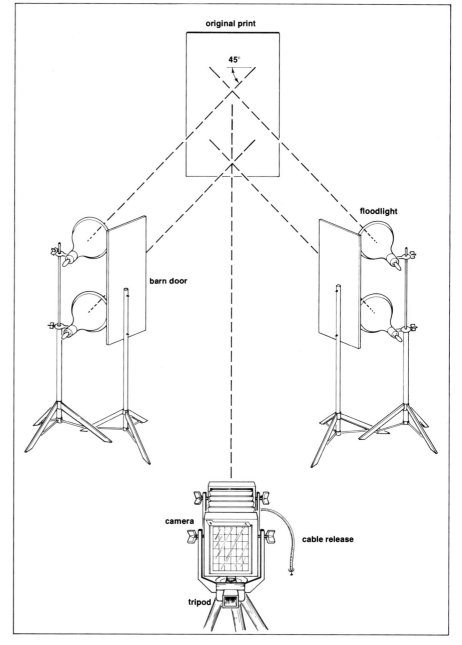

original print

45°

floodlight

barn door

camera

cable release

tripod

Chemical Aid for an Old Calotype

The calotype, the first photographic system that used the present negative-positive method, produced soft images that probably varied in tone from reddish brown to purplish black. The effect depended on the changing methods used by its inventor, an English gentleman named William Henry Fox Talbot, who was an inveterate experimenter.

Apparently Talbot did not fully realize the importance of washing his prints long enough to remove all the residual chemicals—or perhaps the fixing was inadequate. Either fault leads to the retention of processing chemicals that would, in time, decompose or react to light, darkening the background and fading the image—the defect that is now noticeable in many calotypes, some of which are today little more than pale yellow ghosts.

Calotypes were never widely popular, and most of those surviving are in museums. Given the difficulty of determining Talbot's methods in making any individual photograph, restoring calotypes is a chancy business. One expert, Eugene Ostroff of the Smithsonian Institution, uses a technique, demonstrated on the following pages, that was developed for strengthening weak images on modern film. Called silver intensification, the method supplements the silver already present in the image, after a series of baths has removed as many of the residual chemicals as possible—including undeveloped silver.

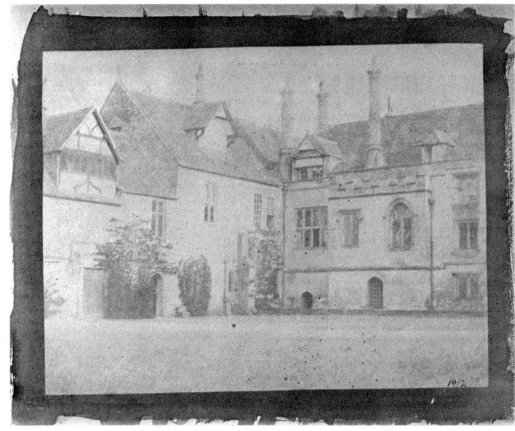

This print of Lacock Abbey, William Henry Fox Talbot's ancestral home and the subject of many of his photographic experiments, has lost much of its definition since it was made more than 125 years ago: The light areas have darkened and the dark areas have grown lighter, probably because the photograph was improperly fixed and washed (pages 76-77). The ragged-looking borders are areas that Talbot missed when brushing the light-sensitive compound onto his paper.

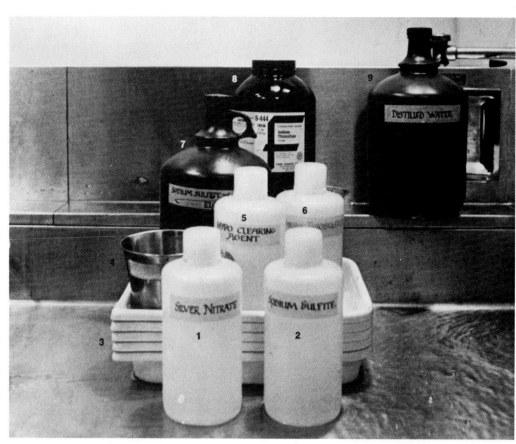

1 silver nitrate stock solution
2 sodium sulfite stock solution
3 trays
4 graduate
5 hypo-clearing agent stock solution
6 sodium thiosulfate (fixer) stock solution
7 sodium sulfite and developer agent stock solution
8 sodium thiosulfate
9 distilled water

Four stock solutions go into the calotype restoration bath. The bath is a silver intensifier formula, such as Kodak IN-5, that is made up from standard photographic chemicals and is ordinarily used for adding contrast to pale images in modern negatives. In addition to other standard darkroom supplies, such as hypo-clearing agent and the five processing trays, the restoration also requires a washing tray with a siphon to circulate the water.

1 copying the print

To make a record of the original, in case of trouble during the restoration, Eugene Ostroff uses a 35mm camera mounted on a vertical stand.

2 first wash

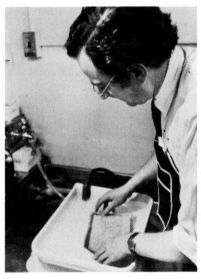

A 20-minute water wash in a siphon-fitted tray removes dirt; to protect the old and fragile paper, circulation has to be very gentle.

3 fixer bath

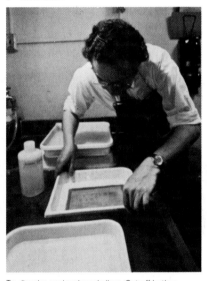

To dissolve undeveloped silver, Ostroff bathes the print in fixer for six to 10 minutes, rocking the tray so that the fixer acts evenly.

4 second wash

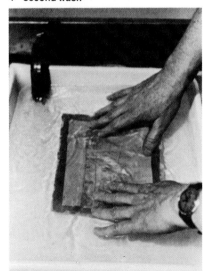

A washing in plain water for one or two minutes, using the siphon-fitted tray, removes much of the fixer and dissolved silver from the print.

5 clearing away the fixer

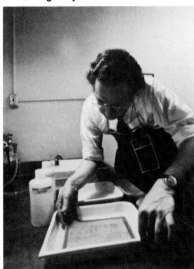

Before the final washing the print is bathed under constant agitation in a solution of hypo-clearing agent for about five minutes.

6 third wash

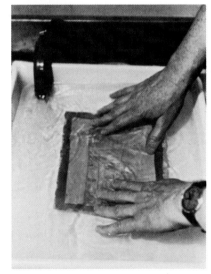

In water that is completely replaced through the siphon at least twice during the process, the print is washed for a total of 10 minutes.

7 preparing the stock solutions

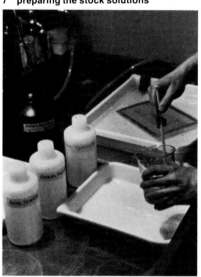

While the print is being washed, the four stock solutions are combined to make the IN-5 intensifier, which is then poured into a tray.

8 intensification bath

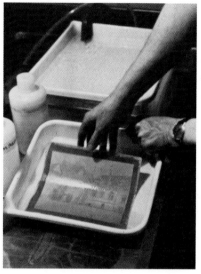

Ostroff slips the print into the intensifier and tips the tray back and forth so that the intensifier acts upon all parts of the image equally.

9 removing the print

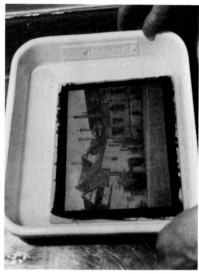

Checking on the progress, Ostroff removes the print when the image is strong enough and washes it briefly in circulating water.

In preparation for intensification of a calotype image, the print is first copied (to provide a record in case restoration fails) and then put through several washing and fixing baths before the four stock solutions for its intensification bath are mixed and bottled. Washing and fixing, in addition to cleaning away surface dirt, also remove leftover light-sensitive compounds with which the silver intensifier might react and cause damage. The four stock solutions can be prepared in advance; but their final mixing to make the silver intensification bath must be done just before use, since the solution remains active only for about 30 minutes. The formulas that Eugene Ostroff used for the four solutions — their materials are available at photography or chemical supply houses — are as follows:

☐ Stock solution Number 1 is made by adding enough distilled water to 2 ounces (59 ml.) of silver nitrate crystals to make 32 ounces (946 ml.) of solution.
☐ Stock solution Number 2 is made by adding enough plain water to 2 ounces of desiccated sodium sulfite to make 32 ounces of solution.
☐ Stock solution Number 3 is made by adding enough plain water to 3 1/2 ounces (104 ml.) of sodium thiosulfate fixer to make 32 ounces of solution.
☐ Stock solution Number 4 is made by mixing 1/2 ounce (15 ml.) of desiccated sodium sulfite and 365 grains (24 g.) of a developing agent, such as Elon, Metol or Rhodol, with plain water to make 96 ounces (2.8 l.) of solution.
To prepare enough silver intensifier bath to restore one print in an average-

sized tray, mix the stock solutions in a beaker in the following order:
☐ Eight ounces (237 ml.) of solution 2 is added to 8 ounces of solution 1 and mixed until a white precipitate appears.
☐ To dissolve the precipitate, add 8 ounces of solution 3 and allow the mixture to stand several minutes until clear.
☐ Twenty-four ounces (710 ml.) of solution 4 are stirred in and the mixture is poured into a tray.

Because the silver intensifier formula is actually designed for modern film, its action on fragile paper calotypes must be carefully watched. The desired result, a deepening of image tones, should be reached in no more than 10 minutes. Left in the bath too long, the silver might begin to deposit onto lighter areas of the picture, fogging it and ruining the restoration.

10 fixer bath

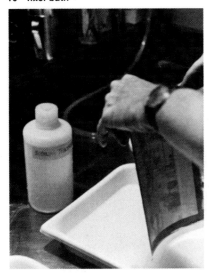

The intensified print is fixed in ordinary
fixer for two minutes, followed by a two-minute
wash in a regular hypo-clearing agent.

11 final wash

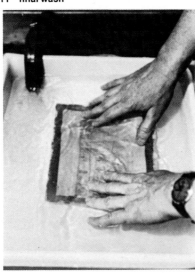

A final and thorough wash in gently circulating
water for 30 minutes removes all remaining
traces of the chemicals used in restoration.

12 drying the print

To prevent the print from buckling, Ostroff
sandwiches it between photographic blotters,
and allows it to dry slowly for several hours.

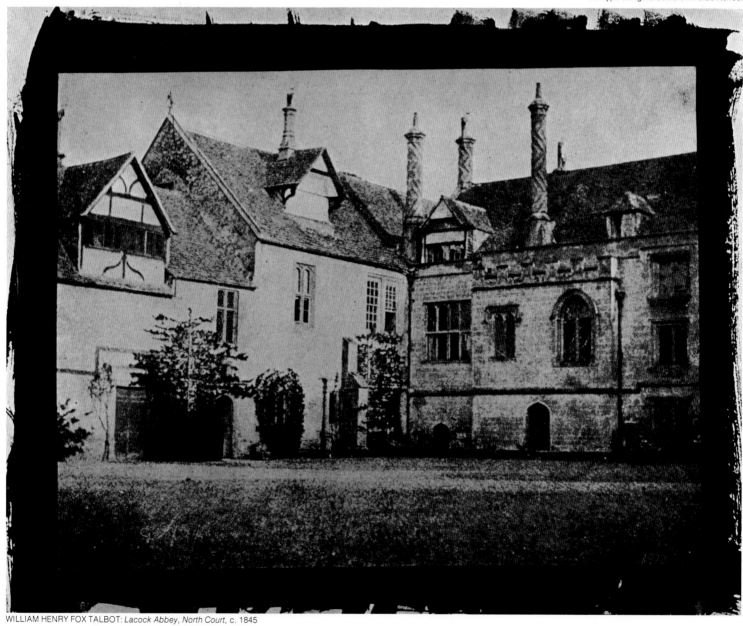

WILLIAM HENRY FOX TALBOT: *Lacock Abbey, North Court,* c. 1845

The silver intensifier that brought Lacock Abbey back to life *(pages 28-33)* also helped revive this badly damaged calotype of a steam locomotive. The print, dated June 1850, had lost so much of its definition before restoration that many of its details were no longer visible. It was also dirty, and at some point in its long history it had been damaged—perhaps by contact with another print or with an album page that left a vertical streak down its right side.

The locomotive calotype was made by William and Frederick Langenheim, the only professional calotypists in the United States. The Langenheims were best known as daguerreotypists; their clients included President John Tyler and Henry Clay. In 1849, the brothers bought the American patent rights to the calotype process from William Henry Fox Talbot, intending to sell licenses to other photographers for $30 to $50. However, not a single photographer applied—probably because no license was necessary to make daguerreotypes and because most people preferred to have the daguerreotype's sharper image. ☐

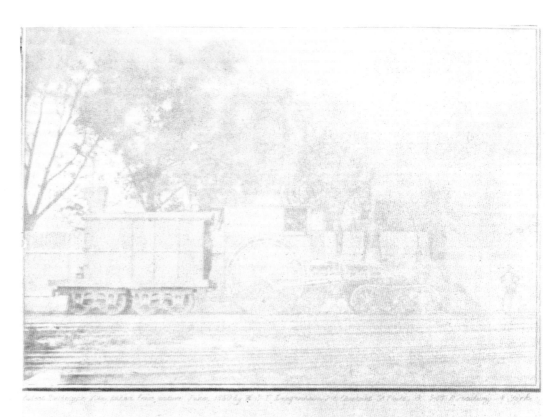

EIGHT FEET DRIVER LOCOMOTIVE

In the unrestored picture of the "eight feet driver locomotive" above, the background trees are almost obliterated; the man standing in front of the engine and a second man between the engine and the tender are badly blurred; a third man, at the window of the cab, cannot be seen at all.

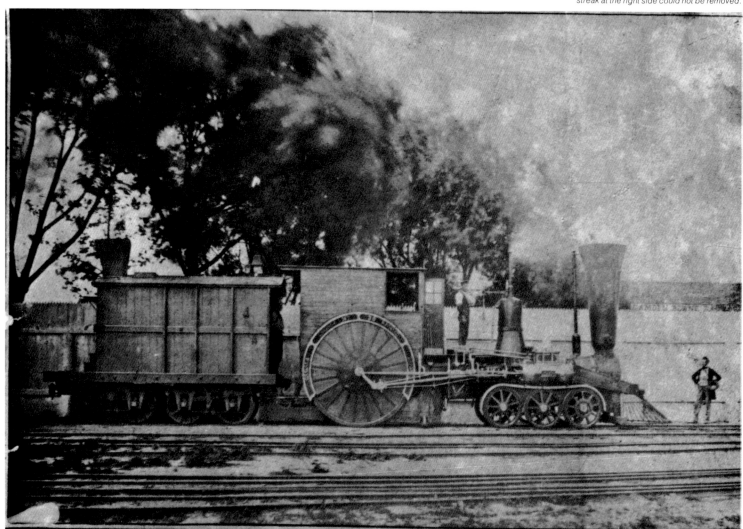

Patent Talbotype View, taken from nature June, 1850 by W. & F. Langenheim 216 Chestnut St Phila. & 247 Broadway N. York.

EIGHT FEET DRIVER LOCOMOTIVE

Built by Messrs. Norris Brother Phila.

WILLIAM AND FREDERICK LANGENHEIM: *Eight Feet Driver Locomotive*, 1850

Cleaning a Tarnished Daguerreotype

The daguerreotype, an instant success in its time—a period that ran roughly from 1840 to 1860—has also stood up remarkably well ever since. The daguerreotype image is an amalgam of mercury and silver on a silver-coated copper plate. Though the image can be permanently scratched by careless handling, the metallic silver surface of the plate itself is fairly tough. Like any silver, however, it tarnishes, and care should be taken never to touch the surface with the fingers.

For many years the standard way of removing tarnish from daguerreotypes was to bathe them in a solution of potassium cyanide, a deadly poison that sometimes overdid the job, removing image along with tarnish. The modern method, shown in the demonstration at right by Eugene Ostroff of the Smithsonian Institution, is safer and easier. The chief ingredients of the cleaning solution are thiourea and phosphoric acid, both available at chemical supply houses and some photographic supply stores.

To clean a daguerreotype, the plate must first be removed from its frame. The frame also always included an embossed brass mat and a piece of clear cover glass; mat, image and glass were taped together, and the taped edges were covered with a narrow metal "preserver" frame. The entire assembly fitted compactly into a hinged case included in the daguerreotype's price—often about two dollars.

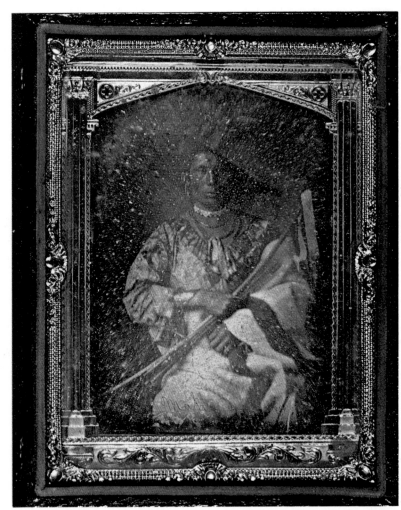

The unknown photographer who made this daguerreotype etched the name of his subject into the plate: Mahe, a Brave. Over the years Mahe's image has dulled and the background has spotted.

1 loosen the daguerreotype

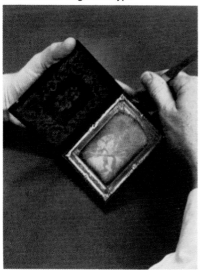

To pry the daguerreotype from its snug-fitting case, slip a slender knife blade between the case and the preserver frame, and gently lift.

2 remove the daguerreotype assembly

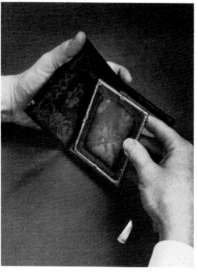

In lifting the daguerreotype from its case, grasp it firmly; its parts may be loose and slip across one another, scratching the daguerreotype plate.

3 open the preserver frame

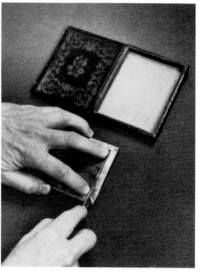

With the daguerreotype face down, gradually pry open the back edges of the preserver frame; the frame, of soft metal, will lift easily.

4 remove the preserver frame

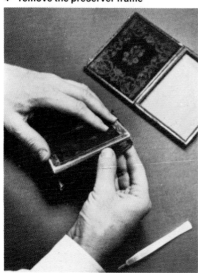

Tilt the daguerreotype upward, resting one long edge against a firm surface; ease off the preserver frame, exposing the taped edges.

5 release the tape

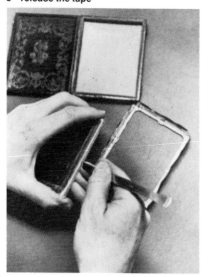

Slit the paper tape along the edges of the cover glass with a small sharp knife. Ostroff uses a scalpel but a razor blade will do just as well.

6 remove the tape

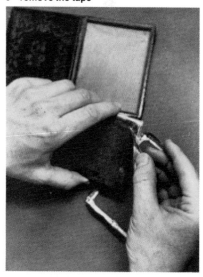

Peel away the tape from the front and back of the daguerreotype assembly. Free the daguerreotype and place it on the board for copying (page 39).

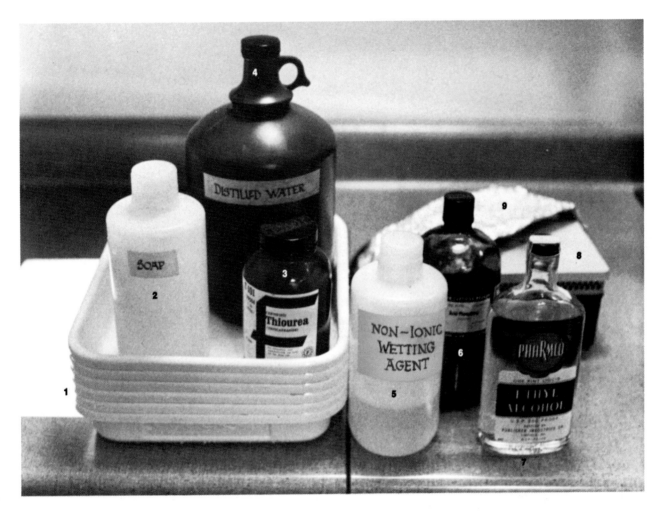

Cleaning a daguerreotype involves several washings and a bath in a thiourea solution that dissolves the silver tarnish. Thiourea is usually not harmful to daguerreotypes, but since old materials are unknown quantities, it is best to make a record copy beforehand.

Distilled water must be used throughout, to avoid contaminating the plate. To make the cleaning solution, combine 16 ounces (473 ml.) distilled water, 2 1/3 ounces (69 ml.) thiourea, 1/4 ounce (7 ml.) 85 per cent phosphoric acid, and 1 drop nonionic wetting agent—to prevent spotting. Add enough distilled water for a total of 32 ounces (946 ml.) of solution. (Ingredients can be bought at chemical and photographic supply houses.)

1 **six trays**
2 **mild soap (not detergent)**
3 **thiourea stock solution**
4 **distilled water**
5 **nonionic wetting agent**
6 **85 per cent phosphoric acid**
7 **95 per cent ethyl (grain) alcohol**
8 **hot plate**
9 **aluminum foil**

7 copy the original

Before shooting the copy, mask the camera with black paper to avoid reflections from the daguerreotype's mirrorlike surface (page 47).

8 clean the framing parts

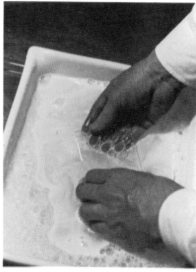

Wash the cover glass in mild soap and distilled water, then rinse it in distilled water. Dust the mat and preserver frame with a lint-free cloth.

9 wash the daguerreotype plate

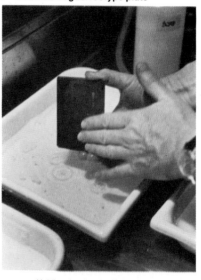

Holding the plate by its edges, agitate it in a bath of mild soap and distilled water; rub soapy water over the back; rinse in distilled water.

10 bathe in thiourea solution

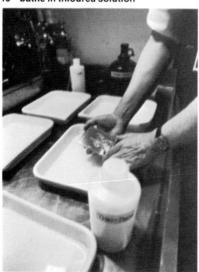

Place the plate face up in thiourea solution and agitate by gently rocking the tray; the tarnish will usually disappear in four or five minutes.

11 rinse off the cleaning solution

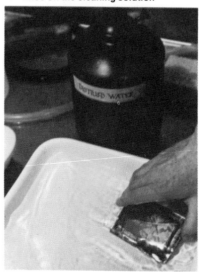

Wash off the thiourea solution by immersing the plate in distilled water; then pour additional distilled water on the front and back of the plate.

12 prepare to dry

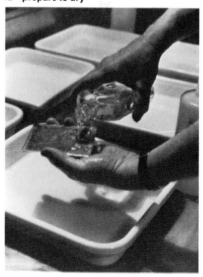

To prevent the formation of water spots and hasten drying, pour 95 per cent ethyl alcohol over the plate; the alcohol clears the water off.

39

13 begin the final drying

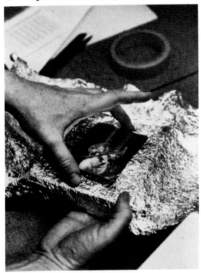

Continue the drying process over gentle heat.
Ostroff uses a hot plate topped with a piece
of crumpled aluminum foil to help diffuse heat.

14 complete the drying

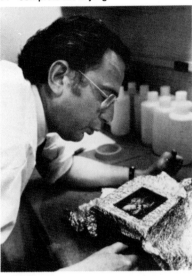

Blow gently across the daguerreotype's surface
to circulate the air heated from below by
the hot plate, and hasten the drying process.

15 reassemble the daguerreotype

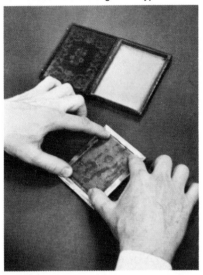

The clean daguerreotype and framing parts are
reassembled, the velvet case is brushed clean,
and the daguerreotype is reinserted in the case.

Cleansed of its tarnish, the daguerreotype shows ▶
Mahe in all his pride: bow and arrows in hand,
ornaments in his hair and at his throat. The image,
brighter overall, is especially so in the highlights.
Mahe's rich brown coloring is the product of
gold toning (pages 84-87), a technique often used
by daguerreotype photographers to protect the
silvery image and make its naturally cool grays
seem warmer. If Mahe's portrait should again
tarnish, as it might in today's sulfur-polluted air,
the same thiourea bath will restore it once again.

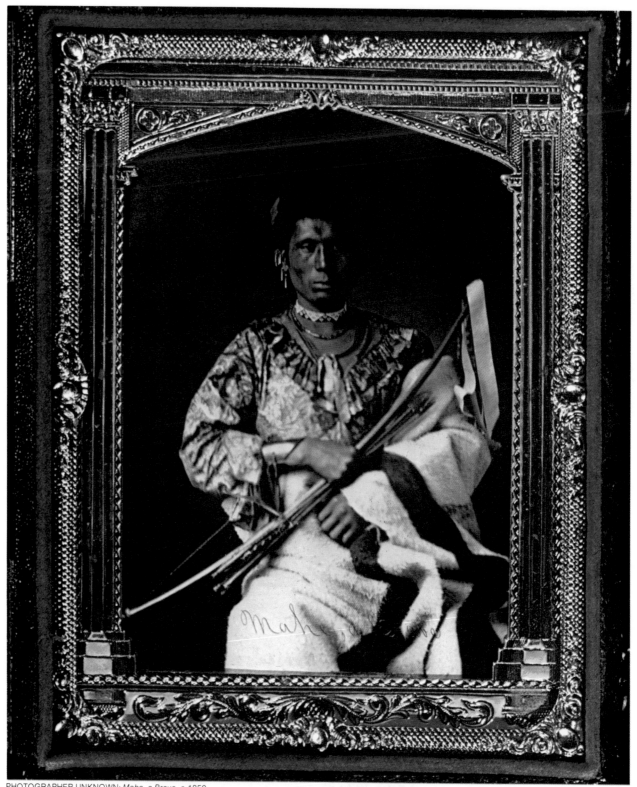

PHOTOGRAPHER UNKNOWN: *Mahe, a Brave,* c.1850

Replacing an Ambrotype Backing

In old photographs, the scars of time frequently seem ineradicable: Great-Grandfather's nose obliterated by a blotch, Great-Grandmother's eyes put out. However, in the case of the ambrotype—a photograph made by a process that flourished in the mid-19th Century—such apparently serious damage is quite easy to repair.

The ambrotype was popular largely because it was inexpensive—the finished picture is actually a glass-plate negative—and no print had to be made. The problem with damaged ambrotypes generally involves not the photographic image itself but the backing. To make the negative image appear positive, the glass plate is backed with black paint, velvet, paper or lacquered metal. Any of them may deteriorate and, in doing so, interfere with the visibility of the image.

To restore the image, it is usually only necessary to replace the backing, a relatively easy operation that involves removing the ambrotype from its case and protective mounting: a combination of brass mat, cover glass and tape, all enclosed in a "preserver" frame.

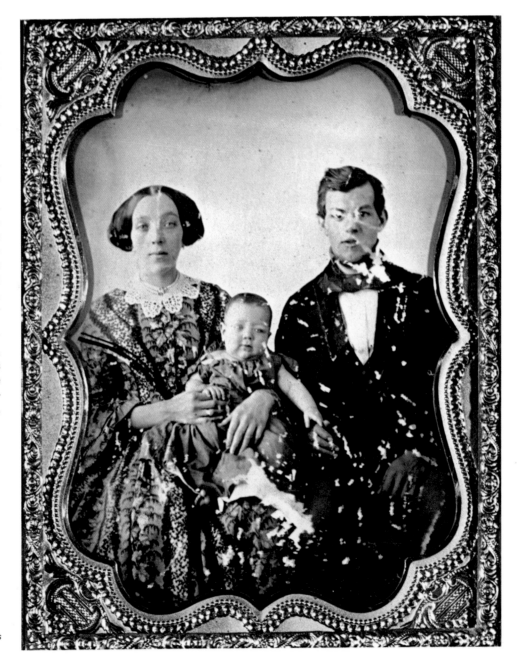

Nothing is known about this family portrait (which appears as the frontispiece on page 11) except that it was probably made in the early 1860s. The blemishes across the woman's forehead and on the man's face and suit are actually bleached spots in the black fabric backing. The image itself, recorded in a collodion emulsion on the front surface of a glass plate, is almost as good as new.

1 loosen the paper tape

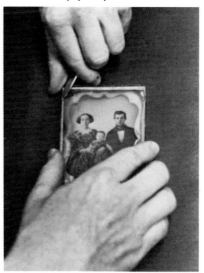

After removing the ambrotype from its case, slit the tape that binds the parts together. Use the edge of the cover glass as a guide for the knife.

2 remove the tape

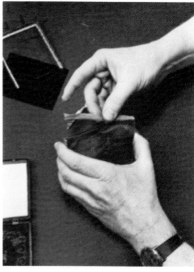

Gently pull away the tape from the cover glass and the backing material. Usually the tape comes off easily because the old glue has deteriorated.

3 separate the parts

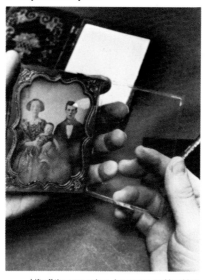

Lift off the cover glass, brass mat and backing. Wash the cover glass in mild soapy water; wipe the mat and the nonemulsion side of the plate.

4 cut a new backing

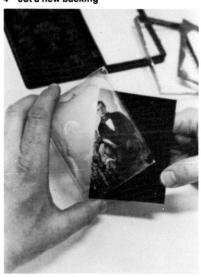

Using the cover glass as a pattern, cut a new backing from black paper. Slide the paper backing against the underside of the ambrotype.

5 reassemble the parts

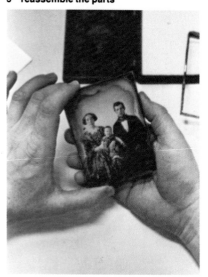

Align the brass mat and cover glass over the newly backed ambrotype, but do not tape the edges: Most adhesives are harmful to images.

6 replace the preserver frame

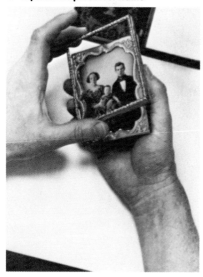

Slip all the parts into the preserver frame and press the frame edges down over the backing. Put ambrotype back in its case (overleaf).

Given a new lease on life with nothing more than a fresh backing and judicious cleaning, an ambrotype portrait sparkles in its original case. Like many ambrotypes, this one was delicately tinted by hand: The cheeks are rosy and the woman's brooch and one of her rings are golden. The hinged case, with its red velvet lining, was made on a wooden frame covered with a pressed-paper material meant to look like tooled leather.

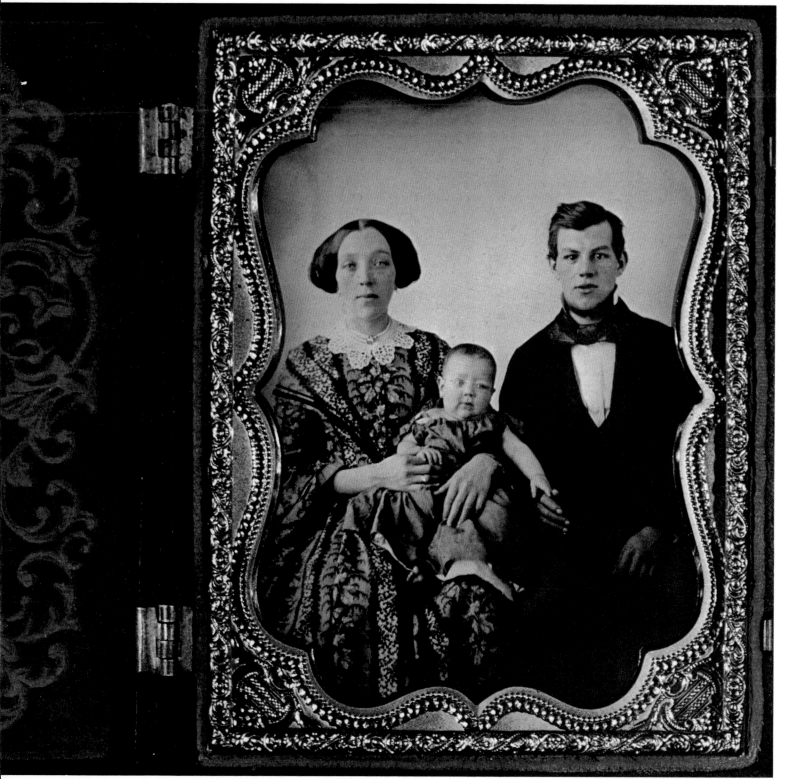

PHOTOGRAPHER UNKNOWN: *Family Portrait*, c. 1860

New Life for a Tintype

Widely used from the middle of the 19th Century until fairly recently, tintypes regularly turn up in attics—portraits of the past whose very age gives them an enduring charm. The popularity of the tintype stemmed from two advantages: It was cheap to make, and it was more durable than anything then available. The backing for the tintype image, unlike the fragile glass backing also used at the time, was a thin sheet of black-enameled iron. It could be shipped or carried about without danger of shattering. During the Civil War, soldiers took advantage of this characteristic to send home tintypes taken by itinerant camp photographers.

But the tintype's image deteriorates, and the metal backing is easily dented. The only way to restore a tintype is to copy it photographically. In doing so, the tintype's shiny surface poses special problems. Scratches and dents are often more noticeable on the copy than on the original—because they are emphasized by the light used for copying. And on occasion the reflective surface may pick up the image of the camera with which the tintype is being photographed—and that, too, shows in the copy. There are two ways to counteract these effects. One is to mask the camera, except for its lens; the other is to use polarizing filters over the lens and the light sources. (Polarizing materials for both lights and lenses are available from large photographic supply houses.) Both techniques are demonstrated by Herbert Orth, deputy chief of the Time-Life Photo Lab, in the pictures opposite and on the following page. Though a view camera was used for the demonstration, any camera equipped for close-up work will serve.

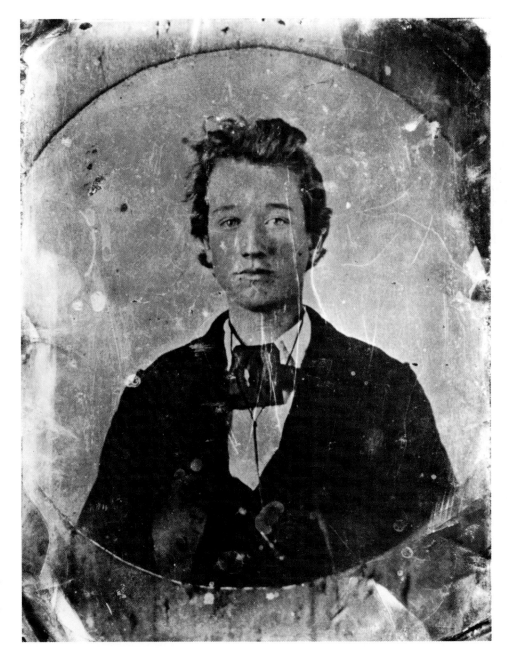

A copy of a tintype made without filters or mask to control light reflections emphasizes its imperfections. Lit by ordinary photoflood lamps, this copy looks even worse than the aged original. How this same picture appears when made with the right equipment is shown on page 49.

1 mount the tintype

To lessen unwanted reflections, mount the tintype with double-sided tape on a wall covered with a sheet of matte-finished gray paper.

2 align the camera

Level the camera so that the plane of the film and that of the tintype are exactly parallel; otherwise the image will be distorted.

3 mask the camera

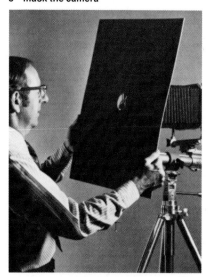

Cut a hole slightly larger than the lens in black cardboard and slip it over the lens to avoid a mirror image of the camera on the tintype.

4 anchor the mask

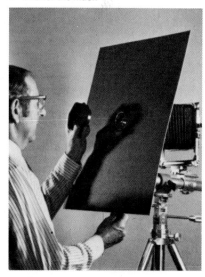

Screw on the lens hood to secure the mask. The mask will usually eliminate unwanted reflections if lights are set at 45° angles to the tintype.

5 focus the camera

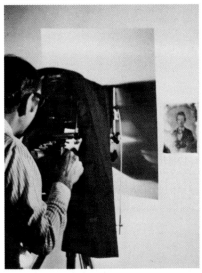

Make certain that the focus is sharp, using a
magnifier, if possible, to examine every detail of
the image as it appears on the viewing screen.

6 double-check for reflections

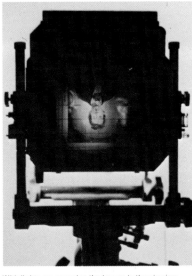

With lights on, examine the image in the viewing
screen to be sure the reflections on the tintype
have been eliminated; here, they are still visible.

7 polarize the light sources

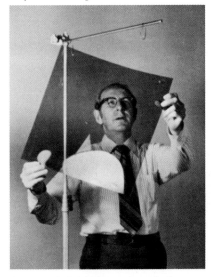

If reangling the lights fails to remove reflections,
place polarizing screens over each light.
They can be clipped on or mounted on stands.

8 adjust the lens polarizer

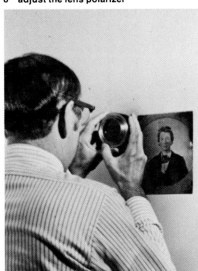

Put a polarizing filter in the lens hood; holding
it to the eye, rotate it until reflections vanish;
then put the lens hood on the camera in this position.

9 calculate exposure

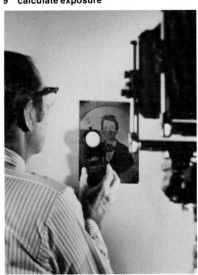

Using a light meter, gauge exposure. Because the
polarizers block some light, increase the
exposure about 1 1/3 stops over the meter reading.

10 make the exposure

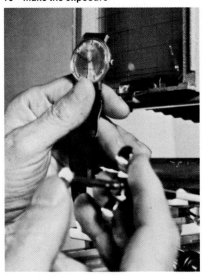

To time the exposure accurately, use a watch—a
fairly long time exposure is generally needed.
A medium-contrast film is recommended.

Photographed with polarizers and other light-controlling measures, the scratches and blemishes so apparent in the badly made tintype copy (page 46) have disappeared and the true nature of the portrait stands revealed. With its sharper definition and dent-free surface, this photographic copy, though it lacks the charm of the original, is in many ways a better image.

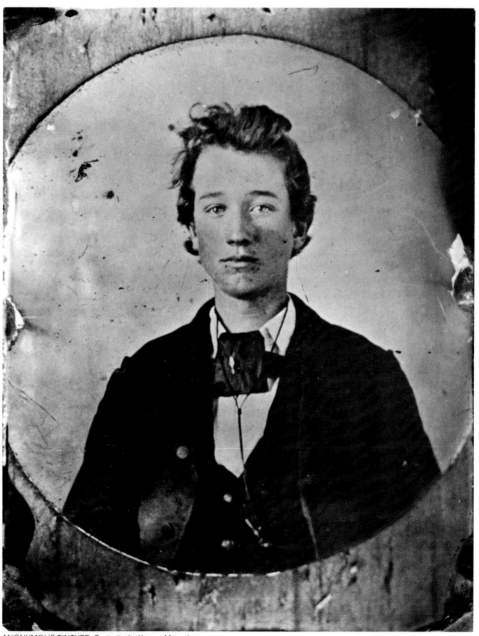

ANONYMOUS TINTYPE: *Portrait of a Young Man*, date unknown

49

The Value of Old-Style Printing-Out Paper

Fine as they are, contemporary printmaking materials are often unworthy of negatives made long ago. The glass negatives used by such 19th and early-20th Century photographers as Eugène Atget frequently contain rich detail and subtle tones that modern papers cannot reveal.

Only one type of paper made today approximates the papers used by Atget and his predecessors. It is the proof paper used by portrait photographers for preliminary prints. Like oldtime materials, it is a printing-out paper, which produces its image directly from the action of light and does not require chemical development. Such paper gives a greater range of tones than chemically developed printing papers because of its so-called self-masking qualities.

As the image is being formed by exposure to the sun through a glass negative, the deepest shadows build up first. The result is fine detail in both the shadows and the highlights. Printing-out paper is too slow to use for anything but contact prints, however, and when it is fixed, the image turns an unpleasant color.

To eliminate this undesirable color and stabilize the print, printmaker George A. Tice uses gold toning. On the opposite page Tice demonstrates how to make gold-toned prints. The gold-toning treatment employs a solution made in three steps. To prepare the solution, mix 200 grains (13 g.) of ammonium thiocyanate in 20 ounces (591 ml.) of water (beware: Ammonium thiocyanate is a poison if taken internally); then mix 15 grains (.97 g.) of gold chloride in 20 ounces of distilled water; finally, to make the working solution, mix 2 ounces (59 ml.) of the ammonium thiocyanate solution in 20 ounces of water, to which are added 2 ounces of the gold solution.

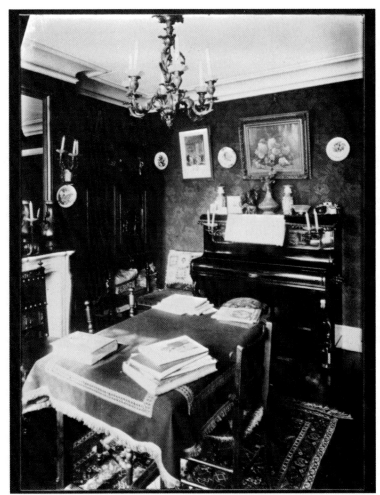

Printed on modern paper, the image from an old glass negative by Eugène Atget lacks some detail. The lettering on the books in the foreground is not clear, and in the room's far corner a cupboard and bric-a-brac are partially obscured.

1 check the progress of the image

Open the frame in dim light to check progress after exposing the proof paper in bright sunlight for two minutes. Expose longer if necessary.

2 preliminary washing

Working in subdued light, wash the exposed print in six changes of water in order to remove the soluble salts and acid contained in the print.

3 tone with gold chloride

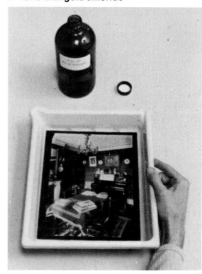

Immerse the washed print in a tray containing a freshly mixed batch of gold-toning solution, and agitate very gently for 20 minutes.

4 wash the print

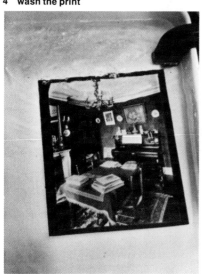

Remove the print from the gold-toning bath and wash it in a siphon-equipped tray of constantly flowing water for at least 15 minutes.

5 fix with hypo

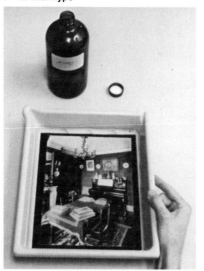

To remove the silver salts that are unexposed, immerse the print in a tray that contains ordinary fixer, and agitate it for 10 minutes.

6 clear away the fixer

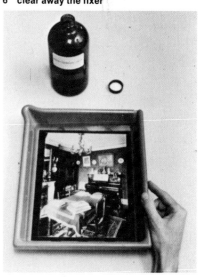

Rinse the print in water, then bathe it for two minutes in hypo-clearing agent, followed by a full hour of washing in running water; air-dry.

When Eugène Atget died in 1927, he left behind a treasure of 2,000 glass negatives, the record of his passion for the city of Paris and for his chosen craft, photography. During Atget's 71-year lifetime, photographic technology advanced rapidly, making photographic processes simple and fast operations. Yet despite the fact that photography was Atget's livelihood (a not especially lucrative one), he preferred to use the clumsy equipment and the complicated processes he had become familiar with early in his career.

Atget carried around an outmoded view camera and heavy glass plates. He printed his pictures on old-fashioned albumen and gelatin papers by painstaking techniques similar to the one described on the preceding page. His reasons for these preferences were simple: The older materials produced the effects he wanted—pin-sharp details and a tonal range that captured every nuance of shading from somber black to radiant white.

Lacking the intermediate gold-toning treatment, this version of the Atget photograph, printed on printing-out paper, has an unattractive reddish hue. Nevertheless, the subtle tonal gradations that were obscured in the modern print on page 50 are all present: The books have titles, the musical score on the piano is plainer, and the cupboard in the corner is clear.

When the Atget photograph is reproduced on ▶ printing-out paper treated with gold chloride before fixing, it gains in detail and also acquires a pleasing purplish-brown cast (right). Atget's own prints resembled this reconstruction. Atget sometimes gold-toned his prints by techniques like the one described on page 51—and sometimes he used self-toning papers into which the gold-toning chemicals had already been incorporated.

EUGENE ATGET: *Paris Interior*, date unknown.

The difference that proof paper and gold toning can make in reproducing the details of an old glass negative was revealed to photographer Lee Friedlander right in his own darkroom when he printed a treasure of forgotten plates he had found in New Orleans.

Friedlander's plates, dating from before World War I, were pictures of prostitutes in a house in Storyville, the city's red-light district. They had been made by E. J. Bellocq, a little-known commercial photographer who was born in France and had a studio in New Orleans from 1895 to the 1940s.

Nothing is known about the circumstances under which the Storyville pictures were taken, but the women appear to have been simply Bellocq's friends. A homely man with an irascible temperament, he may have turned to prostitutes simply for companionship.

With no clue to the appearance of Bellocq's original prints, Friedlander made his first test prints on modern developing paper, and found that he lost much of the negatives' detail. Only when he turned to proof paper and gold toning did he get the results shown here, which reproduce all the richness of tone that is present in Bellocq's plates. □

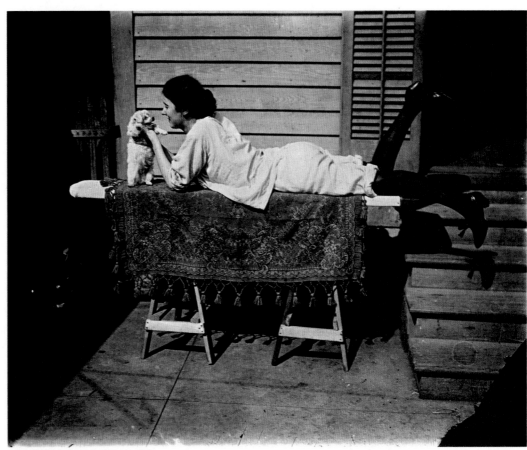

E. J. BELLOCQ: *Storyville Portrait,* 1912

Artfully stretched out on an ironing board, a New Orleans prostitute swaps smiles with a friendly dog. The gold-toned print brings out a wide range of textural detail—wood-grain steps, tapestry pattern, sunlight glinting off the young woman's hair.

Despite the dimly lit interior, Bellocq's picture of a ▶ strangely winsome Storyville prostitute is so sharp in this toned print that it is easy to trace the tufted surface of the design in the Oriental carpet, and to count the tiny beads in the woman's necklace.

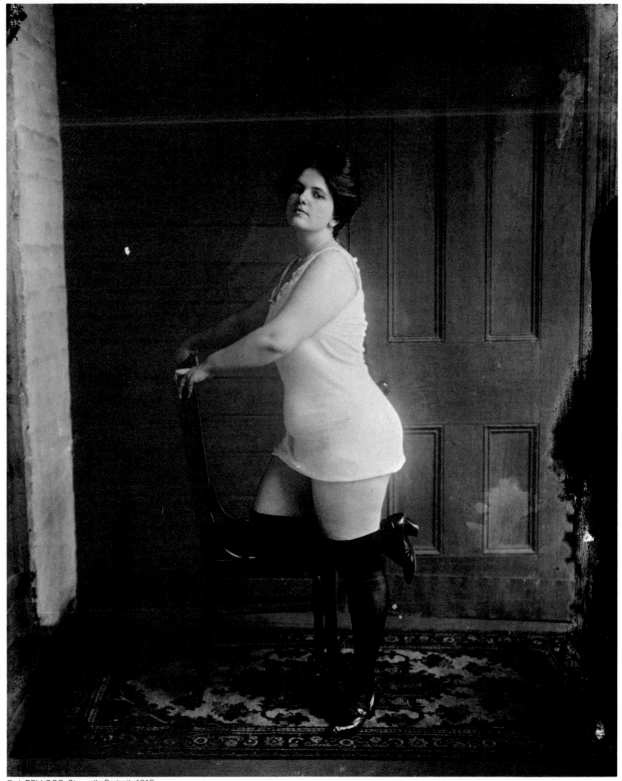

E. J. BELLOCQ: *Storyville Portrait, 1912*

Cleaning Slides and Negatives

Like any other irreplaceable original, film should be cleaned cautiously. The safest course is to blow away dust with a can of pressurized air *(upper left)*. Use a can with a triggered valve for regulating the pressure, and always make a test burst to expel any accumulated moisture. An antistatic brush or cloth *(upper right)* is almost equally safe; it merely breaks the electrical charge that causes dust particles to cling to film.

A more unyielding speck of dirt can be dislodged by applying a film-cleaning solution to the nonemulsion side of the film *(lower left),* which will dissolve the bond that holds the dirt to the film. As a last resort, film may be washed in clean 68° F. (20° C.) tap water *(lower right).* The equipment is simple: a tray, thermometer, cotton swab and film clip. The clip helps prevent excessive handling of the film and should be heavy enough to keep the film submerged.

Always make a duplicate negative first *(pages 20-27),* and then test a film's reaction to water by immersing a dispensable corner. Remember that the emulsion's tendency to absorb water makes it soft and more easily rubbed off or accidentally scraped.

For greatest permanence, color film that has been cleaned in water should be soaked for 30 seconds in stabilizer to harden the emulsion and make the dyes more resistant to fading. Stabilizer also coats the film surface and prevents droplets from forming spots as they dry. With black-and-white film, mix a few drops of wetting agent in the water at the end. To dry, clip the film by the corner, use a damp sponge to blot excess water along the lower edge and then hang in a clean, dust-free room. □

To blow off loosely adhering dust, hold the can of pressurized air upright, about 2 inches away, aiming the nozzle obliquely at the film. Start with short, gentle bursts and then increase strength if needed.

For a particle of dirt that continues to cling, wrap an antistatic cloth around your finger and gently dust both sides of the film, always in one direction, until the particle falls away.

With an even more stubborn speck, moisten a cotton-tipped swab with a dab of film cleaner and wipe the area with light, even strokes. A transparency should first be removed from its mount.

As a last resort, soak the film, emulsion side up, in clean 68° F. (20° C.) water for 5 minutes. Remove the film and rub lightly with a fresh swab. Follow with stabilizer (for color) or wetting agent.

Halting Fungus

1 assess the damage

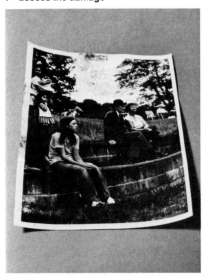

Although the fungus growth on this print looks extensive, it is only the surface coating that is affected by it; the image itself is undamaged.

2 remove the fungus

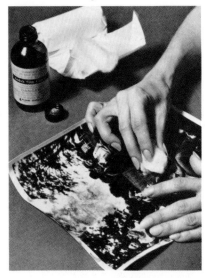

Using absorbent cotton dipped in film cleaner, wipe the fungus off the print. Replace the swab as it gets dirty, in order to keep from spreading the spores.

3 dry the print

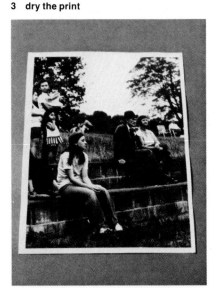

After checking to be sure that all traces of fungus have been removed, place the print face up on a clean surface and allow it to dry thoroughly.

4 spray for protection

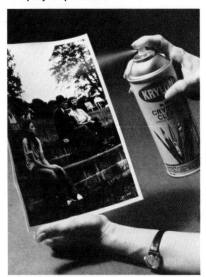

Spray clear plastic lightly and evenly over the print's surface. This provides a tough barrier, difficult for fungus to penetrate. It also eliminates dull spots.

Fungus spores—often called mold and mildew—exist in the air everywhere, but they thrive and multiply with a vengeance in high relative humidity (60 per cent or more) whether the air is hot or cool. Fungus needs a culture medium to grow in, and gelatin photographic emulsions, with their high-protein content, provide it. Insects attracted to fungus are an additional hazard. Chemicals found in insect excretions can fade or bleach the image, and the insects themselves can damage the emulsion layer. Degradation of the emulsion by fungus or by insects may harm the photograph so severely that only copying and retouching can repair it *(pages 58-65).*

But there are methods of preventing the growth of fungus. Proper storage is vital *(Chapter 3).* The container used for storage should include a drying agent, such as silica gel. Cleanliness is also important: Fungus prefers greasy, finger-marked surfaces.

Processing black-and-white prints in hardening fixer baths and in hypo-alum toner will make them more resistant to fungus attack. Hypo-alum toner also provides some protection against the harmful effects of residual chemicals. (Selenium and gold toning are not as effective.) Treatment with a fungicide is effective for black-and-white pictures, but should not be used with color because the chemicals in fungicides will cause dyes to fade.

Finally, damage can be prevented by applying a protective coating of clear plastic directly to the photograph before fungus has a chance to grow. In any case, never use water-based solution to combat fungus, for if the fungus has softened the emulsion, water will remove the emulsion from its backing. □

The Delicate Art of Retouching

Applying dyes and other coloring materials to photographs to repair blemishes requires some mastery of artist's tools. Practice on expendable prints is essential, but the procedures described on the following pages are within the abilities of a diligent amateur. Highly valued prints should never be retouched directly, because mistakes are possible and not all retouching materials are archival. It is best to make a good copy of the original *(pages 26-27)* and work on that instead.

A wide variety of retouching materials *(opposite)* are found in camera and art supply stores. Liquid dyes *(11, 13)* solve the common problems of light-colored specks and streaks. Larger washed-out areas may be tinted with dry dyes *(17, 18)*, which come in hard cakes and are not permanent until they have been set with steam. When skillfully applied, both liquid and dry dyes sink into the emulsion, becoming virtually invisible.

Darker defects have to be hidden with opaque paints. White opaque *(9)* should go on first, followed by whatever other opaque *(10, 12)* is necessary. Soft colored pencils *(23)* touch up small flaws on prints that have first been sprayed with retouching lacquer *(21)* to give the surface some "tooth." Use a pencil with a well-sharpened lead to cover the damaged area with fine strokes. And finally, spraying a print with protective lacquer *(22)* guards the surface against smudging, fingerprints, atmospheric contaminants, humidity and abrasion.

Those print areas not in need of retouching may be protected with a masking liquid *(15)* that is brushed on and then solidifies. It often must first be diluted with solvent *(14)*. White artist's tape *(16)*—a lightly adhering paper-backed tape that comes off easily without causing damage—is used to remove dried masking liquid and is also an effective shield. A sheet of protective paper *(3)* slipped between the hands and the print protects the print from dyes and skin oils.

Fine-tipped sable-hair brushes *(4)* are available in many sizes; they must hold a sharp point when wet for stippling. A water can with built-on brush holder *(1)* and a ceramic palette *(2)* are useful. For very fine work, a magnifying glass *(7)* is indispensable; mounted on a stand, it frees both hands. Paper towels *(6)* and cotton *(8)* serve to blot, wipe brushes and clean up; cotton also spreads on dry dyes. Anhydrous denatured alcohol *(19)* cleans soiled prints and will remove dry dyes before they are set. A 5 per cent solution of ammonia and water *(20)*, made with household ammonia containing no detergent, will remove steam-set dry dyes and excess liquid dyes.

Professionals often use an airbrush *(5)*, which sprays a thin layer of opaque paint or dye and allows color to be applied much more quickly and evenly than an artist's brush does. But it requires compressed air to run it and is not essential.

A well-lighted work area with a color temperature of 3,800° K. to 5,000° K. is a prerequisite for matching colors accurately. Diffused natural light from a window away from the direct sun is best; but a good approximation can be obtained by combining the light from an incandescent bulb and a cool-white fluorescent tube. This combination is often found in drafting-board lamps with flexible arms.

If a picture needs to be corrected with more than one type of dye, begin by touching up details with liquid dyes. Next tint large areas with dry dyes, and then touch up dark spots with opaque paints. Keep pencil corrections for last.

1 **water can with brush holder**
2 **ceramic palette**
3 **protective paper**
4 **sable brushes**
5 **airbrush**
6 **paper towels**
7 **magnifying glass on stand**
8 **cotton**
9 **white opaque paint**
10 **gray-to-black opaque paint**
11 **liquid dyes for black and white**
12 **color opaque paints**
13 **liquid dyes for color**
14 **solvent for masking liquid**
15 **masking liquid**
16 **artist's tape**
17 **dry-dye retouching colors**
18 **yellow dry dye**
19 **anhydrous denatured alcohol**
20 **5 per cent ammonia-water solution**
21 **retouching lacquer**
22 **protective lacquer**
23 **soft colored pencils**

Almost any retouching job on a black-and-white or color print can be handled with the equipment and supplies pictured here. The liquid dyes (11, 13) and the dry dyes (17) are safe for photographs that are intended for archival preservation.

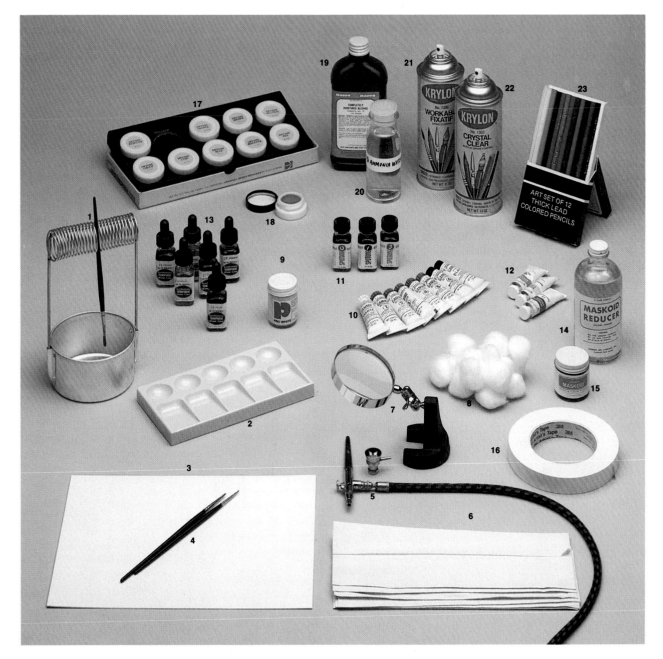

Salvaging Damaged Black-and-White Prints

Strange as it may seem, the first step in retouching a black-and-white print is to determine what color is required. Depending on the composition of the silver compounds and the size of the crystals in the emulsion, the exact color of black in a photograph may range from a warm, almost sepia tone to an icy blue-black. In order to accommodate this range of differences, liquid retouching dyes usually are sold in three tones—neutral, warm and cool black.

To use the dyes, put a few drops of the neutral dye on the palette, and then mix in just enough warm or cool dye to match the tone of the picture. Using the brushwork techniques demonstrated for color on pages 62-63, first apply the dye mixture full strength to spots in totally black areas, then gradually dilute it with water for lighter areas. Keep in mind that the dye tends to dry darker and warmer than it looks when first put on.

When a flaw is darker than its surroundings, like the stain seen in the boy's portrait opposite, conceal it with opaque paints. These are available in sets—neutral, warm or cool—and each set has shades that range from pale gray to deep black. To obtain the exact shade needed, blend in a little white opaque.

Despite a cautionary "Do Not Bend" legend on the envelope, the print at top right was cracked in mailing. Luckily the crack ran through a shadowed part of the picture, and the damage was easily concealed by retouching (bottom) with warm blacks matching the shadow tones.

A carelessly placed coffee cup marred the face in the print at left. Swabbing removed some of the coffee before it impregnated the photograph. After it had dried, the stain that remained was deftly stippled (above) with opaque grays that matched those around the flawed area.

Repairing Color Prints with Liquid Dyes

Dust and scratches on the negative produced a badly marred print that requires skilled retouching to salvage. Flaws in the background are relatively easy to repair, but flesh tones are a real challenge.

1 clean the print

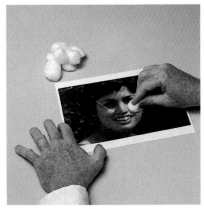

Remove any fingerprints or other marks by gently buffing the print with a cotton tuft. If marks still remain, the print can be wiped clean with anhydrous denatured alcohol and allowed to dry.

2 mix the dyes

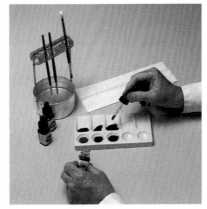

Put a few drops of the dyes into the circular holding areas on the palette; then use the elongated channels for mixing the colors until they create tones that match those in the print.

3 prepare to touch up

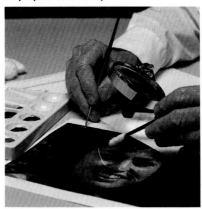

Cover the print with a piece of paper. Prepare a swab for blotting excess dye by wrapping cotton around the top end of a brush. Lightly dampen this swab with water and hold it in your other hand.

For touching up spots and streaks on a color print (those in the example above are the result of dust and scratches on the negative), liquid dyes work best. Mix two or more colors to produce the desired hue, diluting with water for the lighter shades. Test the color by painting a scrap from the margin of the print and letting it dry. Use dye sparingly, making repeated applications to build up color. Be careful to keep the dye confined to the spot that is being filled in order to avoid producing a dark ring around the edges.

Colors can be brushed on in any order. Philadelphia retoucher Frank Reardon, who demonstrates the techniques here, prefers to tackle subtle flesh tones last, when he feels most proficient.

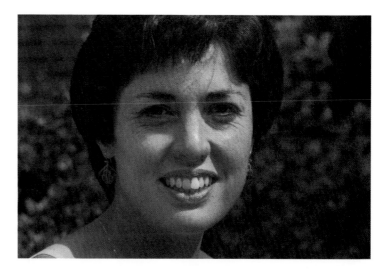

In the retouched print even the worst scratch across the face is hardly noticeable. By proceeding with care, the retoucher matched not only color and density but the skin textures and facial contours.

4 stipple on dye

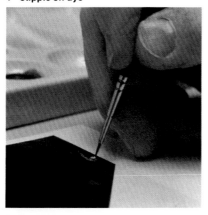

To fill in a blemish, wipe the brush on scrap paper to remove most of the dye and to form a sharp point. Use the point to make a fine stipple over the area. Blot excess with the cotton-tipped brush.

5 correct mistakes

If an error is made, gently rub cotton moistened with a 5 per cent ammonia-water solution over the area to remove most of the dye. Wash the area several times with fresh water and let the print dry.

6 finish with flesh tones

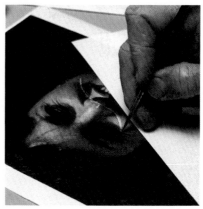

Take special care with flesh tones. Build density slowly, and try to match the subtle gradations in skin texture (from eye to cheek, for example) and the color differences between highlights and shadows.

Repairing Color Prints with Dry Dyes

Atmospheric haze and overexposure produced the bleached-out sky that mars this otherwise pleasing shot of a Washington, D.C., landmark— the original Smithsonian Institution building. An ideal candidate for dry-dye retouching, the picture also gives the retoucher an opportunity to create a more textured and interesting background.

1 mask the image

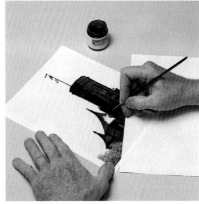

On a buffed print (Step 1, page 62), protect areas that are not to be dyed by brushing on masking liquid. Out-of-reach inner parts need not be covered but edges must be precise. Allow to dry.

2 tape the borders

To preserve the borders of the print, stick white artist's tape over edges adjoining the area to be dyed. Make sure the tapes are straight and squared; they will form the picture's new edges.

3 activate dye

Hold the open dye container about an inch from your mouth and breathe on it; one good exhale gives enough moisture to activate the dye's surface. With a cotton tuft pick up a liberal amount of dye.

4 rub on dye

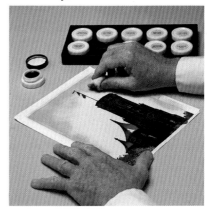

Apply the dye by rubbing the cotton over the print's surface with a circular motion. Make repeated applications until the area is filled, then lightly buff with clean cotton to spread the dye evenly.

Dry dyes are used to add color to large washed-out areas of a print, as well as to warm or cool specific areas like shadows or skin tones. Colors are obtained by blending one dye on top of another on the print. One advantage dry dyes have over liquid dyes is that they allow for experiment before the color is set. Before setting, the dye can be wiped off with a compound known as reducer, or with anhydrous denatured alcohol. Once the print is set—by exposing it to steam, which locks the dyes in the emulsion— color can be partially removed only with a 5 per cent ammonia-water solution. Because the dyes are set by moisture, all materials and prints must be bone dry while the dyes are being applied. □

5 remove excess dye

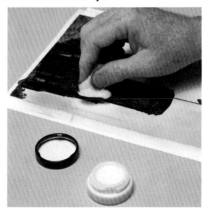

To lighten areas where the dye is too heavy, breathe on the cake of reducer, wipe a cotton tuft over it, and rub the tuft on the print. Buff with fresh cotton to remove excess reducer.

6 add texture

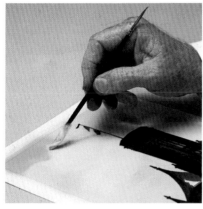

Convincing texture and detail may be added by applying reducer to small dyed areas with cotton wrapped around the top end of a brush. Here the retoucher is creating clouds.

7 remove mask

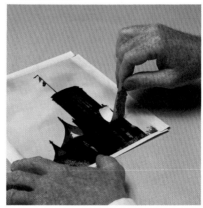

To take off the mask protecting undyed areas, press a piece of white artist's tape to the mask and carefully lift up to peel off the dried masking liquid. Also remove the tape along the borders.

8 set the dye

To bond the dyes to the emulsion, hold the print face down several inches above a steam kettle. Check after a few seconds; the colors are permanent when the waxy traces of dye on the surface disappear.

On the finished print, a retouched sky provides an attractive but unobtrusive backdrop for the picturesque structure. The effect looks almost completely natural because of the way the retoucher handled the clouds. Instead of producing sharply edged, solid white masses, he gave them a wispy appearance by removing subtly different amounts of dyes with the reducer and by softly blending the different areas with a cotton buff.

Re-creating Color

1 **support rail**
2 **calculator bar**
3 **camera**
4 **filter holder**
5 **enlarger lens**
6 **optical glass**
7 **CCU flash**
8 **meter-cell probe**
9 **main flash**
10 **flash-intensity scale**
11 **filter drawer**
12 **power switch**
13 **focus/expose switch**
14 **flash-intensity switch**
15 **open flash switch**
16 **light-intensity control**

Once an original transparency begins to deteriorate, it is gone for good. It can be only approximately restored and then only by copying, using a procedure like the one demonstrated opposite.

A machine such as the elaborate copier shown above or the attachment pictured on pages 118-121 is not a necessity—there is less expensive equipment available—but it does make the job easier. The machine shown here—part copying camera and part enlarger—houses in its base a flash unit synchronized to the shutter, which can be fired in bursts

for the beefed-up exposures sometimes called for in color copying. The base also holds filters for adjusting the color of the light to suit various kinds of copying film and to correct the color imbalance of damaged material *(chart, page 72)*. A calculator bar on the machine makes it possible to find the proper aperture for an enlargement after a same-size reproduction has been made.

When a slide is copied, there is frequently an increase in contrast. In some cases this is desirable; but when contrast needs to be reduced, this copying ma-

chine has a special contrast-control unit (CCU)—a second, horizontal flash and a sheet of optically flat glass mounted diagonally—to add more exposure to dark areas of the slide being copied, thus lowering the contrast between the highlights and the shadows.

For all its versatility, the copier cannot recover the past. The exact original values of a slide that is several decades old can hardly be guessed at, let alone reproduced. But dramatic restorations, like the ones shown on the following pages, can be made with this machine.

1 insert the original

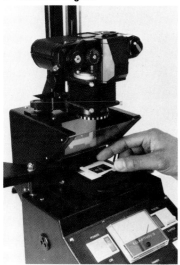

Slip the slide into the holder on the base unit. Prepare to focus by opening the lens to its widest aperture and switching on the focusing light to illuminate the slide.

2 focus the camera

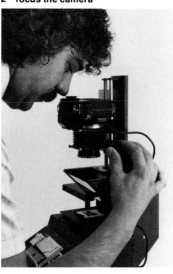

Looking through the viewfinder, move the lens up or down until the slide's edges coincide exactly with the edges of the viewfinder. Then move the camera to focus the image.

3 set the aperture

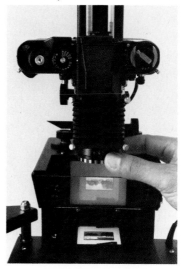

Stop down the lens to the aperture that the manufacturer's manual and preliminary testing indicate as the best for making same-size 1:1 reproductions of the original.

4 filter the main flash

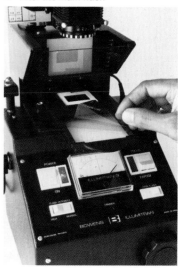

Insert the required filters in the shallow drawer under the slide. The filter combination is dictated by the colors to be corrected and by the copying film being used (page 72).

5 filter the fill flash

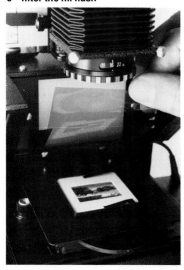

To lighten dark areas, put the same filter combination in front of the flash on the CCU filter holder. Light from this flash will be angled into the lens by the diagonal glass.

6 meter the slide

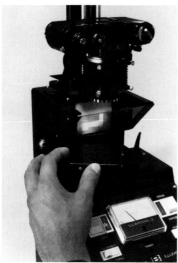

Swing the meter-cell probe over the slide to measure the light passing through the emulsion. This reads the focusing light and indicates flash intensity at exposure.

7 adjust flash intensity

Turn the knob that controls the intensity of the main flash until the meter needle registers zero on the intensity scale. Then adjust the intensity of the contrast control unit's flash.

8 expose the film

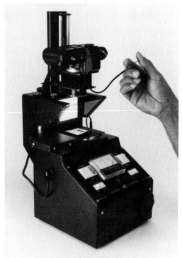

With the metering arm turned away and the light-control switch reset for exposure, take the picture on the copying film by squeezing the cable release with gentle, even pressure.

Rebalancing Color Shifts

In early 1955, *Life* assigned photographer Eliot Elisofon to take a farewell portrait of New York's rickety Third Avenue elevated transit line, which was about to be demolished. In spite of better-than-usual care, the colors of Elisofon's original 35mm transparency *(right)* have shifted noticeably toward red, an indication that the film's cyan layer has faded, allowing the magenta and yellow layers to dominate. The Time-Life Photo Lab selected the most straightforward course of correction for this imbalance: the introduction of an overall cyan tint with filters while copying the image.

Experience has shown that the basic filter combination, or pack, for making an exact duplicate of a normal transparency varies with the kind of copying film that is being used *(chart, page 72)*. The film in this case was Ektachrome 5071, and the Photo Lab knew that the basic pack for making a normal copy would have to be substantially altered to improve the Elisofon transparency. By viewing the transparency through different filter combinations, the lab determined that the most satisfactory result—shown on the opposite page—was gained by rebalancing the basic pack so that the cyan was nearly doubled and the yellow was cut by more than half.

In the original slide, the overall ruddy cast and the bright stripe on the platform reveal that the magenta and yellow dye layers are intact; it is the cyan layer that has faded drastically. To bring the colors back into balance, the original was copied through filters to add the missing cyan (chart, page 72).

ELIOT ELISOFON: *Third Avenue Elevated*, 1955

The filter pack normally used for copying onto Ektachrome 5071 film needs a very strong density of yellow (110 Y) and a moderately strong density of cyan (50 C). Here, the pack was modified to cut the yellow to a moderately strong density (50 Y) while boosting the cyan to a quite strong density (90 C).

Two Steps to Bring Back Ghostly Hues

When Babe Ruth made his last appearance at Yankee Stadium a short time before his death in 1948, Ektachrome—the transparency film on which *Life* photographer Ralph Morse snapped the home-run king—was still a novelty. More than three decades later, the original *(right)* was too badly deteriorated to be corrected by simply rebalancing the basic color filtration during copying, as seen on the preceding pages. Instead, the Time-Life Photo Lab went to a two-step copying sequence that, in effect, rebuilt the image.

The problem was that the original had faded to a ghostly paleness. It had lost most of the color in the cyan and yellow layers, leaving only the magenta layer. It had lost nearly half its density, and contrast had softened, obscuring details.

The first copying of the image *(opposite, left)* was aimed at re-creating the missing contrast and density. Contrast was obtained by shooting with a film that gives contrasty results when used for duplicating slides. Density was restored by a more complicated method: Keying on Babe Ruth's black socks—a known density—the Photo Lab experts put back more of the lost cyan and yellow than the image needed by deliberately using filters that were much too strong. This gave the image more substance overall and added notably to the darkness of the shadow areas. This gain in density was reinforced in the second copying *(opposite, right)* when the excess cyan and yellow were neutralized by shooting through a filter pack that favored magenta.

RALPH MORSE: *Babe Ruth at Yankee Stadium,* 1948

The fading of the yellow and cyan dye layers on the original 2 1/4 x 2 1/4 transparency was so severe that for all practical purposes only the magenta layer survived, creating a purplish imbalance. There was also a noticeable lack of detail-revealing contrast. Finally, and most problematic, the density of the emulsion had diminished, as shown by the weak blacks.

The image was first copied onto Ektachrome 64 in order to heighten its contrast and sharpen details. The normal filter correction for this film — a faint yellow and magenta (10 Y + 10 M) — was replaced with substantial strengths of yellow and cyan (60 Y + 75 C). This overcompensation for the missing colors countered the magenta and pushed the color balance in the other direction.

For the final version, the image was copied onto Ektachrome 5071, a film designed for low-contrast duplicating. To rebalance the colors and eliminate the greenish cast, the strong yellow in the filter pack normally used to correct for this film (110 Y + 50 C) was replaced by a strong magenta (80 M + 50 C). The result is a print with good density and contrast — and authentic-looking colors.

A Guide to Filters for Color Correction

The charts on this page serve as a guide in the use of filters in copying any color transparency to restore its original colors, as described on pages 66-71. The filters are sold as code-labeled gelatin sheets, the code letters indicating basic hue—Y for yellow, M for magenta, C for cyan—and the numbers indicating the shade. Shades range from 05 (very pale) to 50 (very deep), and filters can also be combined—a 10C with a 20C is equivalent to a 30C. There are two grades of filter: The less expensive CP filters are satisfactory if they are placed between the light source and the picture that is being copied; however, the distortion-free CC type must be used if the filters are between the picture and the lens.

The starting point for a corrected-color copy is always the filter combination, or pack, that would be used to make an exact duplicate of a normal picture without any color change. The top chart at right, created for this book by the Time-Life Photo Lab, lists such "normal" packs for six kinds of film, and also gives the exposure correction each pack requires if a separate meter is used or if flash exposure is calculated. Besides the color adjusting filters, a pack should always include a No. 2B ultraviolet filter to remove unwanted UV wavelengths.

Modifications to the normal pack to accomplish specified changes in color are indicated in the middle chart. Precise shades are established by trial. For example, in order to add more blue to a picture being copied on Agfachrome 64, the normal pack—5C + 10M—might first be modified to 15C + 20M. Suggested exposure corrections for each filter are given in the bottom chart; exact values depend on the copying equipment being used. □

filters for normal copying without color change (electronic flash)

film	filter pack	exposure increase
Agfachrome 64	2B + 10M + 5C	+2/3 stop
Ektachrome 64	2B + 10M + 10Y	+2/3 stop
Ektachrome Slide Duplicating Film 5071*	2B + 50C + 110Y	+2 2/3 stops
Ektachrome SE Duplicating Film SO-366	2B + 50C + 110Y	+2 2/3 stops
Fujichrome 100	2B + 20M + 10Y	+2/3 stop
Kodachrome 64	2B + 5C	+1/3 stop

* Although balanced for tungsten light, this film gives good results with flash

filters for correcting color

to add	use	to remove	use
red	yellow and magenta	red	cyan
green	cyan and yellow	green	magenta
blue	cyan and magenta	blue	yellow
cyan	cyan	cyan	yellow and magenta
magenta	magenta	magenta	cyan and yellow
yellow	yellow	yellow	cyan and magenta

exposure correction required by filters in color-correction copying

cyan filters	magenta filters	yellow filters
exposure increase	exposure increase	exposure increase
05C 1/3 f-stop	05M 1/3 f-stop	05Y none
10C 1/3	10M 1/3	10Y 1/3 f-stop
20C 1/3	20M 1/3	20Y 1/3
30C 2/3	30M 2/3	30Y 1/3
40C 2/3	40M 2/3	40Y 1/3
50C 1	50M 2/3	50Y 2/3

FREDERICK H. EVANS: *Westminster Abbey: The Sanctuary*, 1911

Picture-Saving Secrets of the Archivists

Some of the first photographs ever made have held up remarkably well—yet others not nearly so old have faded to a brownish yellow, their scenes perhaps lost forever. One crucial difference between the long-lasting photograph and the faded one is the care that went into its processing. The special techniques described on the following pages are known as archival processing. Photographs processed in this fashion can be expected to outlast the photographer who took them, and with proper storage (Chapter 3) they can last for several generations.

Archival processing is basically an extension of ordinary processing procedures, involving a few extra steps, some additional expense—and careful attention to the fine details of the work. Its principal aim is the removal of chemicals that, although they are essential to the picture-making operation, can ruin the image if allowed to remain in excessive quantities in a finished negative or print. Fiber-based print paper is the paper of choice when preparing archival prints.

Among the potentially harmful substances that archival processing seeks to remove are the very ones that create the normal black-and-white image: salts of silver, such as silver bromide or silver chloride. During development, those grains of silver salts that have been exposed to light are reduced to black metallic silver, which forms the image; but unexposed grains are not reduced and remain in the form of a silver compound. If this is not removed, it will darken when struck by light and blot out the image. The chemical used to remove these unexposed grains is fixer, or hypo as it is sometimes called, which converts them into soluble compounds that can be washed away. The fixer, however, must also be removed. It contains sulfur and, if allowed to remain in a picture, it will tarnish the metallic silver of the image just as sulfur in the air tarnishes a silver fork. Also, fixer can become attached to silver salts to form complex compounds that are themselves insoluble and cannot be easily removed. When these silver-fixer complexes decompose they produce a brown-yellow sulfide compound that may discolor the entire picture. Washing alone cannot make a print entirely free of fixer, and prolonged washing would itself endanger the print by weakening the paper fibers.

Archival processing solves this problem by substantially shortening the fixing step (pages 80-81). The 30-second fixer bath is long enough to fix the image but short enough to prevent the build-up of fixer in the paper fibers. As a result, the wash time can also be substantially reduced. Once the picture is clear of residual chemicals, the final step in the archival procedure is to protect the image with a special treatment using a gold solution or a toner, like selenium (pages 84-89). Either of them unites with the silver in the image to act as a shield against damage from external contaminants that are part of the pollution in the air.

Handling Chemicals Safely

Many chemicals used in photography are serious health and safety hazards unless careful laboratory precautions are observed. The following guidelines are designed to prevent dangerous accidents, and to minimize injury if accidents occur.

General Cautions

1 Treat all chemicals like dangerous substances, especially when disposing of them.
2 Open containers of chemicals only when you are using them. Otherwise, keep containers closed and stored away from children.
3 Do not smoke in an area where there are chemicals. Many are flammable or explosive.
4 Make sure that you have adequate ventilation and running water in the work area.
5 Do not breathe vapors or swallow any chemical, and avoid getting chemicals—especially acids—on your skin or in your eyes.
6 Use protective gear such as safety glasses, aprons, tongs or rubber gloves. Prolonged contact with some chemicals, like selenium, may cause cancer.

Handling Acids

Organic acids, such as acetic acid used in some fixers, are generally safe; but some, like the oxalic acids used in platinum processing (page 92), are extremely poisonous. Inorganic mineral acids are very dangerous: They may overheat, splatter and cause serious burns to skin or to internal tissues if they are swallowed or if their fumes are inhaled. Be very cautious when using any acid, and be prepared to deal with emergencies instantly.

1 Remember the basic rule when diluting acids: ADD ACID TO WATER, NEVER WATER TO ACID.
2 For external contact: Flush with cold water immediately—do not scrub—until the area is completely clean. DO NOT use ointments or antiseptic preparations. Cover with dry, sterile cloth until you can get medical help, if necessary.
3 For eye contact: Immediately flood the eye with running water for at least 15 minutes. Then always call a doctor.
4 For internal contact: Do not induce vomiting; instead, drink a neutralizing agent such as milk or milk of magnesia.

Archival processing calls for special care in several respects. The chemicals used, like those employed in ordinary processing, can be dangerous; most will stain clothing and are poisonous if taken internally (see box at left). Never attempt to process in a kitchen near food, and never use drinking glasses or eating utensils for mixing the solutions.

Meticulous cleanliness is necessary for personal safety, but it is also essential to the success of archival processing. Sloppiness defeats the techniques' purposes by introducing materials that can cause image deterioration. Any chemicals left to linger in trays or bottles may contaminate the solutions next used in them. Similarly, chemical residues in sponges or blotters could be passed on to the picture. The processes also depend heavily on careful preparation of the several working solutions. The formulas must be followed exactly (although they may be reduced proportionally to make small batches). While excess quantities of most solutions can be stored (in amber bottles to prevent light-caused deterioration), it is wise to discard any leftovers and make up fresh batches each time. That way there is no risk of employing chemicals that have spoiled or have been exhausted through use.

Most of the techniques of archival processing are meant to neutralize the dangers that threaten images formed of silver, but photographic images need not necessarily be composed of silver. Platinum printing, for example (pages 90-97), uses paper coated with light-sensitive compounds that produce an image of metallic platinum, an element almost totally impervious to chemical attack; such prints are exceptionally durable. The platinum print on page 75 was made in 1911, yet reveals all the detail attainable with this process. Even color pictures, whose images may be composed of perishable dyes, can be preserved, either by selecting the appropriate color process (pages 98-99) or—in a roundabout fashion—by translating their colors into black-and-white records that can be processed for permanence in the same way as other black-and-white pictures (pages 100-102). Thus any kind of photograph can, if appropriately handled, be guaranteed a lengthy life.

Special Treatments for Negatives

The steps that assure long life to negatives begin after the film is developed in the ordinary way. It is fixing, washing and later treatments that determine how permanent the image will be.

In fixing negatives, extra protection is gained by using two separate baths in order to make certain that fresh solution reaches every part of the emulsion. Either of the two standard types of fixer, ammonium thiosulfate ("rapid" fixer) or sodium thiosulfate, may be used, provided the temperature of the solution does not exceed 75° F. (24° C.). For best results, use two or three trays or tanks. After a normal stop bath has been used and poured from the tank, add the first fixer bath and agitate for half the recommended time; then discard the solution. Next fill another tank with the second fixing bath and agitate again for half the recommended time. The exact fixing times must be observed. If the film is underfixed, silver halides will linger in the negative.

Once the fixing is finished, the fixer and its by-products must be totally removed from the film. Fill a clean tank with rinse water. Agitate the reels of film several times by lifting them up and down by the central rod, discard the rinse water and fill another tank with a standard hypo-clearing agent. Agitate the film in this solution for three minutes.

Only after rinsing and clearing is the film ready for washing, preferably in an archival washer, a device designed to provide great water exchange and circulation without excessive turbulence. If the developing tank is to be used as a wash-er, insert the connecting hose deep into the tank to make sure that the water circulates completely. To make sure such a setup provides sufficient water flow, test it by placing several drops of ordinary food coloring inside the tank. The flow should clear the water of all the dye in five minutes or less. Wash for 10 minutes, and for optimum results maintain the water temperature between 68° and 75° F. (20° and 24° C.).

After the washing, a simple test for residual hypo in the film should be made. One such test calls for the use of Kodak HT-2, which is prepared by adding 4 ounces (118 ml.) of 28 per cent acetic acid to 24 ounces (710 ml.) of distilled water. Add 1/4 ounce (7 g.) of silver nitrate, then pour in enough distilled water to make 32 ounces (946 ml.). Since only a drop or so is used at a time, this solution lasts a long time.

Both compounds are available from most chemical supply houses; but acetic acid is generally sold in special concentrated "glacial" form and must be diluted, 3 parts to 8 parts distilled water, to get the 28 per cent strength needed. Silver nitrate is a poison that can be fatal if swallowed, and it should be handled with caution. In water solution it can stain and burn the skin.

To use the hypo test solution, first cut off a strip from the wet film's clear margin and blot the water remaining on the surface. Using a dropper, place one drop of test solution on the clear area and allow to remain for three minutes. Blot off the excess and compare the stain that ap-pears with one on a Kodak Hypo Estimator sheet, which may be purchased at many camera stores. The stain on the test area should be appreciably lighter than the lightest stain on the estimator sheet. In fact, the test area should show very little stain at all. If the test stain is too dark, continue the washing for a while and test again.

Once washing is completed—that is, after all fixer has been eliminated—the silver image can be protected against chemical attack by treating it with a selenium toner or a gold solution. The solution used for negatives is the same as the one used for prints and should be mixed as explained in the discussion of print protection on pages 84-85. For treating film, fill the developing tank with the gold solution and agitate the film in it for 10 minutes. Then rinse, and wash for 20 minutes. This process will give the film an impervious surface without changing the tones of the image.

The final steps to be taken in processing film for durability are those that will guarantee safe and even drying. Fill the developing tank with any standard photographic nonionic wetting agent that has been diluted in distilled water (not tap water), and agitate the film in it for a minute. The agent decreases the surface tension of the water and allows it to flow off the film evenly without collecting in drops or leaving streaks; sponging to remove droplets should not be necessary. Now hang the film on clips to dry at room temperature; do not use heat, which may cause film to become brittle.

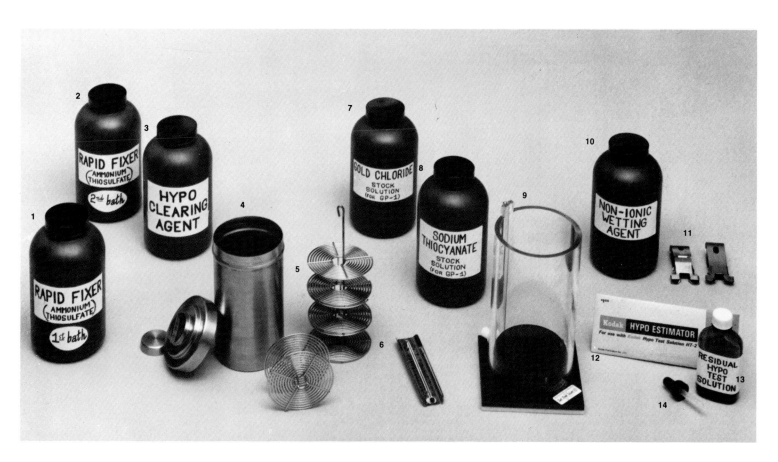

1 fixer for first bath	8 sodium thiocyanate for gold treatment
2 fixer for second bath	9 film washer
3 hypo-clearing agent	10 nonionic wetting agent
4 stainless-steel developing tank	11 film clips
5 film reels and rod	12 hypo estimator stain sheet
6 thermometer	13 residual-hypo test solution
7 gold chloride for gold treatment	14 dropper

Special Treatments for Prints

Prints, like negatives, gain durability from steps taken after normal development. The fixing procedure is the crucial step. With the conventional method, two fixer baths are made with sodium thiosulfate, or with print-strength ammonium thiosulfate. Agitate the print for 2 minutes in the first bath, rinse in a tray of water and agitate for 2 minutes in the second bath.

A protective toner like selenium may then be applied simultaneously with the hypo-clearing bath. Mix 1 1/2 ounces (44 ml.) of selenium toner concentrate in a gallon (3.8 l.) of hypo-clearing agent and pour some of it into a tray. Agitate the print in it for 3 to 5 minutes and rinse for a minute. Wash in running water for about an hour or until the standard test *(pages 78-79)* detects no residual fixer.

An alternate procedure achieves archival results in less time. The key is a fast fix—30 seconds only—with no hardener, using film-strength rapid ammonium thiosulfate to fix the silver image quickly and completely before thiosulfate complexes build up in the paper fibers. Wash time is reduced—5 minutes in the first wash, 10 minutes in a hypo-clearing bath and 10 minutes in the final wash. Use the standard test for residual hypo.

If there is a trace of fixer remaining, it may be eliminated with a bath that is mixed just before use. Mix 16 ounces (473 ml.) of water with 4 ounces (118 ml.) of 3 per cent hydrogen peroxide and 3 1/4 ounces (96 ml.) of dilute ammonia solution (one part 28 per cent ammonia mixed with 9 parts water). This working solution must be kept in an open container—if closed, gases created could crack the bottle. Agitate the print in a tray of this solution for six minutes, rinse, and wash for 20 minutes.

1 **first fixing bath**
2 **second fixing bath**
3 **thermometer**
4 **timer**
5 **three trays**
6 **tongs**

1 **hypo-clearing agent**
2 **selenium-toner concentrate**
3 **thermometer**
4 **timer**
5 **two trays**
6 **tongs**

To clear away harmful residual chemicals, this special washer bathes each print in its own vertical compartment with water circulating on both sides. The compartments reduce the chance of damage, since the prints remain stationary during washing. They also keep the prints from touching and allow new ones to be added without their chemicals contaminating those already being washed.

1 hypo-estimator stain sheet
2 residual-hypo test solution
3 dropper
4 timer
5 two trays
6 tongs
7 thermometer
8 3 per cent hydrogen peroxide
9 28 per cent ammonia

The Importance of Drying

Even drying needs special care if a print is to be long-lived. With a conventional electric dryer, the parts that touch the print are easily contaminated by residual chemicals and require frequent washing.

The special dryer shown above is most advantageous for drying large numbers of prints. The method demonstrated on the opposite page is useful for drying a single print, but several can be handled

in the same manner by alternately stacking blotters and prints.

Blotters must be of high quality, acid-free material, made especially for photography, and should be larger than the print by at least two inches on each side. The blotters may be reused if they have not been exposed to contaminants. Dry them by hanging them from a line, and store them in an acid-free box.

This archival dryer makes it easy to air-dry as many as twenty 8 x 10 prints overnight. The dryer is simply a case with slide-out shelves made of aluminum frames covered with washable fiberglass-mesh screens. A print is first squeegeed to remove surface water (Step 1, opposite), then placed face down on a screen. Some models have double screens to prevent curling, or the curl can be removed after drying by placing the print between blotters and weighting it (Step 6).

1 squeegee the print

Place the washed print face up on a clean surface and gently squeegee water away. Wipe excess water from the work surface and squeegee blade. Turn the print over and squeegee the other side.

2 place print on blotter

Lay the print face up on a single blotter that has been placed on a dry portion of the work surface. Handle the print by the under edges in order to avoid smudging the emulsion side.

3 put second blotter over print

Take a second sheet of photographic blotter paper and carefully position it on top of the print so that the print is sandwiched between the two single thicknesses of blotter.

4 press the blotter

Using the edges of your hands, smooth the blotter over the print so that moisture will be absorbed evenly. After the blotters are thoroughly soaked, remove the print and set aside the blotters.

5 replace the blotters

Sandwich the print between two fresh blotters, top and bottom. Placing another blotter on top will give extra protection against contaminants from whatever weights are added to prevent curling.

6 weight the print

Place a book or similar light weight on top of the sandwich to prevent curling. The weight should cover the entire area of the print. Leave the print until it has dried thoroughly.

An Impervious Plating of Gold

1 **distilled water**
2 **sodium thiocyanate**
3 **tray**
4 **gold chloride 1 per cent stock solution**
5 **gold chloride crystals**
6 **balance scales**
7 **graduate and glass stirring rod**

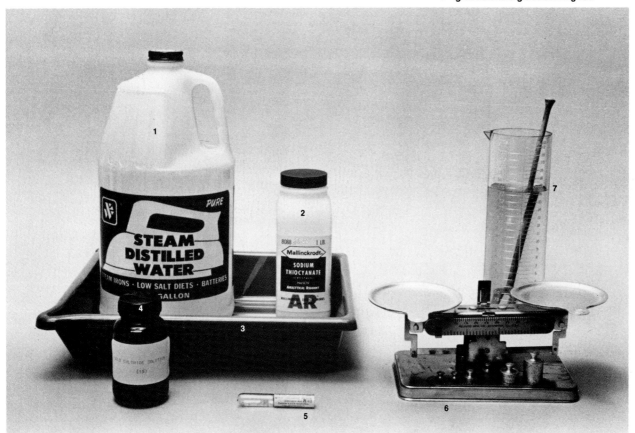

Even photographs that are processed with great care are vulnerable to attack by chemicals in their surroundings, such as pollutants in the air and also image-damaging ingredients contained in the materials used for storage. But there is a way to ward off these external assaults. It is a modified version of the gold-toning process once used to give prints a rich tint of brown or blue-black. (When it is used as a protective measure, the treat-

ment need not alter color significantly.)

The gold-protection treatment is applied after processing *(pages 78-79)* but before drying, while the pictures are still wet from washing. In effect, it plates the silver image with gold, a metal that resists virtually all chemical change. While most often used to protect prints, it can also be used to preserve negatives. The gold solution used here is a mixture of water and two compounds that are ob-

tainable from chemical supply houses: gold chloride and sodium thiocyanate. Caution is required: Sodium thiocyanate is a poison if taken internally.

The solution is prepared in four steps described on the opposite page, the last three of which should be done just before using. But the first step, making the gold stock solution, can be done in advance if the solution is then stored in an amber bottle to prevent deterioration from light.

1 make the stock solution

Add the contents of a 15-grain (1-g.) vial of gold chloride to 3 ounces (89 ml.) of distilled water in an amber bottle and stir until dissolved.

2 mix stock solution and water

To 24 ounces (710 ml.) of tap water measured in the large graduate, add 2 1/2 drams (9 ml.) of the gold chloride stock solution and stir well.

3 prepare sodium thiocyanate solution

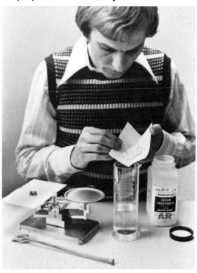

Weigh 145 grains (9 g.) of sodium thiocyanate on the scales. Add it to 4 ounces (118 ml.) of tap water measured in a second graduate. Stir well.

4 make the working solution

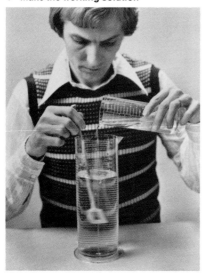

Stir the 4 ounces of sodium thiocyanate solution into the diluted stock solution prepared in Step 2. Add enough water to make 32 ounces (946 ml.).

5 treat the print

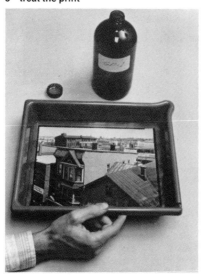

Immerse the washed print — while it is still wet — in working solution. Agitate it for about 10 minutes, or until the image is just perceptibly bluish black.

6 wash the toned print

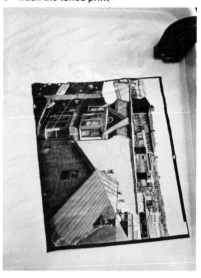

After rinsing the treated print in running water for 10 seconds, wash it in a siphon-equipped tray for 20 minutes; air-dry it thoroughly.

To give this print maximum protection for long life, it was treated with a gold solution, following a procedure (pages 84-85) that was designed to emphasize preservation. The resulting print is not visibly different from an untreated one.

Gold compounds shield a photographic image against deterioration, but they can also give the picture an attractive tint. The process is then called toning. Examples of both uses are shown here, applied to prints from the same negative. The print above was treated with a gold protective solution; its tonal values remain unchanged, but the print itself has gained maximum protection against future deterioration. The print to its right was given an overall deep, neutral brown tone by immersing it in a gold toning solution. Like all gold solutions, gold toner

GEORGE A. TICE: *Rooftops*, Paterson, New Jersey, 1969

provides protection for the image, but not as much as that given by specially formulated gold protective solutions.

Other gold toners can produce tones that range from deep blue to fiery red, the color depending partly on the toners, partly on the printing paper and partly on the duration of treatment. Packaged gold protective and toning compounds can be obtained in many photographic supply stores; but the necessary chemicals are more widely sold, and formulas can be found in publications such as the Photo-Lab-Index and Kodak pamphlets.

The brown tone of this print was produced with a gold solution used principally for the tinting effect, although protection is also given. Both this print and the one on the opposite page were made on neutral semi-matte printing paper.

Chemical Toning for Appearance

Although the gold treatment described on pages 84-85 gives prints the greatest degree of protection, gold is not the only substance that is useful for this purpose. Compounds of other elements, while primarily intended to impart pleasing tints, also guard photographs against the effects of time and the destructive chemicals they may come in contact with.

Some of the most common of these compounds contain sulfur or selenium, others copper or iron. These compounds convert the silver into more stable and permanent chemical complexes. Many of the toning compounds are available in packaged concentrate form in photography supply stores, and are inexpensive and easy to use.

A wide variety of tonal changes is possible, depending not only on the toner selected but also on the degree of dilution of the concentrate, the type of printing paper used, the length of time the print is in the toner, and even the conditions of earlier stages of processing. Some toning compounds are reversible—that is, the original black-and-white image may be restored, either partially or totally, by immersing the toned print in ordinary developer or by painting developer on selected areas of the print. A sample of the effects attainable is shown in the pictures reproduced here, all made by George A. Tice and printed on the same paper. □

GEORGE A. TICE: *Tombstone, Catherine Holland*, Bodie, California, 1965

For the warm reddish-brown tone of this quiet Western scene, Tice used Kodak Poly-Toner, which contains both sulfur and selenium. The bottled concentrate was diluted to a weak 1:100 ratio; a stronger solution gives browner tints.

Picnic on Garret Mountain, Paterson, New Jersey, 1968

The soft brownish tinge of the family portrait
above gives skin tones a pleasingly natural look.
They were achieved with Kodak Brown Toner,
a sulfur compound, diluted in a 1:32 ratio. A
stronger concentration gives a browner tint.

Roaring Fork River, Aspen, Colorado, 1969

A mountain stream was toned a deep purplish
brown in Kodak Rapid Selenium Toner, which was
diluted in a 1:12 ratio; a variety of other tones
can be achieved by using different printing papers.

Durable Beauty in Images of Platinum

Around the turn of the century, some of the most beautiful photographic prints ever made were produced on platinum paper, which has a light-sensitive coating that contains no silver and produces an image of platinum metal. Its subtle gradations of tone and delicately smooth, glare-free surface give unsurpassable clarity and depth. And since platinum is immune to almost all chemical action, the images are virtually indestructible. The process was little used for decades because of the scarcity (and cost) of platinum, but it has been revived, partly for its beauty, partly for its durability.

The revival of platinum printing was stimulated by a renewed interest in the work of a Victorian master of the technique, Frederick H. Evans, who was a London bookseller-turned-photographer. Evans is best remembered for his photographs of architecture, which he made into platinum prints and also into lantern slides for use in illustrated lectures that he gave.

New prints from Evans' original negatives can no longer be made—after his death his widow, for reasons of her own, had all his glass-plate negatives destroyed. In 1970, however, an American photographer, George A. Tice, happened upon a collection of Evans' lantern slides that somehow had survived. To reproduce these photographs in the way Evans would have, Tice worked out a platinum printing method that can be used for any pictures.

The paper must be homemade by coating some commercial chemicals onto high-grade writing paper, but the process is easy to carry out and the materials for it are relatively inexpensive —about five dollars pays for one print.

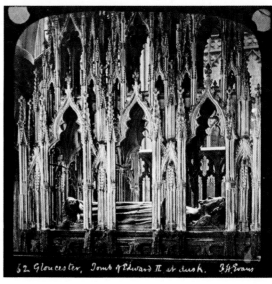

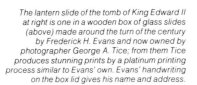

The lantern slide of the tomb of King Edward II at right is one in a wooden box of glass slides (above) made around the turn of the century by photographer Frederick H. Evans and now owned by photographer George A. Tice; from them Tice produces stunning prints by a platinum printing process similar to Evans' own. Evans' handwriting on the box lid gives his name and address.

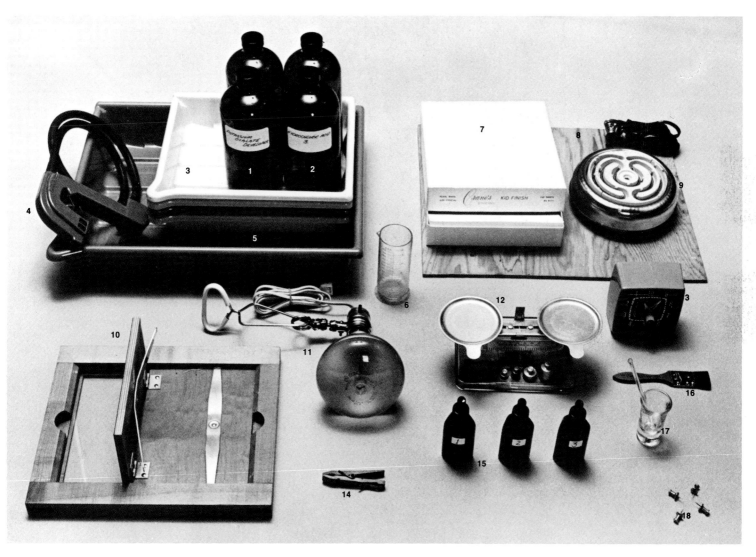

1	potassium oxalate solution	7	100 per cent rag paper	13	timer	
2	hydrochloric acid solution	8	board	14	clip	
3	four trays	9	hot plate	15	three sensitizer stock solutions	
4	siphon	10	contact printing frame	16	camel's-hair brush	
5	washing tray	11	sun lamp	17	glass and stirring rod	
6	graduate	12	balance scales	18	pushpins	

The first step in the platinum printing process is to make a duplicate of the original picture in an enlarger, producing a negative of the size desired for the print; the platinum emulsion is so slow that contact rather than enlarged prints must be made. The compounds that are used to sensitize the printing paper are available from chemical supply houses, but all are poisonous if taken internally; handle them with extreme care *(page 77)*. Because the materials are not especially sensitive to light, however, all the operations can be carried out with ordinary room illumination.

Three stock solutions are required for the procedure George A. Tice uses. To make solution 1, stir 8 grains (.5 g.) of oxalic acid and 120 grains (8 g.) of ferric oxalate into 1 ounce (30 ml.) of distilled water heated to 125° F. (52° C.). To make solution 2, mix 8 grains of oxalic acid, 120 grains of ferric oxalate and 2 grains (.1 g.) of potassium chlorate into 1 ounce of 125° F. distilled water. To make solution 3, mix 1/4 ounce (7 g.) of potassium chloroplatinite into 1 1/4 ounces (37 ml.) of 125° F. distilled water. For storage, these stock solutions may be put in amber, dropper-capped bottles.

The light-sensitive coating for the paper is made by adding 24 drops of solution 3 to variable amounts of solutions 1 and 2, the proportions depending on the contrast desired in the print. For average contrast, use 14 drops of solution 1 and 8 drops of solution 2. For more contrast, decrease the amount of solution 1 and increase the amount of solution 2 to a proportion of 10 to 12 or even zero to 22. For less contrast, use more solution 1 and less solution 2 to a proportion of 18 to 4 or even 22 to zero.

The paper to be sensitized should be a

1 make the negative

Since the final print will be the exact size of the negative, an enlarged negative must be made—in this case by blowing up a lantern slide.

3 mix the stock solutions

To prepare the three stock solutions for the sensitizer, weigh the ingredients on a balance scale and mix as explained in the text at left.

2 process the negative

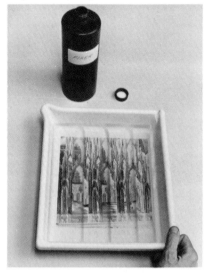

Develop the negative in the normal way, but to ensure its longevity, use the methods shown on pages 78-79 for other steps in processing.

4 make the sensitizer

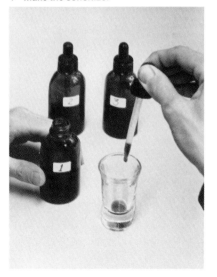

Using droppers, measure the appropriate number of drops of the three stock solutions (text) into a glass, stirring after each is added.

5 sensitize the paper

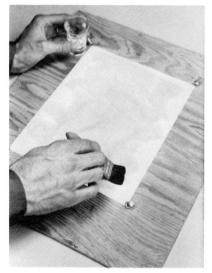

Tack the paper to a board; pour the sensitizer over it and spread the liquid evenly over the surface with a damp camel's-hair brush.

6 air-dry the paper

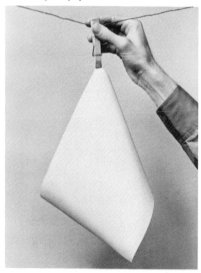

Hang the sensitized paper by a corner from a suspended clip. It takes about 10 minutes to be sufficiently dry for the next step.

7 heat-dry the paper

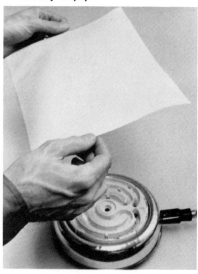

With sensitized side up, hold the paper 8 inches (20 cm.) above a hot plate for 1 1/2 minutes. When fully dry, it will be a yellow-orange color.

top-quality 100 per cent rag. After coating it with the sensitizing mixture, cut unneeded sections from the margins to use as test strips for trial exposures, which are made in the usual way. Exposure can also be estimated as the print is being made, since a faint yellowish image begins to appear before development.

Platinum paper is developed in a solution of one pound (454 g.) of potassium oxalate dissolved in 48 ounces (1.4 l.) of 68° F. (20° C.) water. After development is complete, the image is no longer sensitive to light and fixing is not required. Residual chemicals are removed in baths of dilute hydrochloric acid; prepare three separate baths of it from a solution of 1 ounce (30 ml.) commercial hydrochloric acid in 60 ounces (1.8 l.) of water.

8 prepare to expose

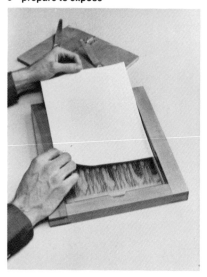

With the paper trimmed to size, place the sensitized surface against the negative; then close both inside the contact printing frame.

9 make the exposure

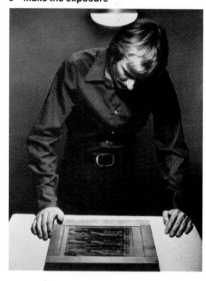

To expose, the frame is put negative side up under a sun lamp that has been heated for two minutes. Direct sunlight can also be used.

10 check the exposure

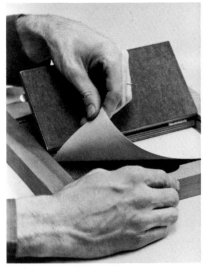

Open the frame and lift a corner of the print to judge the forming image. An average print requires an exposure of about 25 minutes.

11 develop the print

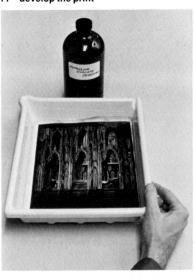

Agitate the print in the developer solution for two minutes at about 68° F. (20° C.). The resulting image will be permanent—and needs no fixing.

12 clear the residual chemicals

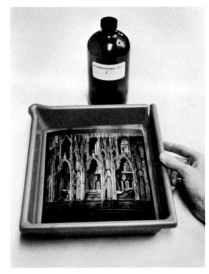

To remove residual chemicals, agitate the print for five minutes in each of the three dilute hydrochloric acid clearing solutions.

13 wash the print

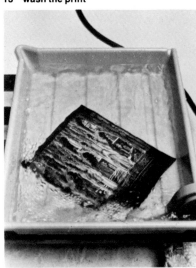

Wash the print for 30 minutes in a tray with a siphon. Adjust water flow for a complete change of water in the tray every five minutes.

14 dry the print

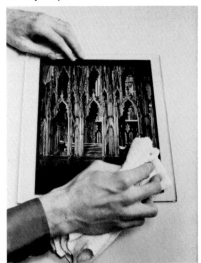

With the print on a clean, hard surface—such as a countertop—blot excess water from face and back with a soft cloth towel. Allow to air-dry.

15 flatten the print

When the print is dry, it can be flattened by placing it between two sheets of mounting board in a dry-mounting press; use low heat.

FREDERICK H. EVANS: *Gloucester Cathedral: Tomb of Edward II, at Dusk,* 1890

FREDERICK H. EVANS: *Kelmscott Manor: In the Attics*, 1897

The wood-beamed attic of an Elizabethan manor house shows how the photographer was able to create an artistic study from the simplest of subjects. The subtle play of light and shadow, the austere lines of the construction and the almost palpable textures revealed in this platinum print, which was made by George A. Tice from one of Evans' lantern slides, indicate the delicacy that can be attained with the process.

The fine detail possible in a platinum print can be ▶ seen in this view of the famous medieval cathedral in Lincoln, England, printed by Tice from an Evans glass slide. In the platinum print itself, the sharply delineated bricks of the houses and the cathedral stonework, muted by wisps of smoke rising from the chimneys, create an astonishing three-dimensional effect that is only partially conveyed when reproduced on a book page.

FREDERICK H. EVANS: *Lincoln Cathedral: From the Castle*, 1898

Choosing Color to Last

Exposure

Incorporated Coupler Chromogenic

color couplers

blue-sensitive layer
green-sensitive layer
red-sensitive layer
base

In common chromogenic slide reversal film, color couplers (circles) are present in the three light-sensitive layers

of emulsion. During exposure, red light from the rose forms a latent image (gray area) in the red-sensitive layer.

The stability of color films and prints varies according to the materials used and the way they are processed and stored. The diagram at right illustrates one important factor—the formation of dyes—in the stability of four familiar color processes, from the least stable *(top)* to the very stable *(bottom)*.

With the chromogenic (color-forming) process used for most color slides, negatives and prints, chemicals called color couplers react with color developer to form dyes during processing. These synthetic dyes consistently sacrifice long-term stability for an initially accurate color image. Because most chromogenic materials include color couplers in the emulsion layers, unreacted couplers stay in the final image and are prone to delayed reactions that cause color shifts or stains. An exception is Kodachrome slide film, which uses color couplers mixed with the developer rather than incorporated in the emulsion. The method allows more stable dyes to be formed and does not leave unreacted couplers in the final image.

The Cibachrome dye-bleach and Kodak Dye Transfer processes both use very stable preformed dyes instead of dyes synthesized during development; both have excellent dark-storage stability. An added benefit of the dye-transfer method *(pages 100-102)* is that the three black-and-white separation negatives—one for each primary color—last indefinitely with proper storage, and a fresh color print can be made at any time.

For color with the permanence of oil paints, there are the infrequently used carbon processes *(not shown)* that create images using ground mineral pigments. Nothing lasts forever, but carbon prints—stable in the dark and on display—come close.

Kodachrome Chromogenic

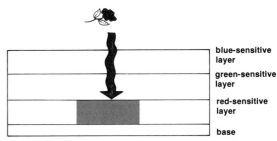

blue-sensitive layer
green-sensitive layer
red-sensitive layer
base

In Kodachrome reversal film, color couplers are not built into the emulsion, thus simplifying its complex of

chemicals. Again, light from the rose forms a latent image (gray area) in the red-sensitive layer of emulsion.

Cibachrome Dye Bleach

yellow dye

magenta dye

cyan dye

blue-sensitive layer
green-sensitive layer
red-sensitive layer
base

The dye-bleach process for making prints from slides uses fully formed azo-type dyes (circles) in the emulsion.

Also used with textiles, this dye family is very stable. Here, the red-sensitive layer is affected during exposure.

Kodak Dye Transfer

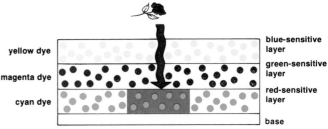

blue-sensitive negative

green-sensitive negative

red-sensitive negative

blue-sensitive matrix

green-sensitive matrix

red-sensitive matrix

For dye-transfer prints, one black-and-white negative is made for each primary color. These are used to print three

sheets of matrix film, whose emulsions harden where exposed to light. The red image area here does not harden.

Processing

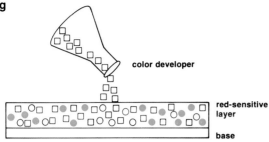

color developer

red-sensitive layer

base

A bath of color developer (squares) converts color couplers to dyes in the nonimage areas of the emulsion.

Cyan dye, which absorbs red light, forms throughout the red-sensitive layer except where the image was formed.

Final Image

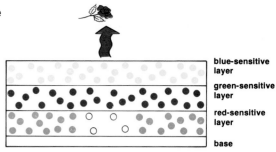

blue-sensitive layer

green-sensitive layer

red-sensitive layer

base

The rose looks red in the slide because the absence of cyan dye in the image area lets red light through; other colors

are absorbed by the other dyes. Unreacted color couplers (circles) in the film may lead to fading and color shifts.

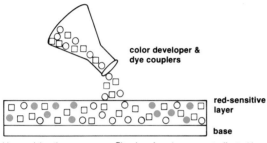

color developer & dye couplers

red-sensitive layer

base

Dyes are formed by applying three separate baths of color couplers (circles) mixed with color developer (squares).

The dyes form in areas not affected by the original exposure. Only development of the red-sensitive layer is shown.

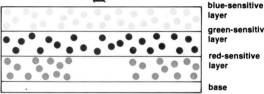

blue-sensitive layer

green-sensitive layer

red-sensitive layer

base

With no cyan to absorb red light, the rose appears red in the slide. The film's simple emulsion structure allows

more stable dyes to be used, and no unused coupler remains in the film to attack the dye or to change color.

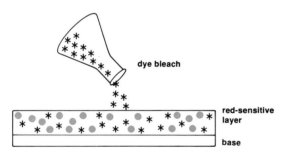

dye bleach

red-sensitive layer

base

A strong acid bath is applied to bleach out dyes in proportion to the exposure received. Cyan dye is bleached out of the

red-sensitive layer only where exposure through the transparency formed a latent image of the rose.

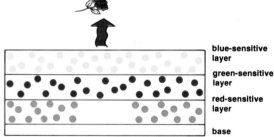

blue-sensitive layer

green-sensitive layer

red-sensitive layer

base

Because no cyan dye is present in the image area, reflected red light creates the picture of the rose. With no residual

chemicals, the print is stable in dark storage; the azo dyes make it stable under controlled display conditions.

hot water

red-sensitive matrix

cyan dye

Each matrix is washed in hot water, dissolving the soft unexposed part of the emulsion. When the appropriate dye is

applied, it is absorbed only by the hardened emulsion. The red-recording matrix shown here absorbs cyan dye.

blue-sensitive matrix

green-sensitive matrix

red-sensitive matrix

receiving sheet

The matrices are pressed to a receiving sheet that absorbs dyes from the hardened portions. Because the image

area of the print absorbs no cyan dye, it reflects the red light of the rose. Various types of stable dyes can be used.

Preserving Color in a Black-and-White Record

the original transparency

A 35mm color transparency provided the starting point for the dye-transfer print shown on page 102. The colors of the original—made in 1967 in Ecuador by Douglas Faulkner—can be recorded and stored in black and white on separation negatives, and from these negatives an accurate, full-color print can be made whenever necessary.

Because most color photographs are formed from dyes, and even the best dyes fade, the life expectancy of color pictures is generally shorter than that of black-and-white pictures. There is, however, a method of preserving a permanent record of the colors of a photograph and, from this, re-creating the original image in a print made by the "dye-transfer" process.

The permanent record is in black and white—a negative for each of three primary colors that constitute the many shades in the picture. From these "separation" negatives a color print can be reconstructed at any time, since black-and-white negatives—if properly processed and stored—last indefinitely. (Because of improvements in dye stability, the color prints themselves are more resistant to fading, provided they are stored in the dark.)

The making of the separation negatives and their use in reconstructing the original image is a job generally left to professionals, for it requires special film and camera equipment. The technique itself, however, can be easily explained. The first step is to make the separation negatives: This is done by copying the color original on sheets of 8 x 10 black-and-white film. Each negative is made through a filter in one of the three primary colors—red, green and blue. The red filter screens out all but the red tones in the original, resulting in a black-and-white record of the

original's reds; the blue and green filters similarly provide black-and-white records of blues and greens.

To re-create the original colors in a dye-transfer print, these negatives are used to make positive enlargements on special gelatin-emulsion film known as matrix film. When the film is developed, the portions of the emulsion struck by light become hard and insoluble, while those unaffected remain soft and can be washed away in hot water. The result is a photographic relief, a kind of flexible printing plate, in which the raised areas form the image. Actually, they do not represent the color transcribed onto the separation negative, but the areas from which that color is absent. In other words, the matrix made from the "red" separation negative now represents the complement of red, cyan; the matrix from the "green" separation represents green's complement, magenta; that from the "blue" represents blue's complement, yellow.

For printing, each matrix is immersed in a dye of the appropriate color: the cyan matrix in cyan dye, and so on. The matrices are pressed, one at a time, onto a special printing paper that absorbs the dyes from the raised surfaces, and the superimposition of the three dye images produces a replica of the original color picture. Photographers interested in greater creativity often manipulate the process to vary color choice, saturation and contrast.

The dye-transfer process for making color prints ▶ requires six ghostly versions of the original: three black-and-white negatives, one for each primary color (top row), and three matrices enlarged from the separation negatives to the size of the final print. Each matrix prints the complement of its negative's primary color (bottom row) to re-create the original color image (overleaf).

red separation negative green separation negative blue separation negative

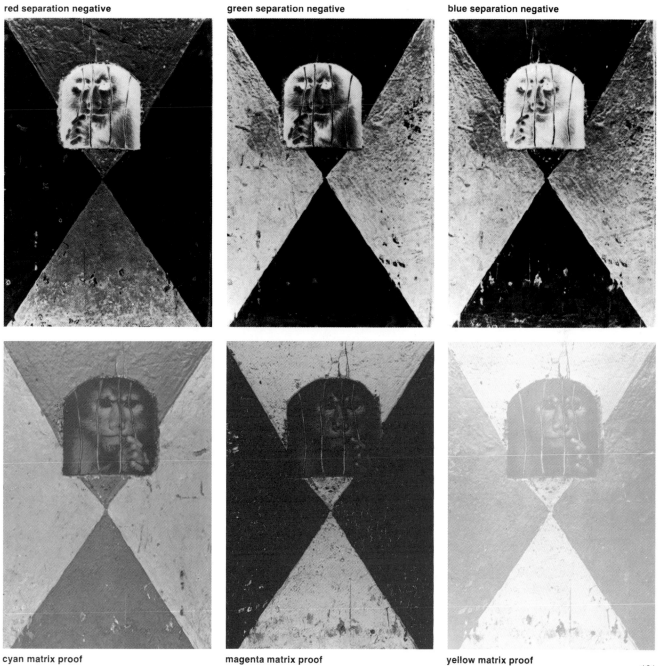

cyan matrix proof magenta matrix proof yellow matrix proof

101

the dye-transfer print

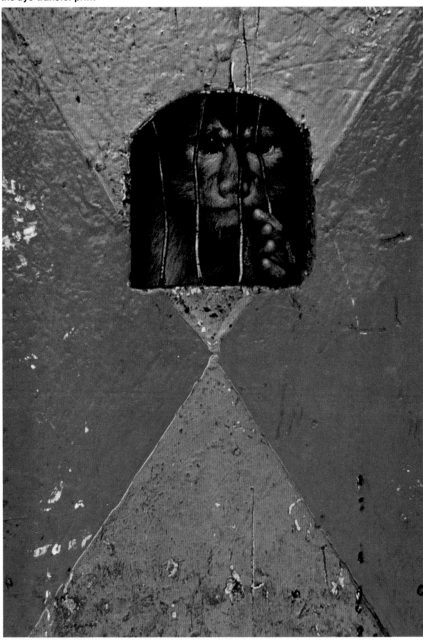

In a dye-transfer print made from separation negatives of the transparency on page 100, the bold hues of a painted cage frame the face of a monkey that tells fortunes with cards. A new, true-color print can be made at any time, since the black-and-white records of the original colors in the separation negatives can be as permanent as any black-and-white picture.

DOUGLAS FAULKNER: *Fortunetelling Monkey, Ecuador, 1967*

AL FRENI: *Filing Photos*, 1972

An Easy-to-Use Filing System

Indexing photographs is a chore to most photographers, even the professionals. Mark Kauffman, when he was a *Life* photographer, was approached by an enterprising former colleague who was starting her own picture agency. Kauffman agreed to let her represent him, but when she asked for his collection of photographs, Kauffman descended to the basement of his home and emerged with two shopping bags haphazardly packed with loose transparencies. In order to find out exactly what pictures Kauffman had, his new agent had to sort them all out and index them. Once she had accomplished this drudgery, she began to make extra money from pictures Kauffman had forgotten he even possessed. Not only had the disorganization cost Kauffman income, but also by putting his photographs in paper bags he had run the risk of damaging them. Over the years, low-grade paper, cardboard, and wood products give off chemicals that can interact with the silver in a photograph and hasten the fading process.

This is not an isolated incident. A great many photographers, professional and amateur, regard filing and storage as a baffling and disheartening experience, one to be delayed or avoided indefinitely. Yet the ability to locate pictures increases the pleasure — and often the profit — photographers get from their work. Correct storage preserves pictures as well. When done systematically, indexing and storing photographs can become as automatic a process as keeping track of the exposures on a roll of film.

One thorough and reliable indexing system has been perfected by the Time Inc. Picture Collection. It is a more ambitious operation than most photographers would attempt by themselves, but the basic idea is applicable to any private collection. Some 3,700 pictures pour into the Time Inc. collection every week from photographers on assignment all over the world for the company's many publications. It also receives from the major wire services hundreds of news photos a week and picks up many other photographs from the important picture agencies. In all, it has access to nearly 19 million pictures, making it the largest indexed picture collection in the world.

Under the Time Inc. system a special number is given to each assignment undertaken by a photographer. This "set number" is stamped on every picture and on any research or caption material relative to the assignment. The set numbers run chronologically. Number one was stamped on the pictures taken in 1936 for a photographic essay on Texas by Carl Mydans — the first assignment made by the editors of the newly founded magazine *Life*. Forty-five years later the set numbers had climbed to the 136,000s and were headed rapidly toward 140,000.

When the set is numbered and ready for storage, its parts are segregated according to type of image: Negatives, contact sheets, prints and color transparencies each have their own metal cabinets. In these cabinets every-

The front and back of the cardboard mount are used to identify and describe this transparency filed by the Time Inc. Picture Collection. On the back (top) is the set number, used for all photographs taken on the same assignment, and the division of the company that assigned the work—BKS, an abbreviation for Time-Life Books. The typed label notes in which book and on which page the picture appeared, while the grease-pencil mark at lower left indicates that the slide is to be kept and the F at upper right shows that it has been filed. On the front side (below), the handwritten phrase describes what the picture is about and where it was shot.

thing is filed in succession according to set number. For ease in handling and storage, negatives are cut into strips of five exposures each and slipped into protective sleeves.

A filing system is only as good as its retrieval system, however. To pull the pictures from the files, a comprehensive cross-reference method is used. There are about 4,000 main headings—such as ACCIDENTS, ANATOMY, ART, and geographic location headings. Each of these is usually augmented by sub-headings, and sometimes even by sub-subheadings. These in turn are supplemented by cross references. For example, under "ANATOMY-Bones" is the listing "see also MEDICINE-Bones."

The notations on the transparency at left illustrate how this filing system operates. The transparency came into the collection as part of a 1970 assignment in Bulgaria for a volume in the Time-Life Foods of the World series. On the cardboard mounting of the transparency is the set number, along with a phrase that explains what the photograph shows, in what publication it was used and on what page it appeared.

The transparency, with 81 others taken on the same assignment, is filed in the collection under its set number. The picture is indexed under five different subject headings: AGRICULTURAL PRODUCE-VEGETABLES-PEPPERS; MARKETS-BULGARIA; BULGARIA-PEOPLE & CUSTOMS; RELIGIONS-ORTHODOX EASTERN-CLERGY-BULGARIA; and VENDORS. Each card includes brief references to those pictures that are related to its subject heading—for example, "An orthodox Eastern priest selects red hot peppers for his basket at open market, Gabrova." All the cards also carry the set number, the photographer's name, the date the picture was taken and that of the publication in which it was used.

Simply by looking through the card index, a researcher can get a good idea of what pictures are on file. And one of these photographs made for a cookbook may serve a totally different purpose in a magazine story about Bulgaria or Eastern Orthodoxy. The researcher looking for pictures in one of the latter categories will be led to it by the cross references in the file.

Most photographers will not need as comprehensive an index system as the one used by Time Inc. Professionals who specialize will require appropriately specialized headings. Amateurs will want to employ generalized, personalized headings. It is wise to use as few separate headings as possible—perhaps only FAMILY; PEOPLE-FRIENDS AND ACQUAINTANCES; EVENTS; PLACES; SPECIAL INTERESTS and MISCELLANEOUS. Under FAMILY would be filed not only pictures of relatives but also all photographs of the home and household. PEOPLE might include pictures of friends, neighbors, visitors and interesting strangers who caught the photographer's eye. EVENTS are birthday parties, graduations, confirmations, Fourth of July celebrations, etc. PLACES would include pictures made while visiting—from a national park to the local zoo. What fits under

The room containing the Time Inc. Picture Collection is shown in slight distortion, caused by joining two wide-angle photographs. The deep-drawer cabinets (center and right) hold the photographs on file, while the card index is located in the small-drawer cabinets behind.

the SPECIAL INTERESTS heading would depend on the individual photographer's pet subject—nature, cityscapes, abstract patterns, sports events. MISCELLANEOUS, of course, includes all those photographs that defy categorization under the other headings.

With all the photographs separated by general subject, they might now be divided according to, say, the relation of the FAMILY member, the name of the person under the PEOPLE heading, the time of the EVENT, the location of the PLACE, the subject of SPECIAL INTEREST or the MISCELLANEOUS item; further breakdowns might be dictated to some extent by the journalist's yardstick of "who, what, when, where and why." With the photographs thus differentiated, a set number can be assigned to each separate group of pictures. The set number should then be keyed to a file card containing a brief description of the photograph, the time it was taken and any other important information. But before arranging the cards in their file, the photographs should be studied once more for purposes of cross referencing so that any picture can be easily retrieved.

Here, for example, is how the pictures taken at Suzie's fifth birthday party at the summer cabin would be filed, with cross references. First, all the pictures of the event would be given the same set number, say, 421. Then four cards would be made out for cross referencing. Under the heading FAMILY would be a card titled "Suzie, fifth birthday party at summer cabin, June 21, 1982. Set number 421." A second card would go under the heading PEOPLE-FRIENDS AND ACQUAINTANCES; the entry would read, "Smith, Joey. At Suzie's fifth birthday party at the summer cabin, June 21, 1982. Set number 421." The card in the section EVENTS would read, "Birthday parties, Suzie's fifth at the summer cabin, June 21, 1982. Set number 421." Finally, under PLACES would be this card: "Summer cabin. Suzie's fifth birthday party, June 21, 1982. Set number 421."

Once this type of system is established, the photographs can be filed in cabinets according to their set number, and the cards can be filed in separate index boxes labeled with the general headings. By consulting the cards in the index files the photographer will easily be able to find the pictures of Suzie—or the summer cabin or even little Joey Smith. The set number is simply found on the index card, and the pictures with that number are pulled from the files. The photographer may have to check through the 20 or 30 pictures in each set, but that is easier than rummaging through an unindexed pile of photographs that have been tossed at random over the years into old boxes or shopping bags.

There are several tricks a photographer can use to make filing easier. When filing large sets of color transparencies—more than twenty 35mm slides—the Time Inc. Picture Collection puts the captioned slides into stiff polypropylene slide pages, numbering the slides in order. When the set is indexed, the card will indicate which portion of the set applies to a particular subject. The subnumbering eliminates the need to look through an entire set to find one

An illustrated card, such as the one made of a Life photograph for the picture collection (above, right), gives an example of the pictures in a black-and-white set. Anyone can make a similar card by gluing a picture cut from a contact sheet to a card bearing the set's number and an appropriate heading. For transparencies, use an index system such as the one described on pages 107-111.

This simple marking method can be used to rate the transparencies in a collection. The top-quality pictures are stacked together and marked with a single line; the stack of second-quality transparencies receives a double line. Pictures that go in sequence as part of a slide show, for example, get a diagonal line, which serves as a guide when they must be reassembled in order.

frame. Under the Time Inc. system, pictures are combined with information on index cards to give an idea of the type of photographs in a set—a device the home photographer can also employ. There are also marking methods that make transparencies easy to categorize *(opposite page)*.

Perhaps the best way to simplify the indexing chore is to weed out incorrectly exposed and low-quality pictures ruthlessly at the time the set is filed. If there are many shots of the same subject, each bracketed with slightly different exposures, only the best should be kept. Photographers must be stern with themselves here, editing their own collections down to size. If they do not stick with their finest pictures, the others will merely clutter up the file and require excessive storage space.

After the photographs are weeded out and indexed, they must be stored in a safe place. Some professionals, fearing loss of their originals through fire or theft, actually keep them in safe-deposit boxes in bank vaults. But even in that secure haven, a photograph can be damaged if it is stored in the wrong kind of box or envelope.

The list of materials that can harm photographs is a long one and it includes many things that photographers regularly use for storage. Cardboard boxes will give off, through the years, discernible amounts of gases and peroxides that tarnish the silver in the film, causing fading and loss of picture detail. Brown kraft-paper envelopes, often used to hold prints, negatives and even transparencies, and the glassine sleeves regularly employed to protect negative strips, are both made of a low-grade fiber that can gradually affect the film's silver. Most adhesives can damage pictures. And some plastics intended to protect negatives or transparencies may in fact mar the emulsion.

Photographs are also susceptible to the peroxides in most bleached and uncoated woods, such as the boards used for shelving. The solution is to paint the shelves—but since photographs are also sensitive to new paint, the shelves should not be used for storing pictures until about a month after they are painted. High humidity and temperatures are also detrimental to photographs; both conditions hasten corrosive chemical activity. Air pollutants can be even more damaging. The pages that follow contain advice on how to avoid these dangers, to ensure safe as well as efficient storage of the photographer's most prized possessions: his pictures.

How to Keep Negatives

Care in storing and preserving a collection of color or black-and-white photographs must begin with the negatives. Since the emulsion is particularly susceptible to the chemicals in adhesives and in low-grade paper envelopes, folders and interleaving sheets, the negatives must be carefully protected. This can easily be done in a number of ways. Negatives can be slipped into polyethylene transparent holders *(opposite)* that can be secured in acid-free paper binders. The holders resist moisture (which can cause glazing on the negative) and will not decay or grow misty with age. Also, the negatives can be viewed—and contact sheets made of them—without removing them from the holders.

Acid-free paper envelopes or folders are another safe way to store negatives, as are the commercial wrappers that protect new film. Acid-free glue and tape are also available for sealing.

It is wise to store negatives in a way that makes for easy retrieval. A metal filing cabinet serves nicely, but its finish should be of baked enamel—the pernicious effects of the paint's resins and peroxide are eliminated by the baking process. A deep-drawer file *(near right)* can accommodate contact sheets, along with any size of negative. The more compact cabinet next to it is made for strips of 35mm negatives. The cabinet drawers are labeled with subject headings.

These are two of the many baked-enamel metal cabinets that can be used for storing negatives. The desk-top file (left) is a regular office model, its 10-by-12¼-inch capacity large enough to hold contact sheets and negatives of any size. The narrow file, which was made expressly for 35mm negatives (right), can hold up to 2,100 frames per drawer.

A number of negative holders are shown here. Polyethylene transparent sleeves for strips of 35mm negatives fit into a binder (top, left). At bottom left are polyethylene holders with negatives inserted. At top and bottom right are acid-free paper envelopes — except in the bottom right-hand corner; this is a cellulose acetate sleeve for 35mm negatives that comes in long strips that can be cut to any length.

How to Keep Prints

This print-storage box is made of heavy-duty acid-free paper. It is bound by metal clips, without adhesives that can cause trouble. The boxes come in different sizes, but should be packed full when stored vertically, so the prints will not curl.

Three materials for holding prints are displayed here. A cellulose acetate holder, with an edge that has been punched to fit a binder, is at top left. Beside it is a side-seam, acid-free paper folder. Below them is an acetate sleeve for prints or negatives.

Proper storage is as important for prints as it is for negatives and transparencies, and the methods described on the preceding pages apply equally well here. As with negatives, prints should be protected with acid-free interleaving papers or sheets of cellulose acetate. Light and stable, cellulose acetate is a thermoplastic that is also used as the flexible backing of most commercial films.

Once the prints are wrapped or interleaved with protective papers or cellulose acetate sheets, they should then be stored in metal cabinets or acid-free paper boxes. The chemicals that are in low-grade cardboard or paper can alter the images in black-and-white photographs, and sunlight fades and bleaches color prints. In fact, the most satisfactory storage for all color materials (prints, negatives or transparencies) is in a frost-free refrigerator *(page 124)*.

A number of materials that can be used for interleaving and filing prints are arrayed here. The interleaving materials are cellulose acetate (any size can be cut from the roll), acid-free tissue paper (left) and trimmed black enlargement-paper wrapping. The acid-free paper folder is for vertical filing.

How to Keep Slides

An enemy to all photographic materials, and especially to color transparencies, is moisture. In an atmosphere that has more than 60 per cent relative humidity, mold or fungus can form on transparencies and negatives. Storage equipment for slides should provide, if possible, for fully circulating air, one of the best preventives of fungus formation. Most carousel trays and metal slide-storage boxes are specifically manufactured to allow air to circulate. And some of the best compartmentalized polypropylene sheets, for holding color transparencies in binders, are designed with grooves that keep the sheet from pressing against the transparency and locking moisture in.

Another way to lower humidity is to place the transparencies in a container along with a can of silica gel. The gel is a special drying agent that draws moisture from the air, and can dry out moisture-impaired slides in a few days. □

Several types of slide holders, grouped around a container of silica gel, include two sizes of polyethylene slide protectors perforated to fit binders (top left); and, clockwise, a metal portable slide file and two kinds of slide holders—one of styrene, the other (lying on top of it) of polypropylene. At bottom left is an indexed polystyrene tray.

The handwritten index labels on the storage box lid read:

PARIS 1969	DOTSON RADER BIRTHDAY PARTY 1971	WOODS	FAMILY
ROME 1970	CHRISTMAS EVE 1971	RUINS	FRIENDS
BARBADOS 1971	MICHEL-VOGEL WEDDING 1972	FLOWERS	
		STONES	

Slides can be stored safely in metal files; the baked-enamel storage box at top left, which has an index on its lid, is for 2 1/4 x 2 1/4-inch slides. Carrousels and trays provide for air circulation but must be covered or protected. The carrousel at top right holds 80 slides and is numbered on the base for easy identification. The straight tray, with a dust-cover index, holds 36 slides.

Color transparencies can be mounted and protected in many ways. At top left is a snap-together plastic frame with glass slide cover; at right, a polystyrene slide mount. In the next row are a metal-and-glass binder and a common grayboard mount. Below them are a traditional cardboard slide mount from a commercial film processor (left) and a large grayboard mount. At bottom are two sizes of cellulose acetate protecting sleeves, made without adhesives.

Duplicating Slides for Safety's Sake

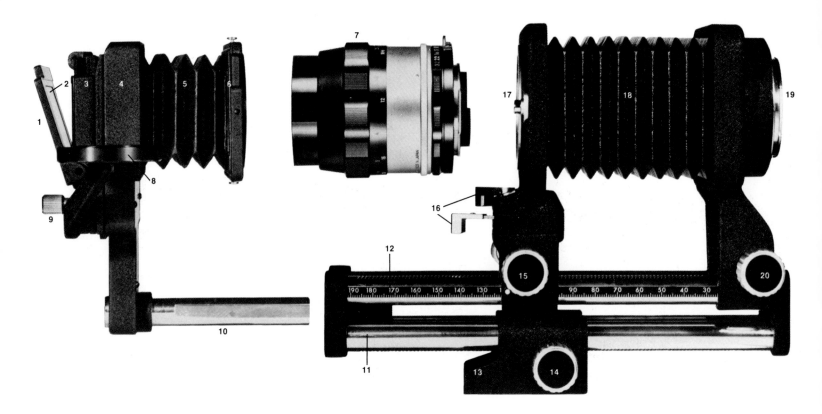

1 **hinged opening**
2 **frosted plate**
3 **slit for mounted transparency**
4 **copying adapter**
5 **bellows of copying adapter**
6 **lens mount to copying adapter**
7 **lens**
8 **holder for roll film**
9 **lock knob for hinged opening**
10 **rod for attaching adapter**
11 **base for focusing bellows**
12 **distance-measuring scale**
13 **attachment for tripod**
14 **knob for moving device on tripod**
15 **knob for moving front of bellows**
16 **bellows swing and shift locks**
17 **lens mount to bellows**
18 **focusing bellows**
19 **camera mount to bellows**
20 **knob for moving back of bellows**
21 **camera**

Nothing can be so frustrating to the photographer who has carefully stored and protected his transparencies as lending them to someone who then either damages or loses them. One solution to the problem is to make duplicates. And the generally accepted premise that copies are inferior is no longer wholly true. There are methods for making duplicates with almost perfect color fidelity.

There are a number of types of duplicating equipment. An elaborate machine for copying and color correcting is pictured on pages 66-67. At the other end of the scale are devices that cost less than $40 but are limited in their application. An all-purpose copying device is shown on

these and the following pages. Since it costs over $600 (not including the camera), it is perhaps a better investment for the commercial photographer than for the amateur. Nevertheless, it produces faithful duplicates for about 35 cents a picture; commercial copies, which are frequently of poor quality, cost about 65 cents—and an expert commercial duplicate can cost up to $40.

This mechanism can be used only with an SLR camera, whose viewfinder shows what the lens sees. The whole assembly, including the camera, is so compact that it can be mounted on a tripod, and it is extremely flexible as well. The device can duplicate transparencies in color when

21

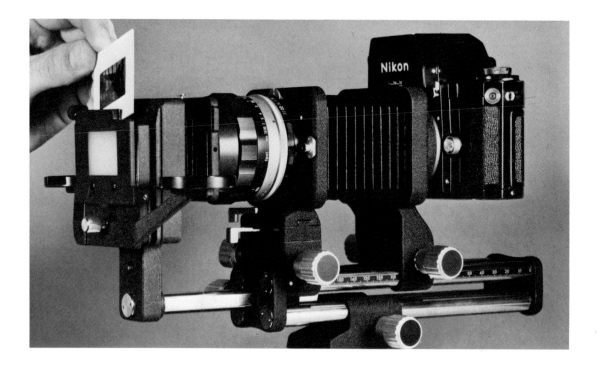

used with the appropriate filters *(page 72)* or in black and white, and it is capable of being manipulated so that it will isolate a detail from an original picture and even enlarge it.

The essential elements of the equipment shown here are a bellows focusing attachment, a lens and a copying adapter. The camera *(above at left on this page)* fits onto the mount that is on the copying mechanism's bellows focusing attachment *(opposite page, right).* The lens *(opposite page, center)* fits between the focusing attachment and the copying adapter *(opposite page, left),* which itself has a small bellows; its principal purpose, however, is to hold the picture that

is to be duplicated. Mounted transparencies fit into a slot to the left of the adapter's bellows. The adapter also has holders on each side for rolled uncut film strips, and there is a hinged opening to facilitate threading the film past the frosted window through which the film is lighted for copying.

A transparency larger than 35mm can be copied by framing it in black cardboard, taping it onto a light box, focusing a tripod-mounted camera at it and rephotographing it. For such use, the copying adapter must be removed from the device. The bellows focusing attachment, with its lens, will then bring the original into proper focus.

With the slide-duplicating device assembled, a color transparency ready to be reproduced is dropped into the slide holder of the copying adapter (left). When the slide is in place, the camera is aimed at a light source. Thus the copy is simply a picture of the original transparency.

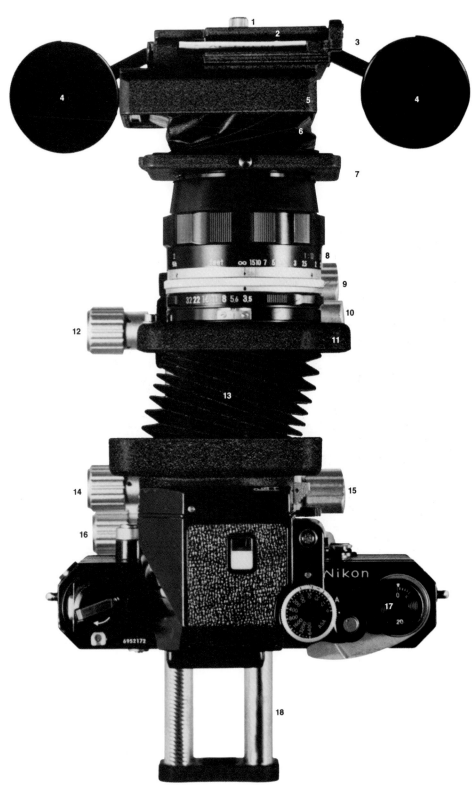

This top view of the slide-duplicating system shows how both sets of bellows can be twisted, allowing the lens to zero in on a given section of the transparency. Without this flexibility in the bellows, the lens would be locked into a straight-on view and detailed blow-ups of a side portion of a transparency (opposite) would be impossible.

1 lock knob for hinged opening
2 hinged opening
3 slit for mounted transparency
4 holders for roll film
5 copying adapter
6 bellows of copying adapter
7 lens mount to copying adapter
8 lens
9 lock knob for copying adapter rod
10 lock for knob to move front of bellows
11 lens mount to bellows
12 knob for moving front of bellows
13 focusing bellows
14 knob for moving back of bellows
15 lock for knob to move back of bellows
16 knob for moving copying device on tripod
17 camera
18 base for focusing bellows

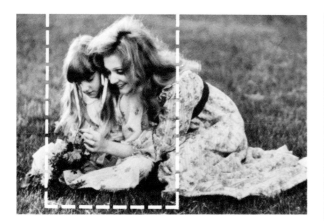

The original picture (left) was a simple color transparency of a young woman and girl enjoying flowers on a lawn. To highlight the focus of the picture—the faces and the flowers—the transparency was cropped in the slide duplicator. First the image of the transparency was put in full view in the camera, then the bellows was adjusted until only the desired portion of the picture showed (dotted line). The picture was then enlarged by extending the bellows, placing the lens closer to the transparency.

A major advantage of this versatile slide-duplicating device is its ability to crop out part of the original. The bellows can be twisted so that the lens is set off-center in a way that segregates one section of the picture. And by employing the bellows to bring the lens in closer, this section can be enlarged *(above)*.

In using this equipment, lighting is important. A good black-and-white facsimile of a color slide can be produced with nearly any light source that is bright enough; pointing the camera toward a lighted window or a bright lighting fixture will serve the purpose. But for a color copy, in which color must be accurate, lighting becomes critical: Film must be balanced for the light source, and filters must be used. Aiming the camera at the sky will produce a good color copy in midday but not in early morning or late afternoon. Even the slight fading of the sun caused by a passing distant cloud can alter the light level enough to change the color in the copy. And shooting toward a window can add a green or blue tinge to the duplicate as a result of the coloring that, although not visible to the eye, is in every pane of glass.

A more trustworthy source of light is electronic flash; direct it squarely at the frosted glass of the copying adapter. In order to make exact color copies, the filters shown in the chart on page 72 must be used along with the corresponding aperture adjustment.

A test roll or two should be shot to gauge the correct exposure. But once the variations in the light source are compensated for, the photographer has a quick copying system that is a welcome insurance against lost or damaged originals, and can even create photographs through cropping. □

An Ideal Room

An ideal archival storage room for photographs would contain a number of the features shown in the drawing at right. In choosing a room, avoid damp basements, hot attics and rooms that get a lot of sun, and closets or other cramped spaces with poor air circulation.

Walls should be coated with water-based latex paint, and the room should be aired for several days before it is used to store photographs. Latex deck paint or linoleum are satisfactory floor coverings; if self-adhesive vinyl tiles are installed, be sure to air the room for several weeks. Shelves, file cabinets and other furnishings should be made of metal, not wood, and should have a baked enamel finish.

Both an air conditioner and a dehumidifier (except in dry climates) are needed to maintain the best possible environment: a relative humidity of about 40 per cent and a room temperature of 65° to 70° F. (18° to 20° C.). A temperature several degrees cooler is better for photographic emulsions; but many air conditioners may ice up below 65° F., and relative humidity becomes harder to control. The air conditioner and the refrigerator for storing color *(next page)* should each have its own electrical outlet.

1 **frost-free refrigerator**
2 **hygrometer for refrigerator**
3 **lightbox**
4 **thermometer and hygrometer**
5 **vertical file**
6 **map file**
7 **air conditioner**
8 **dehumidifier**

This archival storage room accommodates several kinds of work, from color materials to oversized prints to hundreds of 35mm negatives and slides. Window light is blocked, and a thermometer and hygrometer (4) monitor temperature and humidity.

Cold Storage for Color

Even if kept in dark storage at optimal room temperature and humidity, many color materials will show fading and color shifts within two to 10 years. But if held in cold storage, color images can last at least 10 times longer. Research by photographic scientist Henry Wilhelm shows that certain frost-free refrigerators, kept at 35° F. (1.5° C.) and a relative humidity of 25 to 35 per cent, will do the job nicely.

The refrigerator must not be used for food, and it must be chosen with care. Not every frost-free refrigerator retains the requisite low humidity; some models operate on a cycle that includes periods of high humidity very detrimental to photographs. The critical feature is a separate, frost-free freezer compartment from which subzero air is blown into the refrigerator compartment; as the air warms to 35° F., its relative humidity drops to 25 to 35 per cent. A hygrometer in the unit should be checked weekly.

Since water vapor condenses on the coils in the freezer compartment, the air there will often have a relative humidity near 100 per cent, so nothing should be stored in the freezer unless it is sealed in a vapor-proof envelope. Made of aluminum foil coated with polyethylene and laminated to paper, these envelopes are available at photographic supply stores. They can be heat-sealed with an iron for one-time use or can be sealed with acid-free tape for reuse. Envelopes removed from the refrigerator should be allowed to reach room temperature before opening.

Self-closing polyethylene bags provide extra protection for materials that are enclosed in acid-free paper envelopes or boxes and kept in a frost-free refrigerator. But they are not moisture proof and should not be used in a freezer compartment or in a high-humidity refrigerator. □

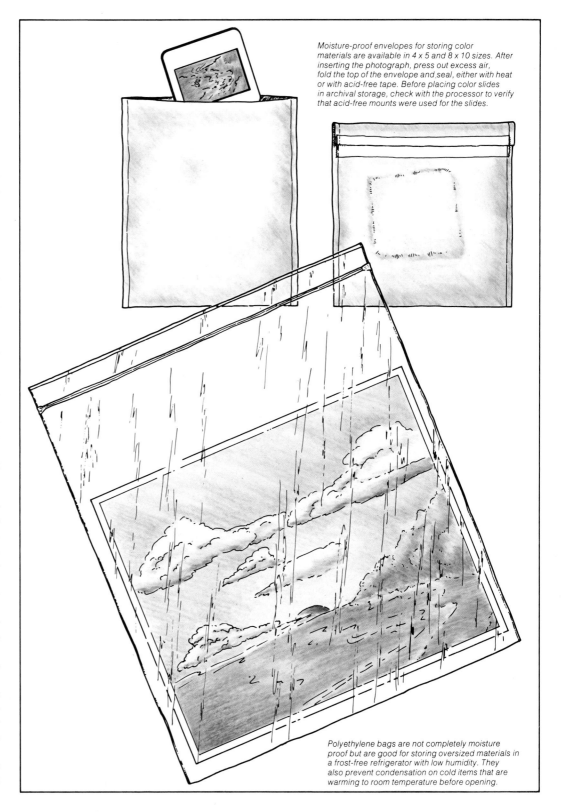

Moisture-proof envelopes for storing color materials are available in 4 x 5 and 8 x 10 sizes. After inserting the photograph, press out excess air, fold the top of the envelope and seal, either with heat or with acid-free tape. Before placing color slides in archival storage, check with the processor to verify that acid-free mounts were used for the slides.

Polyethylene bags are not completely moisture proof but are good for storing oversized materials in a frost-free refrigerator with low humidity. They also prevent condensation on cold items that are warming to room temperature before opening.

ROBERT COLTON: *Color Frames*, 1972

The Many Ways of Enjoying Photographs

Although much of the pleasure of photography is in the taking of pictures, the real reward lies in displaying and viewing the results. Having enjoyed complete artistic control over all the earlier stages of picturemaking—shooting, developing, editing and printing—many photographers naturally choose to do the work of preparing their photographs for display as well, if only because they can make all their own decisions about the size, color and texture of a mat or the style of a frame. The alternative to do-it-yourself work, of course, is to take pictures to a professional shop for custom mounting, matting and framing. But for one quarter the cost of a professional framing job, a photographer who is willing to do some practicing can get equally good results.

The technical aspects of preparing pictures for viewing begin with making a good permanent print *(Chapter 2)* and preserving its condition. It must be protected from careless handling and from injury by heat, humidity and polluted air—and a color print should be kept out of direct sunlight. One way to save a print from tearing, curling or punctures is to mount it on a stiff backing. A picture that is to be on exhibit for a long time also needs the protection of glass or clear plastic over the front. More formal displays often involve placing a picture mat as a border around the print and then framing the matted picture. On the following pages, several mounting methods are shown, step by step, with methods for cutting a picture mat and constructing a frame.

Most of the tools shown are available in photographic, art supply and hardware stores. Mounting materials, such as matboard and dry-mounting tissue, are stock items in most photographic and art supply stores, and may also be ordered by mail from archival supply houses that sell to museums and libraries. Mounting materials for the long-term display of valued prints should be selected with care. Matboard should be high-grade, 100 per cent rag, or purified wood pulp, and must be pH neutral, or acid free. The acids in cheaper cardboard will eventually invade the paper of the print itself, appearing first as a brownish discoloration and ultimately destroying the image.

The wrong kind of glue can also cause trouble. Old-fashioned glues, made from animal matter, tend to disintegrate with age; some of them simply allow a print to curl off its backing, others release destructive acids. Use adhesives whose labels specify that they are meant for mounting photographs and are acid free. Methyl cellulose, for example, has a neutral pH and will not decompose, and organic adhesives such as wheat starch and rice starch are excellent for mounting paper hinges in the traditional museum manner *(opposite)*.

Apart from such basic principles of art and technique, there are procedural questions to be answered—both before and after pictures are ready for showing. The first concern: What photographs are suitable for display? Most photographic prints are no larger than 8 x 10—smaller than most other art works displayed in homes. So the most appropriate images are those with

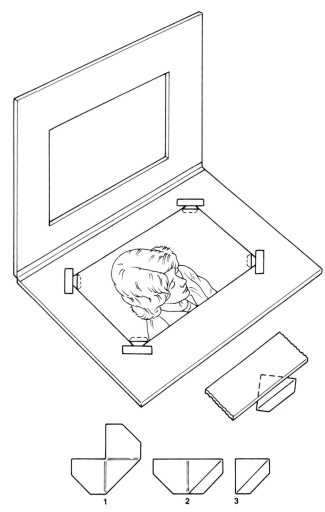

An excellent—and simple—archival display technique is the hinged mat with precut paper or clear-film photo corners. No adhesive is used on the print itself, making it easy to remove later if desired. The two matboards are taped together along one edge with acid-free linen tape. The photo corners are formed by folding each wing along the scored line as shown above. If the photo corners are not self-adhesive, use pH-neutral tape to attach them to the backing board.

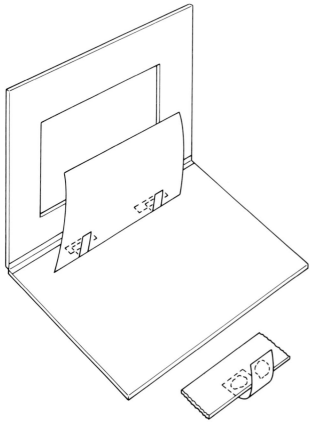

Another way to attach the print to the hinged matboard is with hinges made from strips of acid-free rice paper. One advantage of this method is that the print will not buckle in humid weather, since three sides are loose. Use archival starch to glue half of each strip to the top back of the print. Position the print, and glue the other half of the strip to the backing board. When the glue is dry, reinforce the strips on the board with acid-free tape.

distinct, highly visible elements, bold enough to be seen clearly at eye level from a comfortable viewing distance. Pictures with extremely subtle details and gradations of tone, though easy to view in a book or portfolio, may get lost hanging on a wall.

Where should mounted or framed pictures be placed? The primary consideration is proper lighting. Intense, glaring light can bounce harsh hot spots off a print's surface; lighting should be strong but evenly diffused. Sometimes a single lamp or chandelier, too close to a picture, may give poor, uneven illumination, although a lamp with a strong bulb and a pale shade, which diffuses light, can work well. One good way to light photographs is to set a row of several small bulbs suspended in reflectors on an overhead bar a few feet in front of the pictures.

What places are suitable for displays? No large pieces of furniture should obstruct viewers who want to walk up and examine a picture closely. To display a number of photographs, the walls of a hall or empty corner can be converted into a kind of minigallery with a floor-to-ceiling lining of cork or soft wallboard—the type used for bulletin boards. Pushpins, nails or thumbtacks can be freely used in these materials for arranging—and rearranging—exhibits of mounted or framed prints. With a little help from professional craftsmen, more venturesome displays are possible, such as the expansive murals shown on pages 156-158.

Not every household allows for such extensive installations, however, and not everyone has the time or patience for do-it-yourself mounting and framing. For these situations, several ways of arranging photographs on ordinary walls and shelves—and some of the numerous commercially available picture frames—are shown on pages 146-149.

Cold Mounting—No Muss, No Fuss

The fastest and neatest way to bond a photograph to a matboard is called cold mounting. The technique uses pressure-sensitive adhesives that come in precut carrier sheets ranging in size from 8 x 10 to 16 x 20, or in long rolls of carrier sheets from 11 to 24 inches wide. Most cold-mounting adhesives are acid free, making them ideal for archival display. And because the adhesives bond when pressure is applied, cold mounting is an excellent way to mount sensitive materials such as Cibachrome prints, which may be damaged by methods requiring heat *(pages 132-135)*. A two-roller press to use in cold mounting is available—for about $300—but the method works quite as well with the simple squeegee shown at right, which costs less than a dollar.

The cold-mounting adhesive used in the demonstration on the opposite page —3M's Positionable Mounting Adhesive (PMA)—is the first on the market that allows the print to be tacked to the matboard with light pressure of the fingers and repositioned if necessary before it is permanently mounted. Other adhesives are not so forgiving of mounting errors. With no tissue core, PMA is self-trimming: After the adhesive is transferred to the back of the print *(Step 5)*, the print is simply lifted off the carrier sheet, and no excess adhesive need be trimmed away.

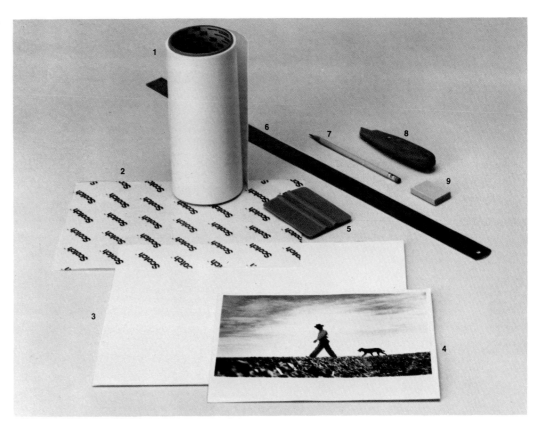

1 **roll of adhesive carrier sheets**
2 **printed release paper**
3 **matboard**
4 **print**
5 **squeegee**
6 **metal ruler**
7 **pencil**
8 **mat knife**
9 **Artgum eraser**

1 trim the print

If the print is to be displayed without a window mat, trim the white border with the mat knife, using the ruler as a guide. Use a razor-sharp blade and make the cut swift and firm to produce clean edges.

2 mark the matboard

Lightly mark the matboard in pencil to show where the print will be placed. Borders that frame a picture usually are the same on the top and sides — here, 2 inches — and slightly wider on the bottom.

3 cut the adhesive sheet

Cut a length of adhesive carrier sheet a little larger than the print to be mounted. If precut sheets are used instead of the roll shown above, separate the carrier sheet from the release sheet attached to it.

4 place the print on the adhesive sheet

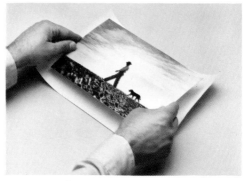

Put the carrier sheet, sticky side up, on a smooth surface and set the print, image side up, on top of it. The carrier sheet must extend beyond the print on all sides so the adhesive will cover all of the back.

5 transfer the adhesive to the print

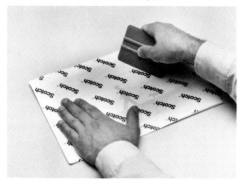

Cover the print and the carrier sheet completely with the release sheet, printed side up. Apply firm pressure with the squeegee, using overlapping, crisscross strokes from the center outward.

6 separate the print

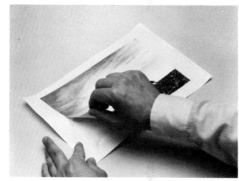

Remove the release sheet and separate the print from the carrier sheet by pulling up one corner of the print at a time. When the print is removed, the self-trimming adhesive will have transferred to the print.

7 position the print on the matboard

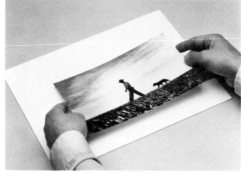

Bow the print slightly and position it within the marks on the matboard. Tack it down with light pressure of the fingers. If the print needs to be repositioned, it can still be moved at this stage.

8 make a permanent bond

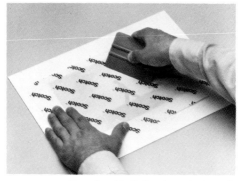

Cover the print with the release sheet — again, printed side up — and burnish with the squeegee. As in step 5, apply firm pressure over the entire surface, working from the center outward.

9 the mounted print

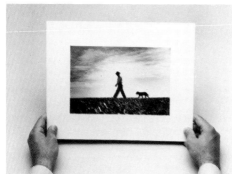

The print above — a prairie farmer and his dog, by Howard Sochurek — is ready to be displayed. If a mat over the mounted print is preferred (pages 140-141) the border trimmed in step 1 may be left on.

Dry Mounting with Heat

1 ruler
2 mat knife
3 tacking iron
4 dry-mount tissue
5 print
6 matboard
7 press
8 tracing paper

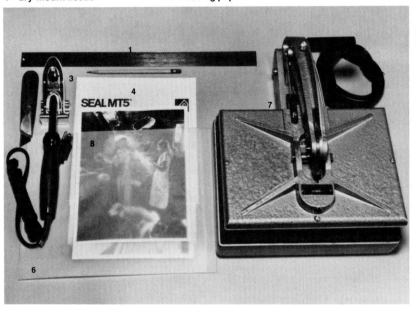

1 dry the materials

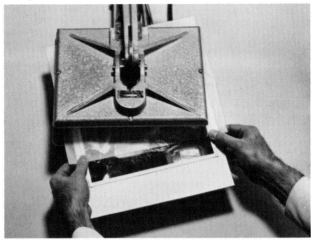

Place the mount board and the print in the press, with a sheet of tracing paper over them. If the press has a thermostat, set it midway between 180° and 210° F.; leave the materials in the press for a minute or two or slightly longer in a humid climate.

Dry mounting is similar to cold mounting in that a thin sheet of special adhesive is used to bond the print to the matboard. However, the adhesive is heat sensitive rather than pressure sensitive, and dry-mount tissue is considerably less expensive than cold-mounting adhesives.

Dry mounting works best if two items of equipment are used: a small tacking iron *(above)* to position the dry-mount tissue on the board and print, and a press to dry the materials and then fix the print to the board with even pressure and temperature. A small press like the one shown above, which can accommodate prints up to 8 x 10, costs about $200—a good investment for the photographer who has many prints to mount. For occasional mounting jobs, an ordinary household iron can be used *(pages 134-135)*.

Some of the available heat-sensitive tissues bond at temperatures of about 210° F.; they are used with fiber-based black-and-white prints. Others bond at lower temperatures (180°-190° F.); these tissues are suitable for most color photographs on resin-coated papers (the dry-mounting method should not be used for Cibachrome prints, however). Be sure to test the press with temperature-indicator strips to see that it stays within the recommended range. For archival display, select dry-mount tissue that is pH neutral.

One prerequisite in using this technique is that the materials be bone dry. They also must be free of dirt to avoid lumps that are caused by tiny dust particles trapped between the print and the board. Finally, since the timing of the bonding process varies with each press and set of materials, experiments with discarded prints are advised.

2 wipe the materials clean

After the materials have been baked dry, let them cool for a few minutes, and then wipe away any loose dirt with cheesecloth; examine them for cleanliness under a strong light. Always use clean cloth, and take care not to grind dirt into the board.

3 tack the mounting tissue to the print

With the print face down and mounting tissue on top of it, tack the tissue to the center of the print. The tacking iron has to be heated in advance; it takes about 10 minutes to get to the temperature that is hot enough to melt mounting tissue.

4 trim the mounting tissue

Using the ruler to guide the blade of the mat knife, trim the mounting tissue to the same size as the print. Since the tissue is thin, little pressure is needed, but be careful not to cut through the tissue into the edges of the print.

5 attach mounting tissue and print to the board

Place the print and tissue, face up, on top of the mount board and tack two corners of the tissue to the board with the tacking iron. The tissue must lie absolutely flat on the board to prevent distorting ripples from forming under the print.

6 mount the print

Put the board, tissue and print, protected by a sheet of tracing paper, into the press. Instructions that come with the mounting tissue specify press temperature and how long to heat the assemblage before removing it for trimming (overleaf).

7 trim the mounted print

*After removing the mounted print from the press
and allowing it to cool for a few minutes, trim the
edges with a firm, swift stroke. While the press is
still hot, use a cheesecloth to wipe it clean of any
adhesive that might have seeped out onto it.*

8 the finished print

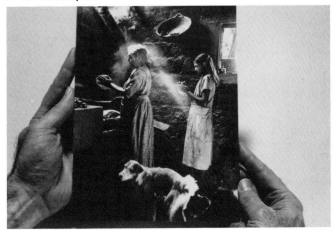

*The print above—a Mexican mother and daughter
in their kitchen, by Leonard McCombe—is trimmed
to leave no border. But the image can as easily
be set off by arranging to leave a wide strip of
the white matboard to show around the print.*

Dry Mounting with an Iron

For dry mounting photographs, an inex-
pensive clothes iron makes a satisfactory
substitute for the press shown on the pre-
ceding pages. The results will be as neat
and permanent as those achieved with a
special press if care is taken and a num-
ber of precautions are observed.

To begin with, an iron that is used for
mounting must not be borrowed from the
laundry. If a retired laundry iron is to be
used for mounting, clean its bottom care-
fully to remove any residue of water min-
erals or starch, which can damage prints.
If it is a steam iron, like the one shown
here, do not put water into it, and take
care to keep the steam holes in the base
plate from leaving circular marks in the
print—a problem avoided by repeated
light strokes with the iron.

Clothes irons are not precision instru-
ments, and at any given setting the tem-
perature may fluctuate as much as 30° F.
Start with the lowest thermostat setting on
the iron, and experiment with discarded
prints and temperature-indicator strips to
find settings hot enough to melt mounting
adhesive (with resin-coated color prints,
be careful not to exceed about 180° F.).
Except for the iron, the materials needed
for this method are the same as those
shown on page 132.

1 dry the materials

To be sure the print and mount board are completely dry, press all moisture out of them with the iron thermostat set at the lowest temperature. When ironing the print, use a cover sheet of tracing paper over it to keep it from being scratched.

2 tack the mounting tissue to the print

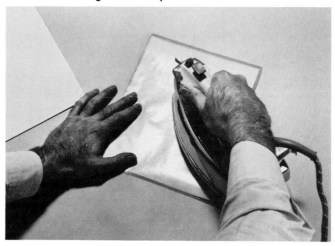

Using the tip of the iron, tack the center of mounting tissue to the back of the print. Turn the print face up, and tack two of the loose corners of tissue to the board. Lift the edges of the print gently to avoid marking its surface.

3 seal the print

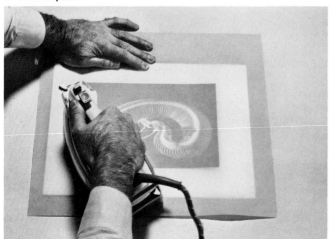

With the cover sheet protecting the face of the print, seal the print to the matboard. The iron should be no hotter than 210° F. for fiber-based prints or 180° F. for resin-coated prints. Use light strokes and work from the center of the print outward.

4 the finished print

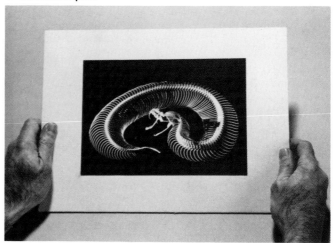

The ironing technique requires some practice, but can yield the elegant results shown here, a display of Andreas Feininger's picture of a snake skeleton. In this case, the photographer left a wide border of matboard to frame the image.

Wet Mounting on Mat Board

1 **sheet of glass** 6 **cheesecloth**
2 **sponge** 7 **organic glue**
3 **burnishing roller** 8 **photographic pan**
4 **matboard for mount** 9 **mat knife**
5 **brush for glue** 10 **prints**

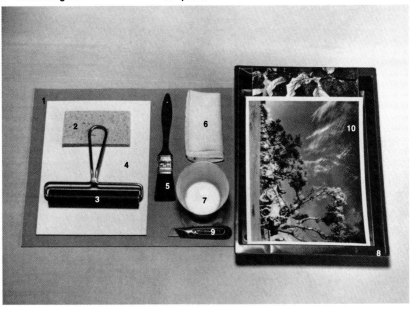

1 soak the prints

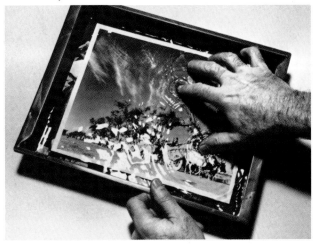

Wet the prints that are to be mounted by immersing them in a tray of lukewarm water. In addition to the print intended for display, another print must be soaked so that it can be mounted on the back of the board to prevent buckling.

2 remove excess water

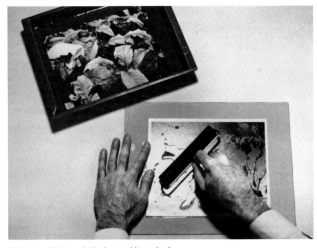

When the display print is thoroughly soaked, press out excess water with a burnishing roller. To avoid tearing the fragile wet print with the pressure of the roller, use many light strokes across the surface rather than a few heavy ones.

The basic materials of wet mounting—paper, glue and water—seem like the ingredients for a messy disaster. But if they are handled with care, they give elegant results, particularly when photographs of mural size are being mounted *(pages 156-158)*. Another reason to master the delicate technique is economy: The materials and tools that are shown above cost less than $20 in photographic and art supply stores.

Wet mounting works best with fiber-based prints; resin- or plastic-coated papers are too slick for liquid glue to adhere to. Buy organic, water-soluble glue and acid-free matboard. The mat knife—a metal holder with replaceable blades—should be bought with extra blades.

Before mounting a photograph, decide whether the picture should be cropped, and whether the print should cover the entire board as shown on these pages, or whether the board should be larger than the print in order to provide a frame of white around it. Then cut the board to the desired size with the mat knife.

One troublesome problem that is found with wet mounting is buckling: A damp print shrinks as it dries and pulls the board into a curve. Buckling can be minimized by mounting a discarded print on the back of the board so that the shrinkage in one counterbalances shrinkage in the other. When mounting the backup print, be sure that its grain—the direction in which the paper's fibers run—is parallel to that of the display print; the grain is visible under a magnifying glass. When they are mounted back to back, the two prints will pull in opposite directions as they dry and, in so doing, prevent the board from buckling.

3 apply glue to the mount board

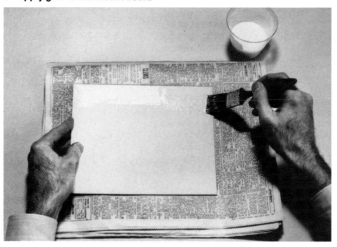

Lay the mounting board on clean, dry newspaper and brush glue evenly over the entire front surface. The glue, which can be thinned with water, should be the consistency of heavy cream. Wash the brush with water immediately after use.

4 apply the display print

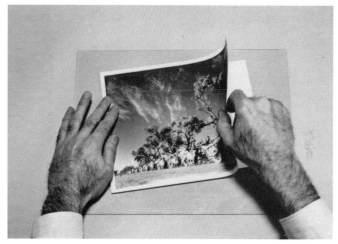

Align one edge of the damp print with one edge of the board and press the print edge down firmly with one hand. With the other hand, roll the rest of the print down slowly into the glue that has been applied to the front of the board.

5 trim the display print

Turn the mounted print face down on the sheet of glass and, using the board as a guide, trim off the edges of the print with a fresh, razor-sharp blade in the mat knife. Take care to make a single, absolutely straight cut without nicking the board.

6 mount the backup print

Transfer the print to fresh newspaper, brush glue over the back of the board, then mount the backup print by the same method previously used. Make sure the grains, or paper-fiber directions, of the two prints are parallel with each other.

7 prepare the print for drying

Before setting the print aside to dry, sponge away any glue that has seeped from under the print's edges. Then spread a single layer of cheesecloth over it; this causes the moisture to evaporate from the print and board slowly and uniformly.

8 the mounted print

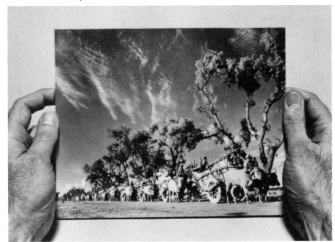

Even when it is dry, the mounted print should be handled only with the fingertips at the edges. This picture by Margaret Bourke-White, showing a peasant caravan in India, is now ready to be displayed—pinned to a wall with tacks or framed.

Wrap-around Mounting

An easy way to prevent buckling in wet-mounted prints—without having to provide a backup print *(page 137)*—is to use a piece of stiff fiberboard, such as Masonite, for the backing. (Keep in mind, however, that fiberboard is not acid free, so this method is not archival.) A print that is mounted on fiberboard can be trimmed so that its edges are flush with those of the board, like the example at left; some photographers prefer to wrap the print around the board, as shown at right, to hide the board's edges and help bind the print to the board.

In order to avoid cropping the image when wrapping the print's edges around the edges of the board, make a print with a generous border of blank paper—at least two inches all around. To crop the print, as in the example at right, the dimensions of the image to be displayed should be lightly drawn on the back of the print—and checked by holding it up to a strong light so the image is visible through the back. Cut the fiberboard precisely to the dimensions of the image. Fiberboard is so tough it is difficult to cut with home tools; however, most lumberyards will sell it cut to size for little or no extra charge.

1 outline the board on the print

Using the precut fiberboard as a template, draw
its outline on the back of the print. Then, following
the steps displayed on the preceding pages,
wet mount the print on the shiny front side of the
board, using the pencil outlines as a guide.

2 cut out the print's corners

Working with a precision knife, cut out the print's
corners from the exact tips of the mounting board's
corners. The cuts should make an angle of
approximately 110° so that the edges of the print will
not show from the front when they are turned under.

3 apply the glue

Lay the mounted print, face down, on clean
newspaper and apply glue in a one-inch strip
around the edge of the board. Since the back of a
piece of fiberboard has a porous surface of
coarse fibers, it may absorb quite a lot of the glue.

4 wrap the edges of the print

Fold the edges of the print up and over the board
and press them down firmly into the glue. Wrap
the longer sides first, then the shorter sides.
When folding, press tight against the edges of the
board to keep the print corners straight.

A Mat to Set Off the Scene

1 **T square**
2 **metal ruler**
3 **Artgum eraser**
4 **sheet of tracing paper**
5 **matboard**
6 **mat cutter**
7 **single-edged razor blade**
8 **print to be displayed**
9 **pencil**

1 measure the picture

Measure the picture and decide on cropping. In this example, the picture measured 9 1/2 inches by 6 3/8 inches; it was cropped to 9 3/8 inches by 5 3/4 inches. Lightly mark the cropping lines on the front of the print with a pencil.

2 figure the dimensions

To figure the dimensions of the mat add the dimensions of border and cropped image. In this example, the border of two inches on the sides, two inches on top and three on the bottom requires a mat 13 3/8 inches by 10 3/4 inches.

3 mark the matboard

Mark the back of the board for the inner cut, using the dimensions of the image that will be visible. Measure with the ruler, but in drawing the lines use the T square firmly braced to align with the mat edge to be sure the lines are square.

4 secure the matboard

Before cutting, anchor the matboard with pushpins to the worktable. The pins must be driven through the part of the board that is to be cut out, far enough apart to hold so that it will not slip under the blade's pressure.

5 cut the mat

Get a firm grip on the mat cutter and brace it against the ruler. Cut each of the inside edges on a line, stopping short of the corners; finish the corners with the razor blade; do not cut too far, but take care to maintain the angle of the cut.

6 the matted print

The matted print—like this scene taken in Montreal at Expo '67 by Michael Rougier—should be handled by the edges so as not to mar the borders. It is ready to be displayed as is, or may be framed as shown on the following pages.

A Custom Frame, Homemade

1 acid-free bond paper
2 picture-hanging wire
3 nail set
4 screw eyes
5 pencil
6 glass
7 corrugated cardboard
8 power drill
9 1/16-inch drill bit
10 tack hammer
11 Artgum eraser
12 1/2-inch wire brads
13 wood filler
14 contact cement
15 picture molding
16 corner clamps
17 mat knife
18 steel tape measure
19 wire cutter
20 miter box
21 backsaw
22 1-inch glued paper tape

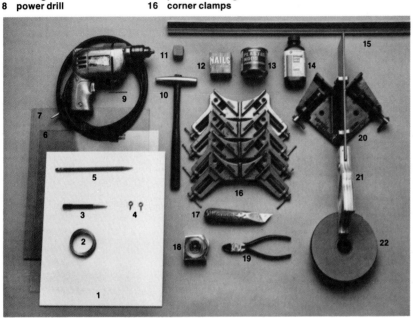

1 measure the mat

Using a tape measure, make a note of the precise horizontal and vertical dimensions of the mat around the print. The dimensions of the mat shown in the demonstration on the preceding pages are 13 3/8 x 10 3/4 inches.

2 figure the molding dimensions

Before cutting the molding, calculate the lengths of the pieces. They must be 1/8 inch longer than the mat dimensions to allow for the width of the mounting lip—cut along the inside of the molding —that holds the matted picture in the frame.

Putting a frame around a picture is a logical last step in preparing it for display—a step often forgone because of the expense of commercial framing and the apparent difficulty of doing the job oneself. Yet a wooden frame is fairly simple to make if the proper tools are available. (Other types of frames are shown on pages 146-149.)

The principal difficulty in constructing a wooden frame is ensuring that it will have square corners, which require cuts of exactly 45° at the ends of each piece of molding. Essential for making such accurate cuts is a miter box, a device that not only holds the wood in the right position to be sawed but also holds the saw—a special stiff type called a backsaw—at a specific angle in relation to the wood. An ordinary carpenter's miter box will serve, but not all such boxes are sufficiently ac-

curate for frame work. Much more precise is the special miter box displayed above, which is constructed for frame making and makes all cuts at exactly 45°; when two pieces of molding that have been cut with this tool are joined, they form a 90° angle, guaranteeing a neat and perfectly matched corner.

The framer's miter box and other necessary tools are standard items carried by art supply and hardware stores. Picture molding, which is made with a lip to hold the print in the frame, is sold by the foot in lumberyards; it is available in numerous designs. When buying molding, make a rough estimate of the amount needed, and buy a few extra feet to allow for mistakes in cutting. A hardware store or a glazier can cut a piece of glass that will fit the inside lip measurement of the finished frame.

3 cut the first end

Before transferring the measurements to the molding, clamp the piece tightly, front side up, in the miter box. Use the backsaw to make the first miter cut a few inches in from the end, being sure the mounting lip faces the handle of the saw.

4 measure and mark the molding

With a pencil, make a clear, straight line on the lipped underside of the molding, at right angles to its edge, at the inner end of the mitered cut. From the first pencil mark, measure and mark off the length for cutting the first piece.

5 cut the second end

Having measured and marked the molding, make the other miter cut in the first piece; then proceed in the same fashion for the remaining pieces. Be sure the cuts in each piece angle in opposite — rather than parallel — directions.

6 glue the ends

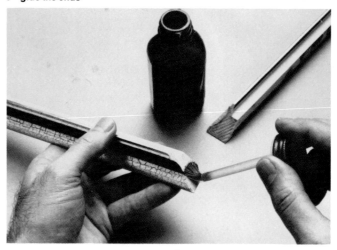

Use the applicator in the cap of the cement jar to brush cement on all eight mitered corners; if the wood seems to be absorbing the cement, add a little more. Let the cement set for a few minutes before joining the pieces together

7 put the frame in the clamps

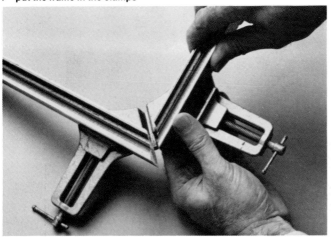

Before pressing the glued ends together, place the strips of molding in the corner clamps. Then slide them together so that the ends are in firm contact with each other, and tighten the clamps enough to hold the corners but not dent the wood.

8 bore holes for the brads

When the corners are braced in the clamps, bore two 1/16-inch holes 1/4 inch from one side of each corner. One hole should be drilled perpendicular to the molding, the other at an oblique angle across the grain, as shown above.

9 nail the corners

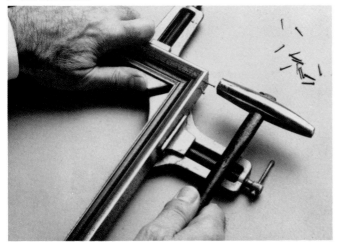

With the tack hammer, drive wire brads into the drilled holes. Hammer gently, using repeated light taps, to avoid jarring the molding pieces out of alignment. Take care not to bruise the molding's finish with the hammer head.

10 countersink the brads

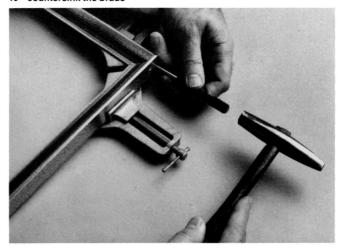

Using the nail set and tack hammer, countersink each of the brads about 1/8 inch into the wood. Take care not to sink them so far that they protrude from the other side of the molding. Tap the nail set gently so that it will not mar the molding.

11 fill the countersunk holes

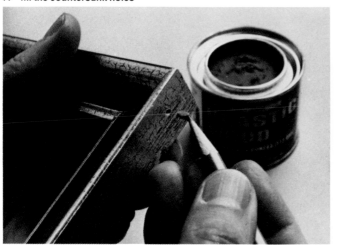

With a pencil point, force tiny blobs of wood-filler compound into each of the recessions made by the nail set. After the holes are filled and any excess filler is smoothed away with a thumbnail, the indentations will be virtually invisible.

12 secure the print in the frame

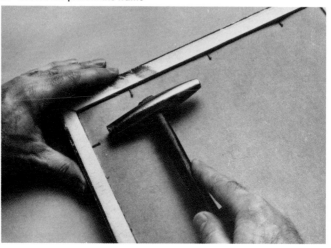

Remove the clamps, turn the frame face down and insert the glass, the matted print, a sheet of acid-free bond paper and corrugated board—in that order—all cut to the mat's dimensions. To secure them, drive brads partway into the rim of the frame back.

13 seal the back of the frame

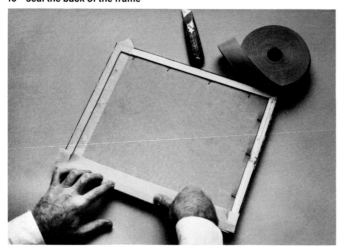

The print can be protected from dust and humidity by sealing the back of the frame with strips of moistened paper tape. For a tight, bulge-free seal, notch the strips at the corners to form a V, and press the edges of the V down firmly.

14 prepare the frame for hanging

To hang the framed print, screw two eye hooks into the frame back about two inches down from the top of each side piece; string picture wire between the hooks and twist its ends tightly so it will not slip loose under the frame's weight.

A Wide Choice of Ready-made Frames

Frames appropriate to their images hold the six ▶
photographs at right: austere aluminum for a
room interior and silhouetted trees; a wood
frame for a wooden fence and house; and clear
plastic for three pictures of people—two elderly
women, a dancer with his children, and a nun

Choosing the right frame for a picture may be a vexing problem, if only because of the diversity of ready-made and precut frames available. But a few simple criteria can make picking out an appropriate frame easier than it might seem.

The first rule for the shopper is so elementary that many people ignore it, to their regret: Carry the picture with you to the shop so that it can be seen in several frames. This precaution prevents the purchase of an incorrect size and it also guards against an esthetic mistake. The style of frame should suit the picture—a stark, angular image generally looks best in a simple rectangular frame, a rounded image in a curved frame—and the frame should not dominate the image.

Aluminum frames that have been precut are an increasingly popular solution to the framing problem. Easy to assemble with a screwdriver, the frames come in silver or gold—to complement black-and-white or color photographs—and in lengths ranging from eight to 40 inches. Moreover, the acid-free aluminum is excellent for archival display.

Each of the four traditional frames at right was selected to complement a black-and-white portrait. The clean line of a woman's profile (near right) is simply enhanced by a severe silver frame, and a period uniform and mustache are lightheartedly displayed in an antique frame of gilt filigree. Two ovals at top and bottom, one baroque, the other unadorned, frame a portrait of grandparents and the face of a girl.

◄ Five color portraits, displayed in diverse standing frames, adorn a polished dresser top. The four contemporary, painted ceramic frames in the foreground rest in miniature brass easels. At the rear, beveled glass topped with filigree sets off the old-fashioned elegance of the photograph.

Made of crystal-clear Lucite, two geometric shapes — a cube and a trefoil — provide a compact tabletop display gallery for a dozen colored photographs. A mirror hanging on the wall behind the table reflects the rear images so that eight of the 12 pictures are visible at a single glance.

Pictures in Plastic for Close-Up Enjoyment

As a rule, valuable photographic prints, like other graphic artworks, carry an invisible HANDS OFF sign. But if they are coated on front and back with hard plastic, they can be passed from hand to hand without risk of damage from thumbprints or scratches.

In the coating process, called lamination, the print is placed between two sheets of Mylar, a clear plastic. The print-and-plastic sandwich is placed in a heat press and heated to 250° F. The plastic melts into the fibers of the print; when it cools, it hardens to make a tough, protective coating on both sides and around the edges of the picture.

Lamination must be done by a professional; but the cost of laminating an 8 x 10 print is about five dollars, and for one as large as 21 x 25 inches, the price is well under $20. Any type of unmounted print, in color or black and white, can be laminated if it is in good condition.

Lamination is a permanent process; once a picture is coated, the plastic cannot be removed. But the technique is ideal for displaying pictures informally on a desk or tabletop where they may be picked up frequently and examined with no more than the ordinary care required in handling a book.

Permanently protected by clear laminated plastic, three enlarged scenic views lie on a coffee table. Such laminated photographs are virtually immune to most damage, and are handsome, highly accessible displays in the bargain.

The New Family Album

The shabby, crumbling family albums of childhood memory are a thing of the past. Contemporary photographers —more conscious of the fragility of their photographs, as well as of the casual treatment they are likely to get at the hands of both children and adults —have found better ways of exhibiting family pictures. On these pages are original, handmade display methods; but there are many commercial albums to choose from *(pages 154-155)* —more protective of pictures, easier to use and priced from a few dollars to nearly $100.

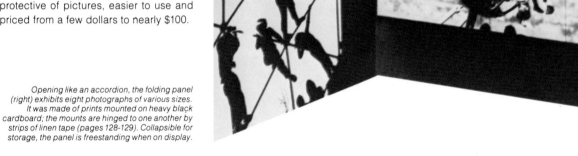

Opening like an accordion, the folding panel (right) exhibits eight photographs of various sizes. It was made of prints mounted on heavy black cardboard; the mounts are hinged to one another by strips of linen tape (pages 128-129). Collapsible for storage, the panel is freestanding when on display.

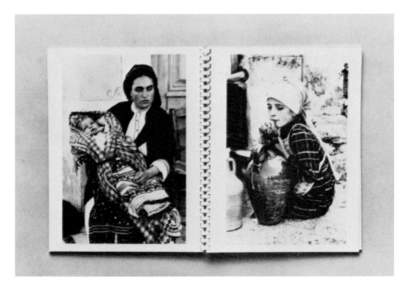

A selection of mounted prints —taken during a photographer's trip to Greece —are plastic-bound to make a book. Though the binding must be done by a commercial bindery, the mounting can be done at home using the techniques demonstrated in the pictures on pages 130-138.

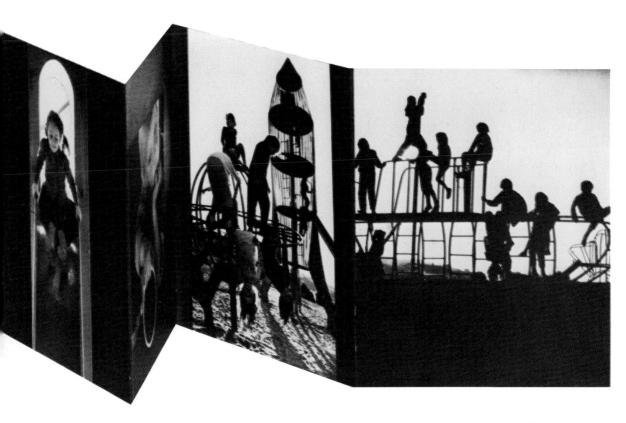

Contained in a handmade, hinged box (right), this portfolio of dry-mounted 3 x 5 prints was a gift from the photographer to his family. The portfolio stands upright, like a book in a bookcase, and was constructed to hold 14 photographs that were all taken during a summer trip abroad.

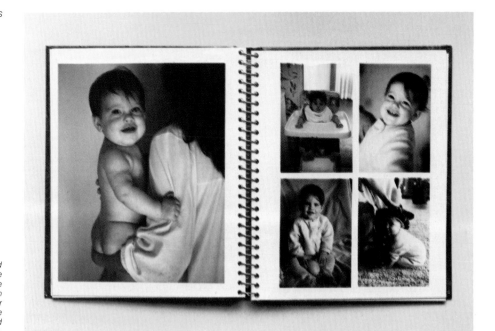

Dispensing with old-fashioned glues and mounting corners, many modern albums, like the one at right, hold a picture against a page embossed with adhesive-coated lines that also aid in positioning the print. A clear polyester cover sheet pressed over the page is gripped by the adhesive exposed around the picture and provides protection against fingerprints and dust.

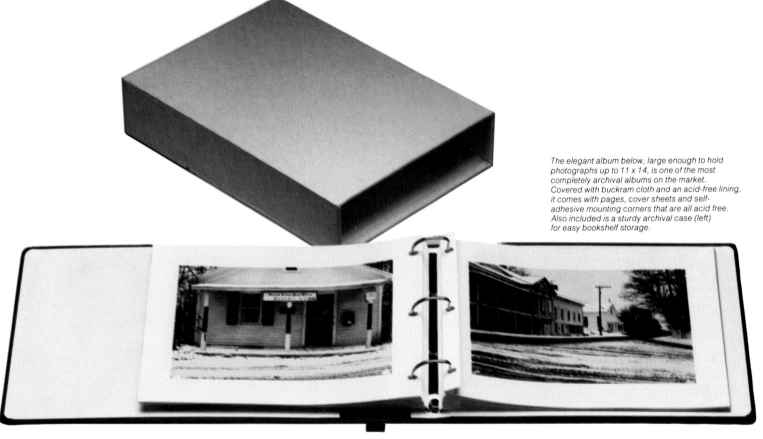

The elegant album below, large enough to hold photographs up to 11 x 14, is one of the most completely archival albums on the market. Covered with buckram cloth and an acid-free lining, it comes with pages, cover sheets and self-adhesive mounting corners that are all acid free. Also included is a sturdy archival case (left) for easy bookshelf storage.

The ingenious binder below, which opens into a free-standing easel and folds to a compact album, can hold as many as 35 paper inserts and their clear acetate covers. It comes in two sizes — 11 x 14 and 14 x 17 — and is made of stiff cardboard covered with leather-grained paper. Though not archival, the album is well suited for the temporary display of large photographs.

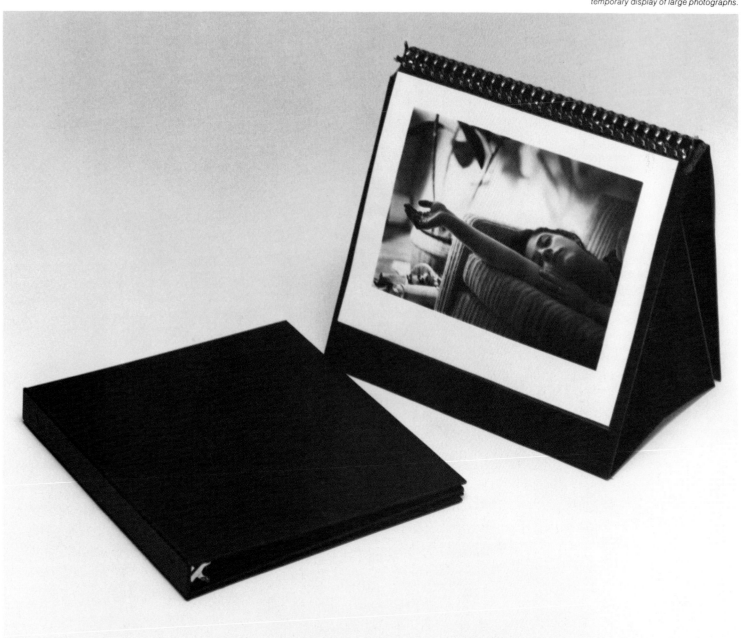

A Mural for the Home

The grandest of all photographic display techniques is the photomural—a single print enlarged to cover an entire wall. A mural can be the size of virtually any wall. Paper for black-and-white enlargements is sold in stock sheets 4 by 17 feet—for color enlargements, 40 inches by 12 feet. For an image larger than a single sheet, the print is made in sections and pieced together like wallpaper. Any black-and-white picture can be made into a mural, but the original must be extremely sharp to give a good image when it is greatly enlarged.

Making photomurals is generally left to commercial laboratories equipped with the necessary outsized enlargers and developing tanks. Many such labs, which charge $85 and up to prepare a small mural, use automated equipment to ensure that the separate pieces of a very large print will match precisely.

Mounting photomurals is also a job for professionals. A covering of linen is first attached to the wall with a compound resembling wallpaper paste. The mural is then pasted to the linen—from which it can be removed if the owner moves. A simpler method that also allows for removing the mural calls for wet mounting the prints on panels of stiff fiberboard. The panels are bolted to the wall—and can later be unbolted.

Enlarged to six by eight feet, a photomural of tree branches silhouetted against the silvery tones of a flooded meadow lends serenity to a game room in a Connecticut home. The huge enlargement was made from an extremely sharp 35mm negative.

Behind a wooden work counter, a photomural of
Japanese daisies gives the illusion of a window
opening on a fantastic world of giant flora.
Blown up 35 to 40 times their original size, the
exaggerated stems of the daisies possess
a luminosity that would be far less visible in a
print of conventional 8 x 10 or 11 x 14 size.

The Photographic Show **5**

ANDREAS FEININGER: *The Family of Man*, New York, 1955

Pictures Organized for an Audience

Slide shows and photographic exhibits are the theater of photography; acts of showmanship designed for an audience, they depend, like a successful movie or stage play, on the artful combination of single details to form a structured display, in this case through the combined effect of a group of pictures. There are no hard and fast rules for assembling a slide show or exhibit; the subject matter and the pictures available (and in the case of the exhibit, the size and shape of the display area) influence the way the material is handled. But there are methods for organizing both types of photographic show—steps in the process of choosing, arranging and emphasizing photographs that lead to successful productions.

First, the organizer should find a theme easily grasped by the viewer—a thread that links the pictures together. It can be as broad as the collected work of a camera club's members, or as individual as the slides taken on a family trip; but every picture must support the theme, and at the same time enhance and be enhanced by its neighbors. This calls for ruthless editing, and the constant exercise of judgment and purpose. If a single picture makes a firm point, it is usually advisable to eliminate similar pictures, however fine, that might be repetitive; on the other hand, deliberate repetition can be used to build suspense. The pictures can be combined in ways that create surprise, arouse emotion or tell a story, and the pace—the variation of movement and feeling—quickened and slowed as the organizer intends.

Of the two methods of showing photographs, the slide show is the more theatrical; in fact, the steps involved in setting up a slide-show presentation are the same as those involved in making a movie. Both, of course, are shown on a screen. The slide sequence, however, is highly concentrated; it must make its point quickly, without benefit of movement or dialogue, and therefore every image must count. But, like a movie, it must have continuity: a beginning that introduces the subject, a middle part that enlarges upon it, and an ending that concludes the sequence. Slide shows tend to be documentary—the story of a vacation or the chronicle of a child's development. But they can also be galleries illustrating high points in a photographer's pursuit of a particular interest—shooting action-sports pictures, observing flowers—or even a record of the photographer's growing skill with the camera. Though it can be fun to assemble the pictures in a way that tells a story, no plot is necessary; but there must be a reasonable progression. When assembling a sequence it is best to begin with an easily comprehended, overall shot that introduces the subject and establishes the scene for the viewer. For an added touch of sophistication, this establishing shot can be turned into a title slide *(pages 106-107)*.

Begin by scanning the slides and discarding those that do not relate to the sequence and those that seem otherwise unusable. Next, arrange them in

some kind of order. This may be chronological at first, but experiment may prove that another organizing pattern, such as flashback, is better. For changes of pace, alternate action shots with more tranquil pictures, and move in and out from long shots to close-ups. Run the show through the projector, rearranging the sequence until it seems both logical and varied. If the sequence involves two themes—if, for example, the action shifts from children playing in the backyard to a supper scene in the kitchen—try to separate the two situations with a transition picture; a shot of the back door might work or a picture of someone in the kitchen window holding up a pie. With experience comes the confidence and technique to visualize slide sequences and write shooting scripts.

Mastering the available technology is also important. A synchronized tape recording of narration, music and even sound effects can add greatly to the show, as can a projector that dissolves one image into the next *(page 165)*.

The rules for a photographic exhibition are somewhat different from those used in a slide show. Projected slides are seen briefly and consecutively, and the show's theme must be strongly conveyed if the audience is to grasp its point. In the exhibition, viewers travel at their own pace, free to study individual photographs as long as they wish, to compare pictures with one another, and to draw their own conclusions. The structure can be more flexible; a show needs no stronger theme than a standard of excellence. But in an exhibit with such a diffuse theme as a year's pictures from the local camera club, certain groupings of pictures by subject will suggest themselves. Even the massive Family of Man show *(pages 170-184),* in which every picture contributed to the overall concept of brotherhood, was broken into categories—sub-themes based on aspects of life, such as motherhood, work, and the joys of play.

Apart from picture selection, putting an exhibit together means solving a series of design problems, a process best begun in sketches. Start by arranging pictures in basic juxtapositions—contrasting verticals with horizontals, dark tones with light, large shapes with small ones. Then decide which pictures to emphasize by enlargement and which to print small. Finally, work out a system of placement—levels at which photographs are displayed—that suits the individual pictures and their groupings, and pulls the entire show together.

The grouping on page 180, captioned "Eat bread and salt and speak the truth," illustrates these principles; the larger-than-life panel of growing wheat, placed so that it seems to spring from the ground, states the theme of this segment: the staff of life. The next large photograph, showing people at a meal, elaborates the theme, and the smaller pictures hung at many levels act as counterpoint—staccato notes that recapitulate the concept.

Showing Transparencies at Home

A professional producer of audiovisual shows peers intently through the open doors of his multipurpose storage and projection cabinet to check the focus of one of six projectors he will use for a presentation. The custom-built cabinet contains all the slide-show equipment except the screen, which is hung from ceiling hooks on the opposite wall and can be rolled up when not in use.

Permanently installed equipment contributes greatly to the enjoyment of showing slides, eliminating the bother of assembling the components for a show and providing neat storage for slides, tapes and other necessities. The professional installation shown on the opposite page, with its 12 projectors, six control units and a four-track tape recorder—much of the equipment custom-made—may be more elaborate than the set-up most photographers would find necessary. But it demonstrates how audiovisual paraphernalia can be arranged so compactly that any large living room or game room can do double duty as a theater.

One item that can transform a run-of-the-mill presentation into a smoothly sophisticated show is a slide dissolver. With a single projector, even the most carefully conceived show remains a string of individual images, separated by distracting moments of blank screen and the monotonous click of the slide tray's turning. However, with two projectors and a dissolve unit to program them *(diagram, right),* the images on the screen fade into one another with a rhythmic continuity that makes even a novice look like a pro.

Not much bigger than a paperback book, a dissolver may weigh as little as one and a half pounds. Thanks to a built-in microcomputer, a number of special effects are possible, from the programing of a sound track to the rapid alternation of two slides to create animation effects.

One image on the screen (top right) fades out and another fades in as the slide dissolver varies the intensity of the lamps in two projectors (right). Advancing the two slide trays alternately, the unit controls the speed, or dissolve rate, of each transition to produce a continuous flow of images. With a stereo tape recorder attached, the dissolver can record a program while it is being run manually, then repeat it for later shows. One channel of the tape may be used for sound effects, the other for electromagnetically coded dissolver commands.

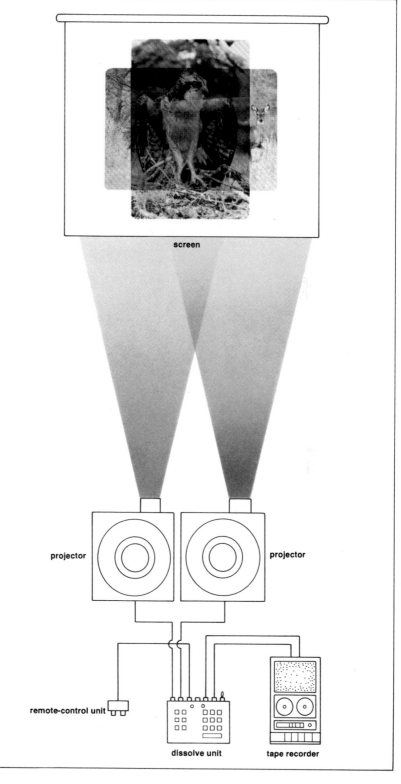

screen

projector

projector

remote-control unit

dissolve unit

tape recorder

165

Tailoring a Title Slide

Title slides add a skillful touch to a home slide show, setting the stage for the images to come. Depending on the type of show, the slides may be simple letters on a plain background or a sophisticated composite of letters and a scenic view.

Three methods of making title slides are shown here; all start with press-type letters *(right).* The easiest method *(below)* uses only basic studio equipment —a camera and lights. For the double-exposure method *(opposite, top),* however, a slide-duplicating device with a focusing bellows and a copying adapter is needed; a camera that has a multiple-exposure lever is also useful. This method and the sandwich method *(opposite, bottom)* require background slides dark or light enough to set off the letters clearly; the background images should also be arresting—but not so arresting that the title itself is overwhelmed.

black-background method

1 *The tools of the title maker's art include a pencil and straight edge for drawing guidelines, an eraser, a sheet of press type and an acrylic, wood or hard-rubber burnisher for transferring the letters from the carrier sheet to the board.*

2 *Position each letter on the guidelines penciled on a sheet of white illustration board and rub lightly and evenly with the burnisher. Press-type numbers and letters are made in a variety of styles suitable for different moods and subjects.*

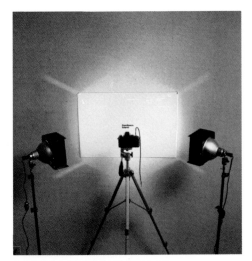

3 *With the camera back set parallel to the board, position two tungsten quartz lamps at 45° angles to the board (pages 26-27). The board must be uniformly illuminated over its entire surface to avoid light and dark patches in the final slide.*

4 *Photograph the title with high-contrast black-and-white film. Use an 18 per cent gray card to determine the exposure setting; otherwise, the dominance of the white background will cause the light meter to indicate the wrong setting.*

5 *When the film is developed—using materials suitable to high-contrast film—the result is a white-on-black negative. The negative may be used as is (above) or may be used to make a composite title slide, as shown at the top of the opposite page.*

double-exposure method

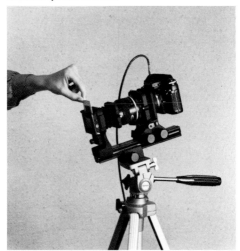

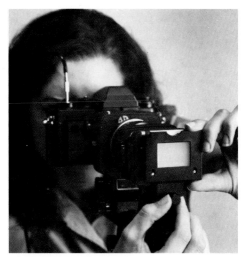

1 Insert the background slide (top) in the copying adapter and make an exposure using color dupe film and appropriate filtration. Push the multiple-exposure lever, cock the shutter without advancing the film, and remove the slide.

2 Keeping the background slide in mind, insert a plain title slide (opposite page) and use the bellows and shifts to manipulate the size and position of the letters against the imagined background. Make the exposure with setting and filtration as before.

3 In the finished slide, the letters have been positioned to clear the treetops and occupy an uncluttered portion of the background image. This method can only be used to make title slides with white letters on dark background slides.

sandwich method

 +

1 Make a title board as shown in Steps 1 and 2 on the opposite page, and set it up as a projection screen. Project a light background slide onto the title board and manipulate the image until the letters and the background form a pleasing composition.

2 Mark the outlines of the projected image, staying just outside the borders of the picture. Switch off the projector and photograph the letters as in Step 3, opposite page, using tungsten color slide film and framing the shot with the guidelines.

3 The resulting transparency has black letters on a clear background (above, left), and can be sandwiched with the background slide in a single mount. This method is used only to make title slides with black letters on a light background.

Varying the Pace

A successful slide show is first of all a show: a concentrated presentation that combines separate pictures to tell a story or explore a subject. Like any show, it must hold the attention of its audience by conveying an idea in an appealing manner, and the techniques for doing so are those that apply to other media—from lecture hall to television screen.

Each slide show will have its own character, but certain organizing principles apply universally. From a well-defined introductory shot to a climactic finish, the slides must move with a sense of continuity. Often, a large or complex subject will need to be broken down into short sequences or subsections. Each sequence should be a self-contained unit dealing with a distinct subtopic, and slides within each subsection must progress logically. At the same time, the subsections must support each other, and smooth transitions between them are essential.

Perhaps most important in keeping the audience's attention is the pacing of the show. If all the slides are long shots or too many are of the same subject, the show will seem plodding. Dissolve units *(page 165)* can help create the illusion of movement, but the slides themselves must be organized effectively. The sample slide show at right—assembled from 15 pictures of Gardiners Island, New York, taken by Alfred Eisenstaedt—demonstrates this principle. The show moves from long shots to close-ups, from exterior to interior, from wilderness to civilization. There is also a marked change in mood, from the bracing outdoor feeling of the opening scenes to the eeriness of the last three shots. Finally, the 15 images might take 10 minutes to project, illustrating one of the most important rules for a successful slide show: Keep it short. □

1 *An aerial view of Gardiners Island establishes the show's geographical and subjective boundaries. Given to the Gardiner family in 1639 by Charles I, the island sits between the flukes of Long Island.*

2 *The second shot takes the viewer down to earth, to a silvery inland pond where the unspoiled natural beauty of the island is established and the first wildlife—a pair of egrets—is glimpsed.*

6 *Two startled does—part of a large herd that has been regularly hunted to prevent overgrazing and starvation—serve as a transition here, alluding to the human presence on the island before it is shown.*

7 *The transition continues with wild turkeys in morning mist, conjuring up hunting parties of mainlanders invited to the island by the Gardiners. One guest at such outings was Ernest Hemingway.*

11 *A close-up of pirate booty ends a sequence—from the whole house to one room to a specific treasure—that echoes the movement of the opening slides and introduces the island's bloody past.*

12 *Back outdoors again and getting ready for the closing sequence: The sails of this 18th Century windmill, when tilted a certain way, warned that unfriendly buccaneers were in the vicinity.*

3 After two introductory long shots, a close-up offers a change of pace and calls attention to the island's wealth of plant life. The grace of ordinary marsh grass sets up more unusual beauty to come.

4 Rare ospreys, their six-foot wingspans extended in flight, provide a sample of nature's handiwork and give the slide show its first dynamic action shot after a rather hushed introductory sequence.

5 Normally it is best to avoid consecutive shots of the same subject, but this close-up of an osprey — poised and alert on its nest — gives the first half of the show a dramatic visual high point.

8 When the hunters themselves finally appear — in another misty shot that marks the midpoint of the show — the stage is set for the next subsection, which will deal with the island's human history.

9 The Gardiner family's estate — the only English royal manorial grant in the New World that is still intact — includes an impressive house. This exterior shot moves the show from outdoors to indoors.

10 From the natural world that figured in most of the slides thus far, the viewer is brought into the domain of manmade objects and human intercourse — the hearth where hunters once swapped ghost stories.

13 The story now shifts from piracy to witchcraft. Near this tidal pool, Gaylor's Hole, stood the cottage of Goodwife Garlick, who in 1657 was accused by one of the Gardiner daughters of being a witch.

14 Capping the eerie theme: a gnarled tree where slaves once were hanged. Founder Lion Gardiner was said to be of "sterling character," but his descendants did not always live up to his example.

15 For the crucial closing slide, a shot of the caretaker's house through the haze returns the viewer to the present — without losing the spooky sense of the past crafted in the preceding pictures.

A Landmark Exhibit

One of the greatest photographic shows ever mounted was "The Family of Man"—503 pictures occupying some 8,000 feet of wall space in New York's Museum of Modern Art. Planned and executed by Edward Steichen, one of the giants of modern photography, the exhibit opened on January 26, 1955. Apart from its size and complexity, The Family of Man owed its greatness to its broad-based theme—embodied in striking photographs depicting the breadth of human experience between birth and death and solidly rooted in Steichen's conviction that all men are brothers.

It is not likely that any private exhibitor or many public ones will ever emulate the example set by The Family of Man—if only because few could set aside two years, employ a trained staff of five, find the necessary cash (about $111,000 in 1954 dollars), root out thousands of picture sources, and have available a whole museum floor for display space. All were available to Steichen. However, because The Family of Man was so meticulously conceived, designed and mounted, it demonstrates every organizational step and presents every display opportunity that could conceivably arise in designing any show.

Steichen began by selecting his theme, which he derived from his belief that photography is a wonderfully effective language for explaining man to man. Then he issued a worldwide appeal for 8 x 10 black-and-white rough prints. Photographers were only too happy to respond, and more than two million entries deluged the museum.

Few exhibitors are likely to be embarrassed by such pictorial riches, but the basic sorting technique developed by Steichen and his staff was extremely workable—a good system for anyone. At the outset, all pictures were placed in one of three groups: "very good," "possible" and "unsuitable." The best were placed in subject folders arranged according to the logic of the theme. Copious notes were made on each picture—how it was taken, when and where—and each was also listed by photographer in a card file. The pictures were endlessly studied and compared; at the end of a year, they had been culled to a workable 10,000.

With the picture possibilities reduced to a manageable number, and the groupings, such as "children at play" and "women working," more or less defined, Steichen and his staff began pinning the pictures to the wall, juxtaposing them in various combinations. This process helped to determine which pictures worked well together, and refined the choice even further.

During the final sorting and selection, Steichen and his staff began thinking seriously about the size each picture should be. Several factors were considered: what size best suited a picture, how the dimensions affected its relationship to its neighbors, and how the size influenced its contribution to the overall pace and variety of the show. These are complex decisions that

depend largely on taste; the creators of The Family of Man, however, relied heavily on such simple rules as avoiding overwhelming a few small pictures with many large ones. With assistance from architect Paul Rudolph, Steichen also used sketches of the display space, with scale drawings of photographs, to attack these problems; the worst mistakes were thus confined to paper. Sketches of wall space were supplemented by a floor plan, which made possible the arrangement of photographs so that the viewer would come upon them in the proper order; every display area, even a large square room, has a natural traffic flow. In the final planning stage, the Family of Man staff found an architectural model a necessity; the design was too complicated to risk making all decisions from sketches and blueprints.

Once it had been planned on a small scale, the exhibit was ready to be put together, with the prints prepared and mounted in actual size. Steichen and the museum staff knew that it is best to have all the pictures mounted in the same fashion — all framed, or all matted: This helps relate the parts of the exhibit to each other, even when their sizes and physical surroundings are diverse. The Family of Man pictures ranged from a 5 x 7 print to giant murals covering entire walls, but since all the prints were displayed without borders, the exhibit had an appearance of uniformity.

Almost all exhibitions require captions: Steichen felt that quotations from world folk culture would reinforce the Family of Man theme.

Hanging the exhibit was the final stage, and all the steps went as planned; there were few last-minute changes. In the hurried moments before the show opened, however, Steichen's assistant Wayne Miller, acting on a belated impulse, hung about 25 copies — some large, some tiny — of a print that showed a happy boy playing the flute. Spotted at random throughout the show, the picture added a joyful, repeated grace note to the entire exhibit.

Questions of Choice

Edward Steichen had a vision of what he wanted The Family of Man to be—it would force the viewer to recognize his own kinship with all mankind—and to achieve that end he chose a journalistic approach. Each section would be as self-contained as a magazine story, yet together all of the sections would reinforce the message of brotherhood. Large pictures would form the exhibit's backbone; smaller ones would amplify points or emphasize moods. The herculean task of sorting and evaluating the 10,000 pictures that were considered for the exhibit was done in a large, unheated loft over a honky-tonk club; when the staff worked late into the night, musical thumps from below enlivened their task.

As Steichen (rear, center) and his staff choose from a group of photographs pinned up for evaluation, a visitor riffles through other pictures in category folders. Outside opinions were welcomed—though not necessarily heeded.

Lying on the floor for a close look, Steichen studies a group of candidates carefully—as he did with each strong possibility. The picture of children running, at Steichen's right elbow, weathered his scrutiny and appeared in the exhibit.

Blueprint for a Traffic Pattern

In the planning of The Family of Man, the related processes of selection and positioning of pictures in groups went on until the show opened. These processes were continually being refined. Three months before the opening, Steichen called in architect Paul Rudolph to draw the floor plan shown on the opposite page—a crucial step in determining the overall arrangement of pictures. To give the show pace and rhythm, Steichen and Rudolph wanted to be sure that people saw the pictures in a certain order—large, keynote pictures alternating with contemplative images, sorrowful subjects interspersed with lighthearted ones. The two men sketched and resketched until they had a blueprint that matched natural traffic flow to the structure of the exhibit. The blueprint also provided for the use of existing wall space as well as for the construction of supplementary panels—which not only increased the available display area but also functioned as conduits for the flow of traffic.

As assistant Wayne Miller looks on, Steichen examines architect Paul Rudolph's preliminary sketch for the layout of the show (a close-up of the sketch and their hands appears at right). As the pictures were selected, Kathleen Haven tested them in various positions on a panel.

In architect Rudolph's sketch, arrows indicate planned traffic flow. The viewing areas were arranged to vary the pace, emphasize certain points or create a mood for the viewer.

Uses of a Model

Indispensable though they were, the floor plans and sketches of the physical layout for The Family of Man by no means completed its planning stages. A project of such complexity demanded a reduced scale model so that the planners could see a small but full version of the show. When Steichen and Rudolph were satisfied with the preliminary drawings, Rudolph built the model of heavy cardboard and wood on a rigid fiberboard base.

In this miniature laboratory, Steichen tested his arrangements of pictures. The photographs were reduced proportionately and positioned in the model; Steichen could then see the pictures juxtaposed in relative size. When adjustments were called for, the pictures could be repositioned and altered in size; entire panels could be moved around to establish new relationships among groups of pictures. Finally, operating on the principle that most of the keynote pictures should be placed close to eye level, and using a movable paper sculpture of a man scaled to average height, Steichen was able to determine how the level of a picture in its group might affect the viewer.

Scrutinizing the half-constructed model, Steichen stoops for an eye-level view before positioning scaled pictures. Wayne Miller (standing) checks the overall appearance of the model; meanwhile architect Rudolph works at the drawing board.

Like a modern Gulliver surveying his wood-and-cardboard Lilliput, Steichen moves a scaled paper puppet around in the model. By marching it around the miniature exhibit he ensured that all the pictures were placed at a good viewing angle. ▶

Poetry for Big Prints

"A camera testament, a drama of the grand canyon of humanity, an epic woven of fun, humor and holiness—here is the Family of Man!" This final sentence of Carl Sandburg's introduction for the show was only part of the concerted effort to find words to go with the photographs. Once the basic groupings had been decided on, three museum staff members spent months sifting through quotations drawn from the wisdom of the world's peoples. The blend of eras and cultures was often highly effective. For example, an array of photographs depicting poverty in the 20th Century—American sharecroppers and an English tramp—was captioned with a quotation from the First Century B.C. Latin poet Vergil: "What region of the earth is not full of our calamities?"

Steichen, meanwhile, went on to the printing and mounting of the pictures. The format he chose was both simple and elegant: For uniformity and ease in hanging, all the prints, large and small, were mounted without borders. With meticulous attention to the model and floor plan, workmen then constructed panels to supplement existing wall space and help direct viewers through the exhibit.

With pictures mounted and captions written, the show was ready to be installed. This final process was the first chance to see the real thing—and the last chance to make minor corrections.

Shown at the typewriter, poet Carl Sandburg, Steichen's brother-in-law and lifelong friend, helped him choose captions from the material provided by the museum staff. The captions—quotations drawn from the world's religions, literature and folklore—guided the visitor through the exhibit, underscoring the show's message as stated by Sandburg: "I am not a stranger here."

A technician at the laboratory that printed and
mounted The Family of Man checks a strip of print for
flaws before gluing it to a fiberboard panel. This
photograph of workers at a dam in India was so large
it had to be mounted in three sections.

The theme of the grouping at left, the ritual of daily bread, is stated by the vertical panel of wheat, seemingly growing up through the floor — and reinforced by its caption, a Russian proverb: *Eat Bread and Salt and Speak the Truth.* All the other photographs in the group enlarge upon the subject. In order to move the viewer's eye, Steichen contrasted verticals and horizontals, large and small panels, and a variety of levels.

1

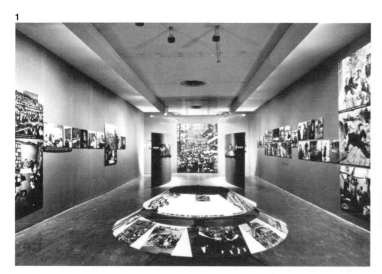

2

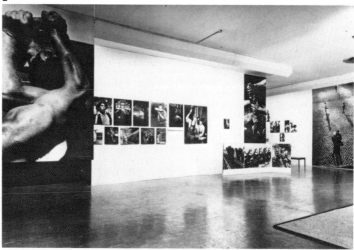

3

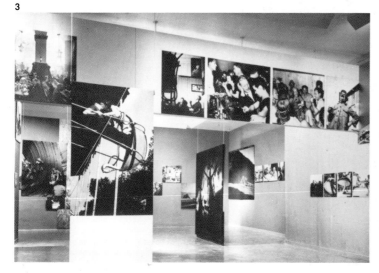

4

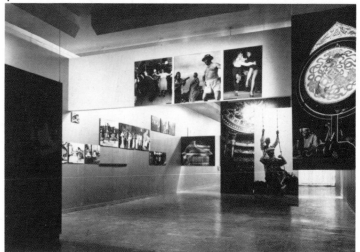

Often the subject suggested the appropriate display technique: Children's round games (1) are similar the world over, and the carrousel-like frame reinforces the theme. An enormously enlarged arm (2), symbolizing man's strength, introduces a section devoted to labor. The pictures of swings and people swinging (3 and 4) are opposite sides of one panel; the panel itself swung to and fro.

"The Family of Man" around the World

The Family of Man opened at The Museum of Modern Art in January 1955. Public response was overwhelming; by the time the exhibit closed in New York in May, 270,000 visitors had seen it.

The show had also been widely reported all over the world; and in response to the demand created by its publicity, The Family of Man, packed in custom-made felt-lined cases, went on the road in June. The show proved highly adaptable to almost any gallery space. Elevations and scale drawings were sent to exhibitors, along with extremely detailed instructions for installation. But the museum made it clear that each exhibitor was free to set up the show in the manner best suited to his gallery space and individual taste, so long as the thematic scheme and overall visual effect remained true to Steichen and Rudolph's original design.

Both full-scale and small-scale copies of the show were circulated; the reduced versions contained only 115 panels compared with the full show's 503, but all the photographs were included. In one version or another The Family of Man was exhibited in the United States until 1959.

During the same years, and in fact until 1963, other versions — and eventually the original — were shown in Europe, South America, Africa and Asia under the sponsorship of the U.S. Information Agency. Foreign exhibitors were given the same free hand to adapt the show as were exhibitors in the United States. The original version was badly damaged during an uprising in Beirut in 1958, and subsequently had to be junked; but in 1975 — two years after Steichen's death — a full-scale copy was permanently installed in Luxembourg, his birthplace.

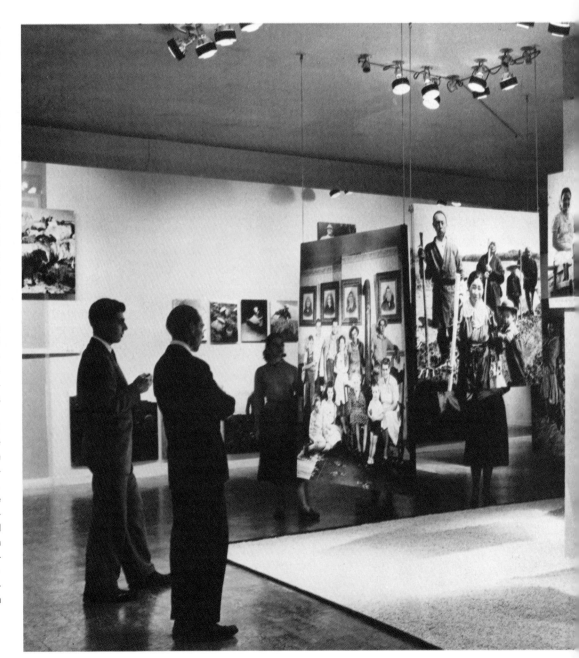

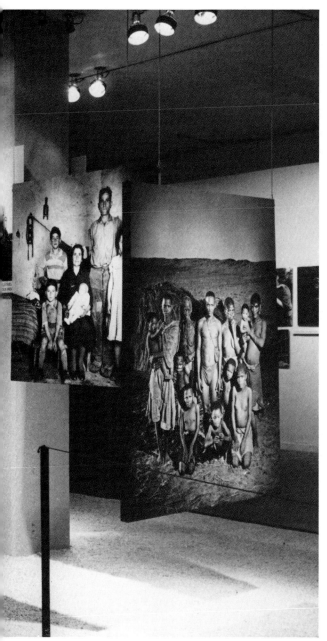

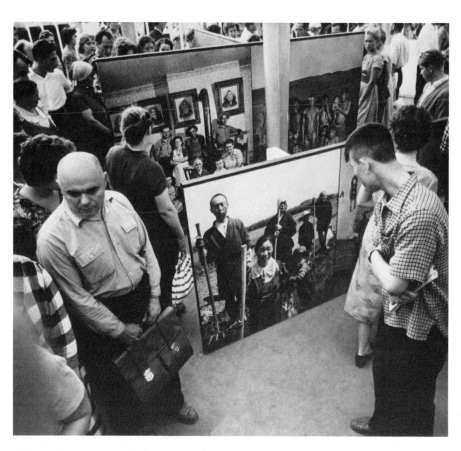

In Moscow (above) viewers see the family group from close up — the arrangement that was best suited to available display space when the show traveled to Russia in 1959 under United States government auspices. Though thematic groups remained intact, exhibitors everywhere were allowed great flexibility in arranging pictures. The picture of the Japanese family rested on the floor in Moscow — though it had originally been hung at eye level in the New York show.

◄ At New York's Museum of Modern Art, visitors contemplate the heart of the exhibit, the central family grouping. The public circulated freely around this installation, which was placed in a dramatic setting — a floor-level bed of gravel that also protected the pictures from being touched.

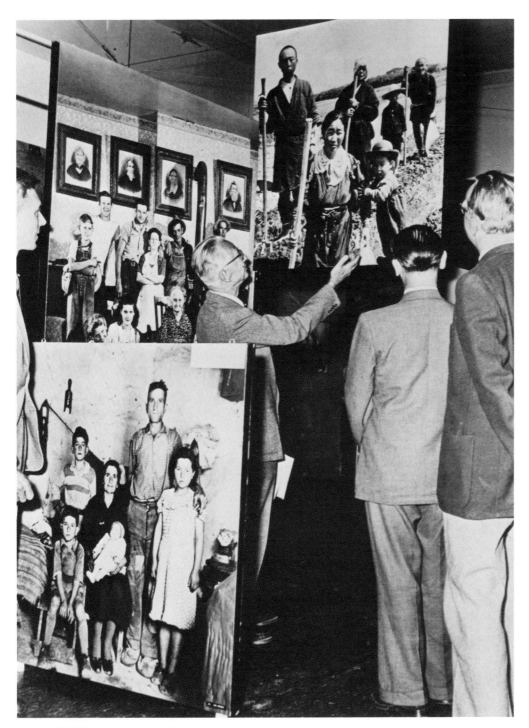

In Berlin in 1955, Steichen, who attended The
Family of Man there, points to a detail in the
Japanese family photograph — this time placed
well above the viewer's eye level in another
arrangement of the central group of pictures.

Bibliography

General

Focal Press Ltd., *The Focal Encyclopedia of Photography*. McGraw-Hill, 1969.
Morgan, Willard D., ed., *The Encyclopedia of Photography*. Greystone Press, 1967.

History

Eder, Josef Maria, *History of Photography*. Columbia University Press, 1945.
Friedman, Joseph S., *History of Color Photography*. Focal Press, 1968.
Gernsheim, Helmut, *Creative Photography: Aesthetic Trends 1839-1960*. Faber & Faber Ltd., 1962.
Gernsheim, Helmut and Alison:
 The History of Photography from the Camera Obscura to the Beginning of the Modern Era. McGraw-Hill, 1969.
 ***L.J.M. Daguerre: The History of the Diorama and the Daguerreotype.* Dover Publications, 1968.
Mees, C. E. Kenneth, *From Dry Plates to Ektachrome Film: A Story of Photographic Research*. Ziff-Davis, 1961.
Newhall, Beaumont:
 The Daguerreotype in America. New York Graphic Society, Ltd., 1968.
 The History of Photography from 1839 to the Present Day. Doubleday, 1964.
 †*Latent Image: The Discovery of Photography.* Doubleday, 1967.
Newhall, Beaumont, ed., *On Photography: A Source Book of Photo History in Fascimile*. Century House, 1956.
Pollack, Peter, *The Picture History of Photography from the Earliest Beginnings to the Present Day*. Harry N. Abrams, 1969.
Snelling, Henry H., *The History and Practice of the Art of Photography*. Morgan & Morgan, 1970.
Stenger, Erich, *The March of Photography*. Focal Press, 1958.
**Taft, Robert, *Photography and the American Scene: A Social History, 1839-1889*. Dover Publications, 1964.
Wall, E. J., *The History of Three-Color Photography*. American Photographic Publishing Co., 1925.

Photographic Art

Abbott, Berenice, *The World of Atget*. Horizon Press, 1964.
Friedlander, Lee, and John Szarkowski, *E. J. Bellocq: Storyville Portraits*. New York Graphic Society, Ltd., 1970.
Morgan, Murray, with photographs by E. A. Hegg, *One Man's Gold Rush: A Klondike Album*. University of Washington Press, 1967.
Newhall, Beaumont and Nancy, *Masters of Photography*. Bonanza Books, 1958.
†Steichen, Edward, *The Family of Man*. The Museum of Modern Art, 1955.
Talbot, William Henry Fox, *The Pencil of Nature*. Da Capo Press (facsimile edition), 1969.
Trottenberg, Arthur D., ed., *A Vision of Paris: The Photographs of Eugène Atget; The Words of Marcel Proust*. Macmillan, 1963.

Photographic Science

Eaton, George T., *Photographic Chemistry in Black-and-White and Color Photography*. Morgan & Morgan, 1965.
Freeman, Michael, *The 35MM Handbook*. Ziff-Davis Books, 1980.

James, T. H., and George C. Higgins, *Fundamentals of Photographic Theory*. Morgan & Morgan, 1968.
Mees, C. E. Kenneth, and T. H. James, *The Theory of the Photographic Process*. Macmillan, 1966.
Nebletté, C. B., *Photography: Its Materials and Processes*. D. Van Nostrand, 1962.
Pittaro, Ernest M., ed., *Photo-Lab-Index*. Morgan & Morgan, 1970.
Rhode, Robert B., and Floyd H. McCall, *Introduction to Photography*. Macmillan, 1971.
Spencer, D. A.:
 †*Color Photography in Practice.* Focal Press, 1966.
 Photography Today. Oxford University Press, 1955.
Thomson, C. Leslie, *Colour Films: The Technique of Working with Colour Materials*. Chilton, 1969.

Special Subjects

Adams, Ansel, *The Print*. Morgan & Morgan, 1967.
American National Standards Institute:
 **American National Standard Method for Comparing the Color Stabilities of Photographs, PH 1.42.* American National Standards Institute, Inc., 1969.
 **American National Standard Method for Evaluating the Processing of Black-and-White Photographic Papers with Respect to the Stability of the Resultant Image, PH 4.32.* American National Standards Institute, Inc., 1980.
 **American National Standard Practice for Storage of Processed Safety Photographic Film, PH 1.43.* American National Standards Institute, Inc., 1981.
 **American National Standard Requirements for Photographic Filing Enclosures for Storing Processed Photographic Films, Plates and Papers, PH 1.53.* American National Standards Institute, Inc., 1978.
 **American National Standard Specifications for Photographic Film for Archival Records, Silver-Gelatin Type, on Cellulose Ester Base, PH 1.28.* American National Standards Institute, Inc., 1981.
 **American National Standard Specifications for Photographic Film for Archival Records, Silver-Gelatin Type, on Polyester Base, PH 1.41.* American National Standards Institute, Inc., 1981.
Eastman Kodak:
 **Cementing Kodachrome and Ektachrome Transparencies to Glass, Pamphlet No. E-34.* Eastman Kodak, 1972.
 **Copying, Professional Data Book M-1.* Eastman Kodak, 1974.
 **Filing Negatives and Transparencies, Pamphlet No. P-12.* Eastman Kodak, 1967.
 **Kodak Color Films, Publication No. E-77.* Eastman Kodak, 1980.
 **Kodak Dye Transfer Process, Pamphlet No. E-80.* Eastman Kodak, 1980.
 **Mounting Slides in Glass, Pamphlet No. AE-36.* Eastman Kodak, 1971.
 **Notes on Tropical Photography, Publication No. C-24.* Eastman Kodak, 1970.
 **Preservation of Photographs, Pamphlet No. F-30.* Eastman Kodak, 1979.
 **Prevention and Removal of Fungus on Prints and Films, Pamphlet No. AE-22.* Eastman Kodak, 1980.

 **Processing Chemicals and Formulas for Black-and-White Photography,* Professional Data Book J-1. Eastman Kodak, 1977.
 **Retouching Black-and-White Negatives,* Pamphlet No. 0-10. Eastman Kodak, 1967.
 **Retouching Color Transparencies,* Pamphlet No. E-68. Eastman Kodak, 1968.
 †*Retouching Ektacolor Prints, Pamphlet No. E-70.* Eastman Kodak, 1981.
 **Stains on Negatives and Prints, Pamphlet No. J-18.* Eastman Kodak, 1952.
 **Storage and Care of Kodak Black-and-White Films in Rolls, Publication No. AF-7.* Eastman Kodak, 1969.
 Storage and Care of Kodak Color Materials, Pamphlet No. E-30. Eastman Kodak, 1980.
 **Storage and Preservation of Microfilms,* Pamphlet No. P-108. Eastman Kodak, 1965.
 **Storage of Microfilms, Sheet Films, and Prints,* Pamphlet No. F-11. Eastman Kodak, 1955.
Fritsche, Kurt, *Faults in Photography: Causes and Correctives*. Focal Press, 1968.
*Hertzberg, Robert E., *Photo Darkroom Guide*. Amphoto, 1967.
Ilfobrom Galerie, Pamphlet No. ILP-7905. Ilford Inc., 1979.
Towler, John, *The Silver Sunbeam*. Morgan & Morgan (facsimile edition), 1969.
Weinstein, Robert A. and Larry Booth, *Collection, Use and Care of Historical Photographs*. American Association for State and Local History, 1977.

Magazine Articles

Feldman, Larry H., "Discoloration of Black-and-White Photographic Prints." *Journal of Applied Photographic Engineering,* February 1981.
Foley, Michael, "Mounting Materials and Methods." *Photomethods,* February 1980.
Hendriks, Klaus B., "The Conservation of Photographic Materials." *Picturescope,* Spring 1982.
Ostroff, Eugene:
 "Early Fox Talbot Photographs and Restoration by Neutron Irradiation." *The Journal of Photographic Science,* 1965.
 "Preservation of Photographs." *The Photographic Journal,* October 1967.
Parsons, T. F., G. G. Gray, I. H. Crawford, "To RC or Not To RC." *Journal of Applied Photographic Engineering,* Spring 1979.
Schwalberg, Bob, "Color Preservation Update." *Popular Photography,* January 1982.
Tice, George A., "The Lost Art of Platinum." *Album,* December 1970.
Tuite, Robert J., "Image Stability in Color Photography." *Journal of Applied Photographic Engineering,* Fall 1979.
Vestal, David, "Process for Permanence." *Popular Photography,* March 1979.
Wilhelm, Henry:
 "Color Print Instability." *Modern Photography,* February 1979.
 "Storing Color Materials." *Industrial Photography,* October 1978.
Wilson, William K., "Record Papers and Their Preservation." *Chemistry,* March 1970.

†Also available in paperback.
*Available only in paperback.
**Also available in hardback.

Acknowledgments

The index for this book was prepared by Karla J. Knight. For their assistance in the preparation of this volume, the editors wish to thank the following: Carol Appelman, Nikon House, New York City; Dr. Charleton Bard, Eastman Kodak Company, Rochester, New York; Jeanne Beausoleil, Curator, Photothèque Cinémathèque Albert Kahn, Boulogne, France; Henri Bendel Inc., New York City; Martin Bennett, Lenco Products, Inc., New York City; Roloff Beny, Rome; Henry Beville, Annapolis, Maryland; Blondelle Frames, New York City; Lester Bogen, Bogen Photo Corporation, Englewood, New Jersey; Mr. and Mrs. Gerald Bouchard, South Glens Falls, New York; Peter C. Bunnell, The Museum of Modern Art, New York City; James O. Burns, Print File Inc., Schenectady, New York; Robert Cardinal, Alexandria, Virginia; Walter Clark, Pittsford, New York; Design Research, New York City; James L. Enyeart, The University of Kansas Museum of Art, Lawrence, Kansas; Evan Evans, Leatherhead, Surrey, England; Henry Fassbender, Eastman Kodak Company, Rochester, New York; John Ferguson, PMS, Sausalito, California; Al Freni, New York City; Marie Frost, The Museum of Modern Art, New York City; Jean-Paul Gandolfo, Responsable du Laboratoire, Photothèque Cinémathèque Albert Kahn, Boulogne, France; General Electric Housewares Division, Bridgeport, Connecticut; Gucci Shops Inc., New York City; David Haberstich, The National Museum of American History, Smithsonian Institution, Washington, D.C.; Harriet Hall, United States Information Agency, Washington, D.C.; Harrison Inn, Heritage Village, Southbury, Connecticut; Kathleen Haven, New York City; Robert Haymes, New York City; Robert Heaton, Fuller & d'Albert, Inc., Fairfax, Virginia; Richard W. Henn, Kodak Research Laboratories, Rochester, New York; Arvia Higgins, The Metropolitan Museum of Art, New York City; Hans Holzapfel, United States Information Agency, Bonn; Dennis Inch, Light Impressions, Rochester, New York; Ira Itkowitz, Royaltone Camera Stores, New York City; Georg Jensen Inc., New York City; Henry Kaska, Eastman Kodak Company, Rochester, New York; Jerry Kearns, Library of Congress, Washington, D.C.; Rose Kolmetz, The Museum of Modern Art, New York City; Barbara Kulicke, Kulicke Frames Inc., New York City; Marchal E. Landgren, Washington, D.C.; Dr. William Lee, Eastman Kodak Company, Rochester, New York; Ken Lieberman, Berkey K + L Custom Photographic Services, New York City; Samuel Locker, Royaltone Camera Stores, New York City; Richard LoPinto, Nikon, Inc., Garden City, New York; Tom Lovcik, The Museum of Modern Art, New York City; Jerald Maddox, Library of Congress, Washington, D.C.; Mark Cross Co. Ltd., New York City; Grace M. Mayer, The Museum of Modern Art, New York City; Wayne Miller, Orinda, California; Modern Age Photographic Services Inc., New York City; Pearl L. Moeller, The Museum of Modern Art, New York City; Robert D. Monroe, University of Washington Libraries, Seattle, Washington; Martha Morales, The American Institute for Conservation and Artistic Works, Washington, D.C.; Agnes Mullins, Arlington House, National Park Service, McLean, Virginia; Richard Nast, Vue-All Inc., New York City; Margaret P. Nolan, The Metropolitan Museum of Art, New York City; Doris O'Donnell, New York City; Ismael A. Olivares, Kodak Research Laboratories, Rochester, New York; Eugene Ostroff, The National Museum of American History, Smithsonian Institution, Washington, D.C.; Fred Otto, Bogen Photo Corporation, Englewood, New Jersey; William F. Pons, The Metropolitan Museum of Art, New York City; Karen Preslock, The National Museum of American History, Smithsonian Institution, Washington, D.C.; Print Processes Display Ltd., London; William H. Puckering, Eastman Kodak Company, Rochester, New York; Carol Pulin, Library of Congress, Washington, D.C.; Frank Reardon, Haverford, Pennsylvania; Vilia Reed, Eastman Kodak Company, Rochester, New York; Paul Rudolph, New York City; Elaine Schilling, Nikon, Inc., Garden City, New York; Edward Sclafani, New York City; Constance Shermer, Light Impressions, Rochester, New York; Joel Snyder, Chicago, Illinois; John Szarkowski, The Museum of Modern Art, New York City; Gene Thomas, United States Information Agency, Washington, D.C.; George A. Tice, Colonia, New Jersey; Tiffany & Company, New York City; Richard Tooke, The Museum of Modern Art, New York City; Clifford Whitaker, 3M, St. Paul, Minnesota; Henry Wilhelm, Grinnell, Iowa; Mark Wolfe, Fuller & d'Albert, Inc., Fairfax, Virginia; Betsy Gary Young, New York City; Harvey S. Zucker, New York City; Max Zweig, Penn Camera Exchange, Washington, D.C.

Picture Credits *Credits from left to right are separated by semicolons, from top to bottom by dashes.*

COVER: Fil Hunter

Chapter 1: Pages 11 through 45 except pages 20 through 27 are courtesy Smithsonian Institution. 11: Joel Snyder. 20, 21: Courtesy Arlington House, copied by Henry Beville. 22, 23: UPI, courtesy Library of Congress, copied by Henry Beville. 24, 25: William Henry Fox Talbot, from the collection of Eugene Ostroff. 26, 27: Drawing by Walter Hilmers Jr. from HJ Commercial Art. 28: William Henry Fox Talbot, copied by Eugene Ostroff. 29 through 32: Joel Snyder. 33: William Henry Fox Talbot, copied by Eugene Ostroff. 34, 35: William and Frederick Langenheim, copied by Eugene Ostroff. 36: Copied by Eugene Ostroff. 37 through 40: Joel Snyder. 41, 42: Copied by Eugene Ostroff. 43: Joel Snyder. 44, 45: Copied by Eugene Ostroff. 46: From the collection of Rodney Congdon, copied by Herb Orth. 47, 48: Al Freni. 49: From the collection of Rodney Congdon, copied by Herb Orth. 50, 52, 53: Eugène Atget, printed by George A. Tice, courtesy The Museum of Modern Art, New York. 51: Sebastian Milito. 54, 55: E. J. Bellocq, from the collection of Lee Friedlander. 56: Henry Groskinsky. 57: Al Freni. Original photograph Edward Albert. 59: Fil Hunter. 60, 61: D. Craig Johns. 62, 63: Fil Hunter. Original photograph Neil Kagan. 64, 65: Fil Hunter. Original photograph John Neubauer. 66, 67: Henry Groskinsky. 68: Eliot Elisofon for *Life*. 69: Eliot Elisofon for *Life*, copied by Time-Life Photo Lab. 70: Ralph Morse for *Life*. 71: Ralph Morse for *Life*, copied by Time-Life Photo Lab.

Chapter 2: 75: Frederick H. Evans from the collection of George A. Tice, copied by Herb Orth. 79-82: Al Freni. 81: Original photograph Evelyn Hofer. 83: Henry Groskinsky. Original photograph Dmitri Kessel for *Life*. 84, 85: Sebastian Milito. 86, 87: George A. Tice, from *Paterson*, Rutgers University Press, 1972. 88, 89: George A. Tice. 90: George A. Tice—Frederick H. Evans, copied by George A. Tice. 91-94: Sebastian Milito. 95: Frederick H. Evans, printed by George A. Tice. 96, 97: Frederick H. Evans, printed by George A. Tice, courtesy Witkin Gallery. 98, 99: Drawing by Frederic F. Bigio from B-C Graphics. 100: Douglas Faulkner. 101: Douglas Faulkner, separations and matrices courtesy Berkey K + L Custom Services Inc. 102: Douglas Faulkner, print by Berkey K + L Custom Services Inc.

Chapter 3: 105: Al Freni. 107: Sheldon Cotler, copied by Al Freni. 108 through 121: Al Freni. Original photographs 110: John Olson for *Life*; Alfred Eisenstaedt for *Life*. 122, 123: Drawing by Allen Carroll. 124: Drawing by Walter Hilmers Jr. from HJ Commercial Art.

Chapter 4: 127: Robert Colton. 128, 129: Drawing by Frederic F. Bigio from B-C Graphics. 130, 131: Fil Hunter. Original photograph Howard Sochurek for *Life*. 132 through 145: Ken Kay. Original photographs 134: Leonard McCombe for *Life*. 135: Andreas Feininger for *Life*. 136 through 139: Margaret Bourke-White for *Life*. 140 through 145: Michael Rougier for *Life*.

146 through 151: Robert Colton. Original photographs 146: Larry Burrows for *Life*—John Loengard for *Life*; Courtesy Mrs. Arnold Holeywell—Harry Benson from Black Star. 147: John Loengard for *Life*—Kosti Ruohomaa from Black Star—Courtesy Library of Congress; John Dominis for *Life*; Ralph Crane for *Life*. 148: Toni Frissell, courtesy Library of Congress—Rodney Congdon (3)—Suzanne Szasz. 149: Eliot Elisofon for *Life* and John Loengard for *Life*. 150, 151: William M. Mears III—Jay Maisel—George Silk for *Life*. 152, 153: Ken Kay. Original photographs Bill Ray—Constantine Manos from Magnum; Lee Hassig. 154, 155: Fil Hunter. Original photographs Neil Kagan. 156 through 158: Photomurals by Robert Backhard, copied by Paulus Leeser.

Chapter 5: 161: Andreas Feininger for *Life*. 164: Richard Meek. 165: Drawing by Frederic F. Bigio from B-C Graphics, photographs by Alfred Eisenstaedt for *Life*. 166, 167: Fil Hunter. Original photographs Alfred Eisenstaedt for *Life*. 168, 169: Alfred Eisenstaedt for *Life*. 172, 173: Wayne Miller from Magnum. 174: Homer Page, courtesy Wayne Miller. 175: Diagram by Paul Rudolph. 176: Homer Page, courtesy Wayne Miller. 177, 178: Wayne Miller from Magnum. 179: Erich Hartmann from Magnum. 180: Andreas Feininger for *Life*. 181: Ezra Stoller © Esto. 182, 183: Andreas Feininger for *Life*; Carl Mydans for *Life*. 184: Courtesy USIS Bonn—The Museum of Modern Art, New York.

Index
Numerals in italics indicate a photograph, painting or drawing.